LANDSCAPE PHOTOGRAPHY IN PRACTICE

LANDSCAPE PHOTOGRAPHY IN PRACTICE

Axel Brück

DAVID & CHARLES
Newton Abbot London

An Element technical publication
Conceived, designed and edited by
Paul Petzold Limited, London.

First published in 1983

British Library Cataloguing in Publication Data
Brück, Axel
 Landscape photography in practice.
 1. Photography—Landscapes
 I. Title
 778.9'36 TR660

 ISBN 0-7153-8405-8

Designer Roger Kohn

Typeset by ABM Typographics Limited Hull
and printed in Great Britain
by Jolly & Barber Ltd Rugby
for David & Charles (Publishers) Limited
Brunel House Newton Abbot Devon

CONTENTS

CONTENTS

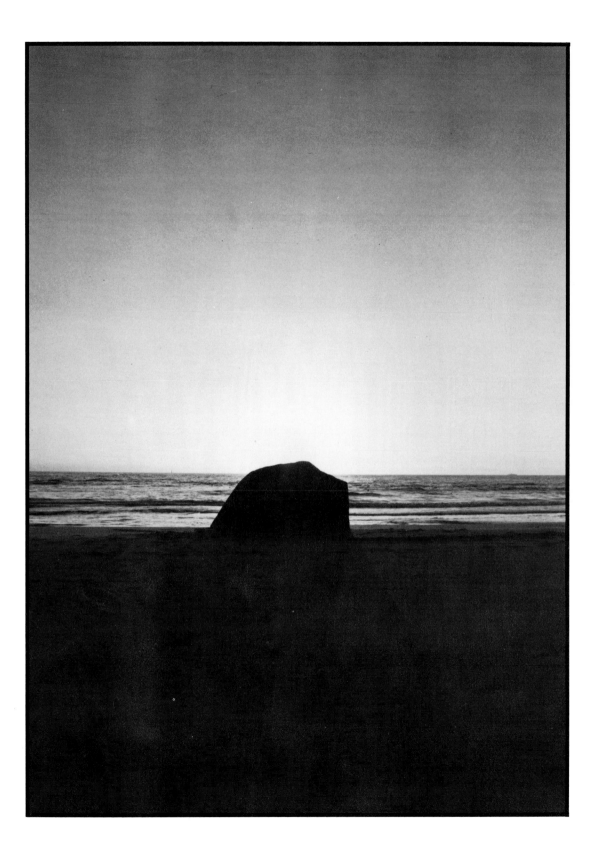

1 PHOTOGRAPHING LANDSCAPE

Landscape is perhaps the most popular of all photographic subjects. According to various surveys, at least, it is the subject of a vast majority of amateur photographs. There are several reasons for this:

First, many landscapes are inherently interesting, appealing and beautiful. Secondly, many people take most of their photographs on holiday, when the locality itself may be of particular importance to them. Third, holiday makers often photograph other people (or each other) and objects in outdoor surroundings, thus inadvertently creating landscape pictures.

All of these reasons are, of course, valid, but I think that to the serious photographer the appeal of the landscape itself is always a major part of his motivation. This aspect requires some examination, but before doing this I would like to take a general look at photographing landscape in order to provide a basis for the discussion that follows.

Types of landscape

Obviously, each type of landscape has a character of its own, which sets it apart from others. But it is also important to note to what extent all elements of a landscape are interdependent.

This not only involves the geological formation of the terrain, the vegetation and animals, but also the architecture, people living in the locality, and the weather.

The fresh experience of a new country and people, strange climate and curious architecture may induce you to capture these impressions in landscape photography. This means that your pictures should (and are likely to) show typical *traits* of each landscape. The problem is that these are not always as obvious and conspicuous as the New York skyline or the Pyramids. One of the arts of an accomplished photographer consists in finding these characteristic traits in all aspects of a landscape, from the greatest to the smallest.

As major features are usually self-evident, I will give you a few examples of the kind of thing that tends to get overlooked.

Even if you do not notice the fact consciously, secondary roads and paths in rural districts are often surfaced with a material found locally and characteristic of the district. Colours can vary from black through red and grey to bright yellow.

Another example would be clouds. You might think that the movement and formation of clouds depends simply on the weather. But the form of clouds may also be related to the ground formation beneath. Ordinary cumulus clouds, for example, can appear very different over a dry plain or flat country with lakes and waterways in it, compared with those typically seen over hilly country, in mountains or above the sea. The same applies to all other kinds of metereological phenomena. Different conditions characterise different regions.

Another type of difference is in the way houses are built. Older ones, at least, are usually constructed to suit the people living in the district, although that no longer applies to the products of our steel-and-concrete age. This may extend even to the way that fields and meadows are separated from one another. In contrast to today's post-and-wire divisions, traditional enclosures may consist of hedges, irregular walls of loose stones, carefully mortared brick and so on. This, again, depends on the district and the outlook and resources of the people living there.

One could continue and list vegetation, animals, the distribution of lakes and reservoirs, milestones, telegraph poles, even the contours of the ground itself—all these things are a reflection of characteristics peculiar to the landscape of which they form an integral part. This would apply not only to nature 'in the raw', or rural landscapes, but also to towns and industrial landscapes. Indeed, later we will discuss the peculiarities of landscape types and how to photograph them. My aim here, however, is to alert you to the fact that although a

1 The fascination of landscapes often lies in the small things: a cloud and a tree are nothing unusual in themselves. But if both come together in a similar shape and apparent size, you are suddenly confronted with interesting subject matter. It is of course impossible to 'construct' such subjects, but being constantly on the alert certainly helps in finding them. (21mm lens, 35mm camera, ASA 400 film)
2 Sometimes a landscape is characterised by a detail, sometimes by a panoramic view. Often, it is not the famous beauty spot which most typifies a locality (that is usually a spectacular view and, as such, atypical) but another scene which may mean very little to the inexperienced photographer. This majestic mountain, high in the Andes, is a case where both aspects are combined – it is spectacular and, at the same time, typical. (50mm lens, 35mm camera, ASA 125 film)

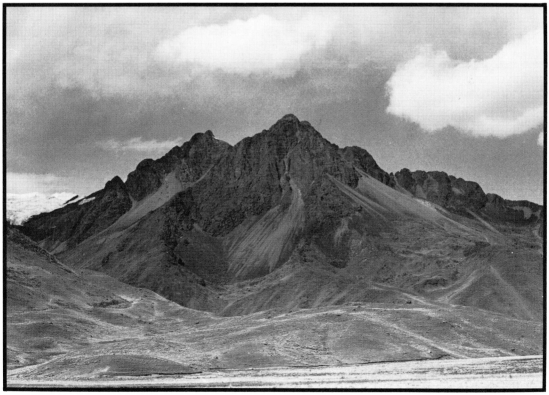

camel in front of a palm tree is, indeed, a characteristic subject, so is a cow in a meadow or on a plain under a sky dotted with clouds.

I am not suggesting that it would be interesting to deduce the whereabouts of the subject in a Holmesian manner from its details. But the overall impression of a photograph is made up from the combination of small things like these, which the photographer should notice and use.

Seeing and perceiving
Successful work of this kind requires an intimate knowledge of the landscape or, alternatively, a photographer who is really alert and notices things.

An overlooked detail can be either a lost opportunity for a good photograph or, conversely, the spoiling of an otherwise good one. In one of the Sherlock Holmes stories, Dr Watson complains that he didn't see anything. Holmes retorts that he saw all right, but he did not *observe*. We can see that Holmes has the magnifying glass, fingerprint powder and test tubes essential to his work. And so does Lestrade, blundering police detective. But where Lestrade fails, Holmes succeeds, because of his superior perception (and

his reasoning powers which are, alas, a bit superhuman).

The same applies to photographers. They all have their cameras and accessories. Some turn out better pictures than others, not on account of their superior equipment, but because they perceive and make use of things that others only see, but do not really notice.

That is not quite all. As with Holmes' reasoning powers, a photographer must have the skill to turn what he observes into a photograph using only the means at his disposal. Later I will discuss this process, too.

3 and **4** These two illustrations show the difference between a 'typical' and an individual landscape photograph. Both show a different part of the same subject, namely Mt. St. Michel (Brittany, France). The first shows parts of all the important features of the scene: the ancient buildings, the wide expanse of shore belt with the boat and the rather oppressive sky are representative of this part of the country. Here they are put together in a way that enhances their individual emotional qualities. The second picture shows another part of Mt. St. Michel, which is very different in character. It is typical of nothing except itself and it is in fact quite irrelevant where it was taken. (Both pictures: 6 x 9cm view camera, 49mm lens, ASA 400 film)

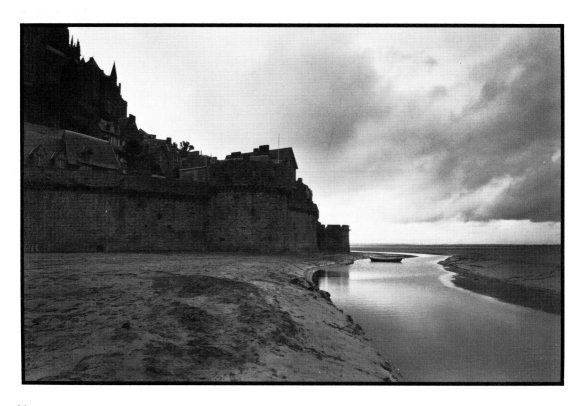

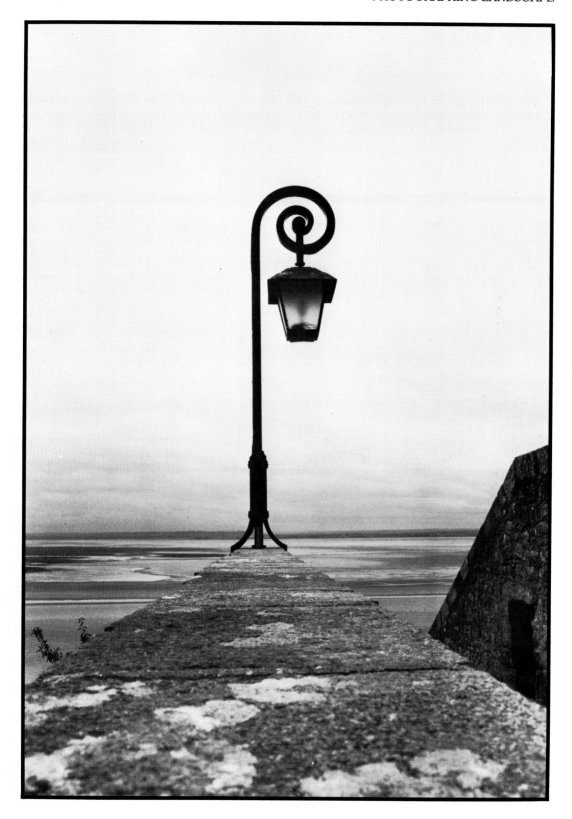

Individual landscape subjects

In any one type of landscape it is, of course, possible to find a wide variety of individual subjects. In a rural district one might find, for example, buildings surrounded by meadows and fields, a tree in a meadow, or a road seemingly leading nowhere. There is, however, a basic difference between these subjects and those mentioned previously.

If your idea is to show some typical aspect of a landscape, first you have to go looking for a subject which represents this most clearly. Having found it, you might still have to wait until all the conditions, especially the weather, are right, for the most impressive (ie. characteristic) result.

Alongside this is the type of picture that 'happens'. You see a scene that impresses you just as it is. The things in it—clouds, shadows, and everything else—are perfect and express something that you would like to capture in your camera.

Your approach to landscape photography is certain to be dictated by your temperament. You may like to plan and investigate in advance. If, on the other hand, you prefer to react spontaneously to situations as they arise, you will produce a different kind of picture.

Perhaps pictures achieved by the first method have a more documentary and informative flavour. The second often shows the subject in a rather personal, subjective and emotional way. The obvious conclusion is this: if you want to take photographs that appeal to as many people as possible, a good mixture of both types is called for. You should have the anecdotal photograph of things seen and people met as well as the 'character-study' of the landscape in question. If you are more interested in creative photography, your method must be quite different.

So your aims should be clear. The next question is how to go about creating these pictures. This book is dedicated to that problem.

How do you take good photographs?

If you had imagined that the key to this question lies in some hard and fast rules that guarantee success and that it is just a matter of explaining them in a few brief paragraphs, then I am afraid you will be disappointed. Were this the case, every photographer would be taking masterpieces all the time. In reality, there could never be such formulae, nor any way of applying them.

But we *can* approach the problem step by step, starting with the most basic and important factor, which is not the landscape, nor the camera, but *you,* because *you* take the photographs. First, therefore, we will discuss your reactions to landscape, then tackle the more practical question of how to turn these responses into good photographs, with the technical ways and means available. In doing this I have tried to divide my attention equally between the 'why' and the 'how' because, in my opinion, they are of equal importance.

5 Photographers see things in different ways. Anyone might have noticed the scene depicted here and, in fact, many people did. Some might have felt a bit uneasy about the wrecking of another piece of landscape but that's that.

6 Or is it? The difference between this and the preceding photograph lies in exactly 1.8m, this being the difference between the two viewpoints. But this photograph allows you to share some of the feelings which this destruction of the landscape had evoked in me – apart from being a striking and bold composition. It does not need special equipment or technique to make striking landscape photographs but sensibility and awareness on the part of the photographer. (Both: 21mm lens on 35mm camera, ASA 400 film)

2 LANDSCAPE AND THE PHOTOGRAPHER

A landscape photograph is a photographic picture, which contains as its main subject some kind of landscape. This statement may be true as far as it goes, but there are many bad and only a few really outstanding landscape photographs, so that we may well ask: what is a *good* landscape photograph?

If you really start thinking about that, you will soon realise that it is one of those apparently simple questions that is close to impossible to answer in a satisfactory way. Therefore I will try to avoid being foolish by sticking to the aphorism which states that the art of receiving answers lies in asking the right questions. With regard to the above question this means that I will have to split the initial query into 'subquestions' that may be easier to answer and which you can piece together according to your personal preferences and interests.

For a start, I am assuming that the secret lies buried in the personality of the photographer rather than in the picture itself or in the landscape on its own. (This assumption seems self-evident. Nevertheless I will discuss it at some length in this and a later chapter because it is really nothing of the kind.)

The photographer's perception

You will have noticed that the chapter heading consists of two *unknowns:* the landscape and the photographer—or does it? What actually is a landscape?

A landscape is not a static 'something', an 'object out there'. Landscape as such does not exist outside the man who perceives it. For a photographer, it can best be defined as an holistic experience (ie. a natural grouping of parts to form something greater than all of them added together, like a tune made from a group of notes), which comes into being through his perception and so, as it were, forms itself in his mind.

This probably very provocative statement

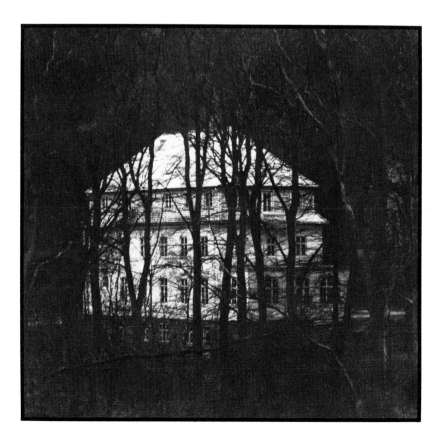

7 In this I have explained how the (physical) approach to a subject and its surroundings forms part of its impact as a picture. Here is an example where this could be made visible: the white house was situated in the middle of a very dark wood and very gradually became visible when approached, first showing only as white patches between the trees but finally revealing what it was. This very curious experience led me to compose the picture in this way. (100mm macro lens, 35mm camera, ASA 400 film)

needs some explanation because it will prove to be the key point of our discussion.

Landscape consists not only of what you see. As a truly holistic experience it makes itself felt through all your senses. The smell of the air, the sea, the flowers, other plants or the earth itself; the feel of the wind on your skin, of the sun's warmth, of scratching branches or of the hard pavement under your feet; the auditory element in the form of animal noises, or of sounds made by plants swaying in the wind, or by running water—all this and even the sense of tasting (after all, you 'taste' the salty air of the sea, as the writers have it) come together to form your impressions of a landscape.

But there is even more to it than that. Landscape, or to be more precise, its experience or impression, does not come to you in a flash (like the 1/125 sec. exposure of a photograph). It is a process that takes some time. You move in a landscape, you look around. At any given moment, you see only a small section of what is directly in front of you. But your perception of a landscape contains everything you have seen. It even includes your approach to a landscape. If

some spot was very difficult to reach, if the way to it was especially pleasant, if it is very secluded or crowded by sightseers, if you had to walk or even to climb there, or if you came by car and shot your photograph through the side window—whatever it was, it will have coloured your perception of the landscape whether you noticed it consciously or not.

The photographer's experience

All these perceptions and everything else you can think of in this respect come together to form your experience of a landscape. But the process does not end there. Figuratively speaking, this experience enters your mind and comes in contact with

8 The feeling provoked by wide and empty landscapes may make a deep impression. But it is one of the hardest things to express in a photograph because this, too, must be mainly empty which, in turn, does not usually impress the viewer. I have tried to convey this feeling here by using an off-centre element in the composition, which has some visual interest without crowding the predominantly empty space. (100mm macro lens, 35mm camera, ASA 100 film)

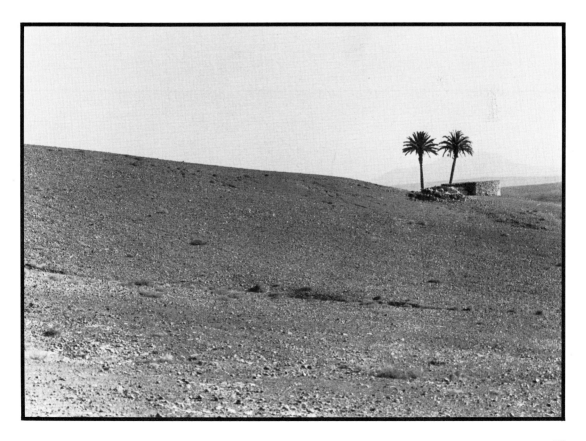

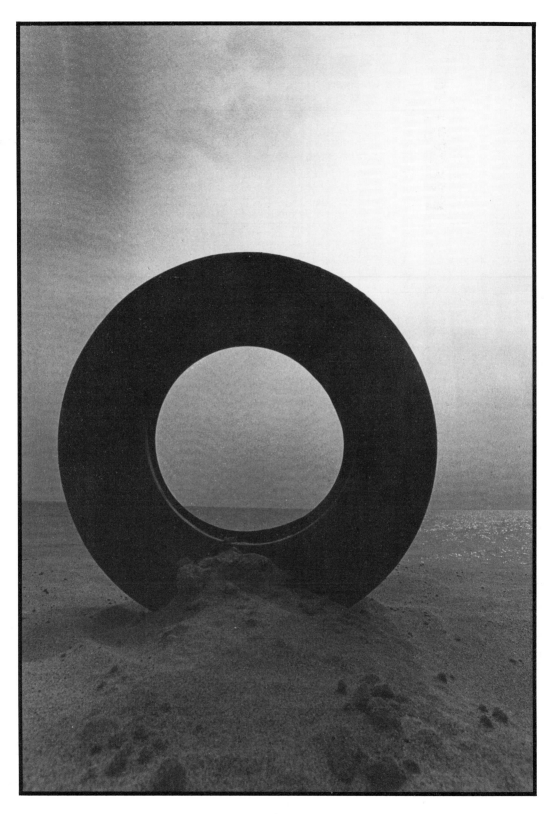

all other things which happen to be there. If, for example, you experience a certain type of landscape for the first time, you will react entirely differently from the way you do to a type of landscape with which you are already familiar. If you dislike heat, your attitude towards deserts and other 'hot' types of landscape will be different from that of someone who really enjoys this kind of climate.

On another, less superficial level, you may like wide open landscapes and will therefore feel a distinctly different reaction to the small scale, secluded type. Perhaps you subconsciously prefer smooth, rounded forms to straight, angular ones (which could mean that you are more attracted to stones and rocks than to trees or man-made structures of the industrial kind). Again, you may prefer certain kinds of colour to others and are therefore attracted by specific varieties of landscape.

I think the direction of the argument is so obvious that I do not have to find further examples for what is happening when you perceive or experience a landscape. But you should note that the process involves all layers of your personality, down to the depths of your subconscious.

So, the perception of the landscape is a very subjective and personal experience and comes about through the mind of the photographer. This is bound to be reflected in the photograph in some way or other.

The photograph as memory

Many, or perhaps even most people take up photography because they want to preserve their memory of things, either for themselves or for their children and grandchildren. Of course, a photograph is not a memory in itself; it can only serve to trigger or help to refresh your memory, which—with regard to landscape—consists of the experiences described above.

That is a very important point, because a photograph, be it a simple snapshot, a documentary statement, an aesthetic object, a description of feelings or impressions or a message, is always a

'memory' (in the sense described above) for the person who took it. From this we can deduce, that the photographer always sees more in his photograph than anybody else can, because he more or less automatically relates it to his experience of the landscape depicted.

The same purpose could be served by something that you found there at the time, a stone perhaps, or a flower which you have pressed between the leaves of a book, or a poem which you wrote apropos of this experience (if you are so inclined). So it is hardly worth discussing photographs-as-memories from a photographic viewpoint. They are as personal as the original experience and relate solely to their originator.

The significance of the point lies in the fact that many people are deceived by this very personal relationship with their own photographs. They are led to believe that this, the 'memory' part of the photograph, can be appreciated just as easily by others as by themselves. (This happens to very experienced photographers as well—although less frequently—because it is sometimes extremely difficult to recognise those parts of a photograph that can only be of interest to the person who took it.)

The situation is relatively complex. On the one hand each and every photograph can serve as a memory for the person who took it. On the other, this memory is—as we have seen—very personal and private and usually not available to other people.

The photograph as a statement

This dilemma leads to a first and tentative answer to our initial question: what is a good landscape photograph?

The conclusions we have so far reached are:
1 The landscape is not a static 'object out there', it is an *event* which takes place in the photographer's mind.
2 This event consists of the concrete situation, which cannot be repeated and the photographer's personality, which is unique as well.
3 It cannot be assumed that a third person, a viewer, can see or recognise the above in a photograph.

If you succeed in removing these obstacles, that is, if you take a photograph which transmits your personal experience to a viewer so that he or she can appreciate it, then you have produced a good landscape photograph.

What does this mean? It means that a tree grow-

9 The strange object shown in this picture is nothing but an old tyre which some children had been playing with on the beach. The low viewpoint, the backlighting and the fairly static composition turn it into a more or less mysterious object which, at least in part, appeals to the viewer because it leaves him wondering what it is, or means. (21mm lens, 35mm camera, ASA 100 film)

ing in a meadow does not make a good landscape photograph. But your idea or feeling about this tree does, provided that it comes across in your photograph.

If you feel inclined to take a picture of this particular tree, it must have some special property (or to be more precise, it must be part of some special state of mind of yours) which seems worth depicting, as opposed to those countless trees which you did not photograph. And this is exactly what you must make apparent in your picture. You must do this in a way that can be understood and appreciated by a person looking at your photograph.

A landscape photograph is a visual statement directed to others.

A personal approach to landscape

This visual statement necessarily contains all the elements so far described. That is, it contains the visual components, the particular part of nature at which you are aiming your camera when taking the picture as well as all your feelings, emotions, ideas and associations in relation to it.

Therefore landscape photography is an intensely personal process (which it shares with all other kinds of creative photography). Its main ingredient is not the object to be photographed—a controversial argument which we will discuss in a later chapter. Nor is it the camera or the technique. It is simply you yourself—the personal message in visual terms.

This leads to the inevitable conclusion that the state of the photographer's mind is responsible for the quality of his photographs. Or, put simply: if you want to make a statement, you must have something to say. This may sound dangerous, but it is actually nothing of the kind, because if you feel compelled to take a certain photograph, you usually *do* have something to say.

The real problem is a more practical one. It is important to be precise. If you want your photo-

graph to carry an emotion, this should be strong and clear.

If you want to put across a more intellectual idea, it should be precise and not muddled with other ideas and so on.

To make a personal statement does not mean to be obscure. On the contrary, the more personal your approach, the clearer you must make your meaning so that you can be understood.

Although this all sounds quite above board, it is actually a very difficult point. Clear does not necessarily mean that your picture must be simple or easy to understand. It can be as mysterious or even mystical as you like—but not vague! Your picture will be clear in this sense of the word, when everything in it, every detail of its conception and its composition down to the presentation of the finished product conforms to one single idea, feeling, mood, association or whatever it is, that you want to express.

The photographer who wants to succeed with his work has to be absolutely singleminded—for one photograph. He or she can, of course, be of an entirely different mind for the next one, if need be.

I am stressing these points as much as I can, because photographic discussion is usually restricted to technical matters, which so far I have not even mentioned. You may wonder about this, but it is a fact that, however difficult or involved it may be, the mastery of technique is a relatively minor matter.

Photographic technique is a tool. Anyone can acquire it, with some degree of competence. The problem is how to wield this tool in a useful way. In this book photographic technique is discussed as far as it applies to landscape photography and its role in helping you to express your ideas visually.

It will be your job to keep what we have discussed so far constantly in mind because your attitude to the technique and the ideas you express with it are always more important than the technique itself.

10 According to the conventions of photography, this picture is no good: it shows bleached out areas and inky black shadows. But if you take these away, nothing remains. A photograph as a personal statement often calls for the breaking of rules and for unusual means to express the feelings of the photographer. (21mm lens, 35mm camera, ASA 100 film developed for contrast)

3 ELEMENTS OF LANDSCAPE

Even if, in the final analysis, the photographer's personality is responsible for the quality of his landscape photographs, the importance of other points remains undiminished. You obviously need a camera and lenses, film and whatever may happen to take your fancy in order to create a landscape photograph, as well as trees, stones, water, earth, clouds and all the other parts of nature.

But even with all these there is another component for a good landscape photograph that is less easy to identify.

Ingredients of a powerful photograph

We might well ask ourselves: is it possible to define what constitutes a good or 'powerful' landscape photograph? It seems not. Presumably, if it *were* possible then there would be a reliable recipe for taking this kind of picture. In view of the fact that many try their hand at it but only a few succeed, it seems that this foolproof answer does not exist. As I said before—no easy formulas.

On the other hand, we can easily recognise a powerful photograph if we see one. The reason for this seeming contradiction lies in the fact that tastes, and many other factors, vary and that one man's masterpiece may be another man's aversion—a point I cannot go into here, because it is a question that would fill a book by itself. I mention it only to ensure that you take all my reflections on 'good' and/or 'powerful' photographs for what they are—personal opinions based on my own work and my experiences with the work of others, but decidedly not final truths which must be accepted without question.

The ingredient that makes a good photograph a strong one cannot possibly be the subject itself because no subject yields only good photographs, as everyone who has tried will know. On the other hand, it cannot be the force or quality of the photographer's personality alone, as one can see by the abundance of mediocre photographs.

Although all these things play a part in the realisation of a landscape photograph, the decisive factor seems to be a very special skill, namely, the ability to bring together and to fuse the technical potential on one side and the idea to be expressed on the other.

The approach to a powerful landscape photograph, therefore, is twofold. The questions one asks are: what makes this tree so interesting, why do I want to photograph it, what does it mean for me, what do I feel about it? And, at the same time: how do I go about putting this in a photograph, how can I use the elements of nature that are there in front of me and the technical possibilities at my disposal, to form this into an appealing, powerful picture? Answer both these questions successfully, and you have all the ingredients of a strong landscape photograph.

But do not misunderstand me. This process does not need to involve conscious thinking or working out. Some people do it entirely by instinct, others realise it in a purely intellectual way and still others have the most curious mixtures of method. It does not matter at all how you do it, as long as the thing gets done in some way or other.

But it always helps to discuss these things, because even the instinctive approach to landscape photography is improved if you reflect on the problems involved and let your answers sink into your subconcious from where they will worm their way into your work.

We can now look more closely at the two aspects in question, the transformation of the elements of nature into a visual statement and the application of technical resources which allows us to do so.

Transforming landscape into an idea

If you want to take successful landscape photographs you should never fall into the trap of taking what you see for granted. The visual elements of the landscape you want to photograph are nothing but the raw material which you shape by means of photographic technique according to your ideas.

Take, for example, the sky: is it important for the feeling or idea you want to express? If so, you can place the horizon close to the lower border of your photograph. Should the clouds be incorporated,

11 What looks like a small canyon is in fact nothing but the edge that the retreating high tide left in the sand. It is only approximately 10cm high but looks much larger due to the extreme wide-angle lens used and the very low viewpoint. This is an example of the transformation of subjects by means of photographic technique. The power of the thing depicted more often lies in your vision and in your photographic ability than in the subject itself. (21mm lens, f/16, focusing distance 26cm, 35mm camera approx. 10cm above ground, angled viewfinder)

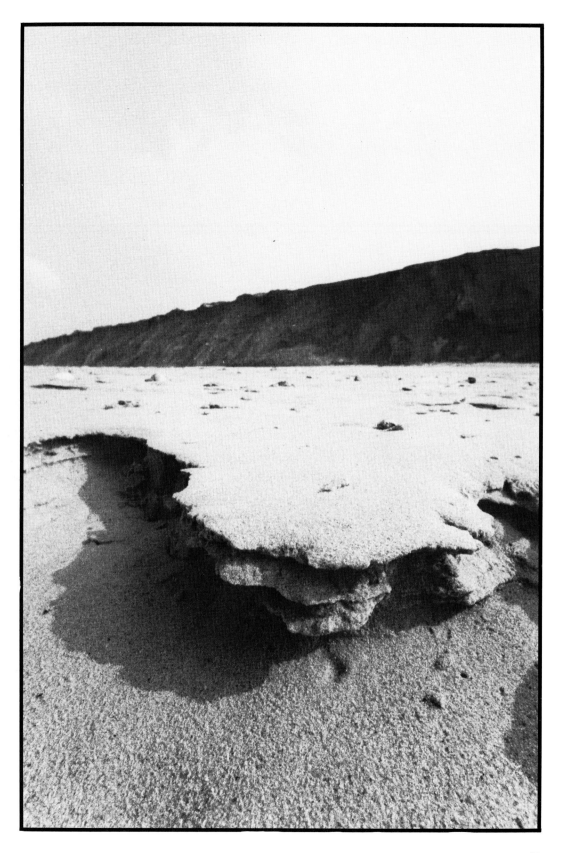

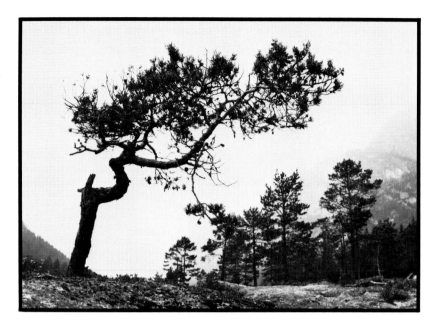

12 This waist-high tree was barely visible against the background of other trees. It seemed nothing much – but was transformed into a striking photograph firstly, by choosing a viewpoint only inches above the ground, which positioned it effectively as a silhouette against the sky and, secondly, by the exposure, which favoured the dark foreground. The importance of the background was further diminished by the use of a wide-angle lens. (55mm lens, 6x7cm camera, ASA 100 film)

13 Transforming landscape into an idea (and this into a photograph) does not always require extreme technical measures. Often, it is sufficient to see the potential in a subject and just shoot straight away – an approach that is just as challenging in its own way as a carefully planned and organised method. Quite possibly, the more deceptively simple a photograph appears in technical handling, the harder it may have been to take. (50mm lens, 35mm camera, ASA 125 film)

or would a clear 'empty' sky conform better to your idea? The proper use of films and filters allows you a choice. Or take the main subject: the tree which you want to photograph. This may impress by its size, volume, form and structure. If so, you should place it in the foreground of your picture. Or are its surroundings more important? Then the tree should obviously be in the middle distance or background.

Perhaps the relationship between the tree and other parts of the picture is important. If so, use a wide-angle lens to stress the space between the various elements, or a telephoto lens to show the closeness of the subject or the relative sizes of its various parts in relation to each other.

Do you want to stress the seclusion and completeness of your subject? If so, you might consider having a black border and a white margin around your picture. Or do you prefer a more dynamic and 'open' impression? Then your photograph should be border, margin and frame-*less*.

In fact, every technical possibility you can think of serves to transform the elements of nature according to your ideas.

Taking a photograph is not an act of depicting reality (whatever 'reality' may be construed to mean). Even a so-called documentary photograph is actually nothing of the kind. The simple act of pointing your camera at something by the very fact of simultaneously excluding other things is an interference or manipulation and constitutes a transformation of nature into an idea.

Variables in your hand

I do not want to pursue these debatable points further. My aim was to alert you to the fact that taking a landscape photograph is an act of transformation and that you should always keep this in mind when you look at the technical possibilities at your disposal.

If we were to discuss films, for example, the only relevant question would be: what does the use of this or that film do to the impact of my picture? Or the lens, the viewpoint, the exposure time, the filter, or whatever else you have.

You should never be deceived into believing that there is something like the perfect exposure time for a given subject, or that one lens is better than another for a certain kind of subject.

These are variables that you can use according

14 Some of the most powerful variables in your hands are extremely simple: a change of viewpoint, a different treatment of exposure or slight changes in depth of field can alter the entire effect of a photograph. This picture, again, was taken with the simplest means – a standard lens on a 35mm camera. The picture would have gained nothing from the use of more sophisticated equipment. Here the choice of viewpoint was the most important factor; even a slight shift to the left or right, or up or down would have changed the whole composition and, with that, weakened its impact. (50mm lens, 35mm camera, ASA 125 film)

to your ideas, not to conform to the preconceived notions of others.

In the absence of preconceived ideas or sure-fire 'rules' you will, of course, have to grapple with the problems of how to go about turning your ideas into good pictures. There are various ways to approach this in practice, but it will obviously always end with a comparison of your ideas with the way in which you turned them into a picture.

Visualisation by instant photography

That is often much more difficult than it sounds, the main reason being that there is usually quite a considerable interval between the moment you

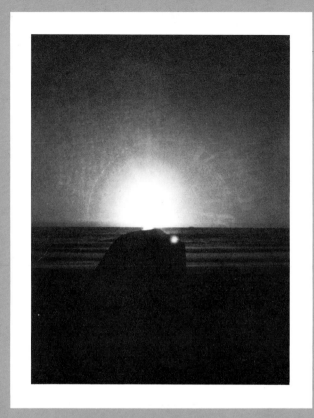

15 The plastic lens of my instant camera has a curious optical quality which becomes apparent when direct sunlight strikes its surface. These irregularities in the plastic substance are responsible for the interesting structures of this sunset picture. I do not regard them as a fault, they rather enhance the compositional scope of instant photography.

16 In my experience instant materials handle grey values extremely well. Nevertheless, a severe reduction of the grey scale often helps to enhance the impact of a composition like the one shown here, so that it looks fairly impressive despite its very small size. Exposures like these are bit tricky, because you cannot compensate for mistakes by darkroom manipulation – but this can be regarded as an educational quality of instant photography!

17 Even if there is a lot of detail in a subject, it will not be perceptible in the instant picture when you choose to take an overall view. Such pictures work only on account of their general shape and grey values and you have to take this into account when choosing a subject. (All instant pictures in this book were taken with the same camera, a simple instant camera with plastic lens and automatic exposure system.)

18 Apart from its uses as a tool for learning, instant photography offers an interesting photographic challenge in itself. The prints are very small (here: approx. 7.5 x 9.5cm or 3 x 4in) and the choice of subject and the compositional treatment must take that into account. Simple composition without detail is, more often than not, more effective than a conventional approach.

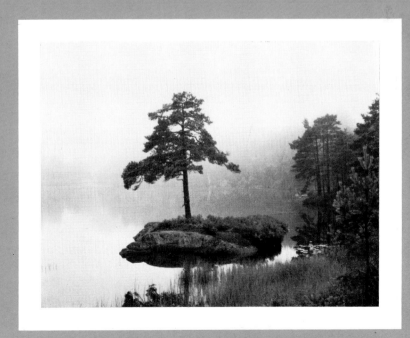

take a picture and the time when you have the finished product in your hand.

You may be able to recognise a failure and a success without difficulty, but it is not so easy to pin down the exact reason why something failed or succeeded when the 'magic moment' is long gone. Can you really remember the exact reason why you handled every detail in the way you did?

Even if you do remember, you cannot go back for a second attempt: your state of mind, the weather, the time of day, or the season, perhaps even the subject itself may have changed, so that a renewed attempt would have to result in a different picture anyway.

The only technique which offers you immediate control over your results and thus gives you a chance for a second attempt (in most cases) is instant photography.

A few seconds after you have taken the exposure, you can check the photograph against the picture in your mind's eye. I always find this process quite sobering. When you take pictures in the 'normal' way, the lapse of time blurs the memory of your original intentions, so the fact that you like the resulting photograph usually blinds you to the recognition that you failed to put your original intentions across.

With instant photography this cannot happen. Your memory is still fresh and you really can compare what you wanted to do with what you really did. Additionally, you cannot 'cheat' in the darkroom by cropping or hiding mistakes in exposure —the finished photograph is a faithful record of what you really did.

I think this is why many people mistrust instant photography. They tend to believe the materials or the cameras defective or inferior because the pictures often look so bad. But this is not so. It is true that instant photographs show every mistake mercilessly. And, what is more, they reveal the defects in the realisation of your idea.

That is exactly why I believe instant photography to be the best tool for learning about photography in general: as I have explained already, the main problem is forming the elements of nature, with the technical means available, into a picture. So, due to the transitory nature of ideas, immediate results offer the best way of doing so.

If you want to make use of instant photography in this way, you should remember that the idea is not to take a single picture, but to repeat the process until you have arrived at a really satisfying result. Or, if you are not entirely sure about your idea or the form it should take, you could attempt various alternative solutions which you can then compare with the subject and the idea you had in mind.

One limitation of instant photography is that you do not usually have interchangeable lenses. (This does not apply to special film backs for view- and medium-format cameras or to the Polaroid 600 S.) I do not regard this as a severe limitation for the purposes discussed here. On the contrary, the restriction to one focal length may even speed up your learning process.

Instant photography as a medium for landscape

Apart from its didactic value just described, instant photography is, of course, a completely independent photographic medium, which is perfectly suitable for landscape work.

As far as the impact of the finished picture is concerned, the main difference between 'instant' and 'normal' photography is in the size of the print. The lay person is not very likely to experiment with the professional materials in 18 x 24 cm (7 x 9½ in) or even 50 x 60 cm (20 x 24 in) sizes, so the maximum print size available to you is likely to be 9 x 12 cm (3½ x 5 in). Naturally your choice of subject and the way in which you render it must take this limitation into account.

Although an instant print can resolve fine detail, the need to examine it at close range is a strain on the eye. So it is usually best to aim for a relatively bold and large scale composition.

On the other hand, the very fine resolution would allow you to incorporate detail below the normal visibility threshold, which adds depth and richness to very small-scale and intimate subjects.

Compared with 'normal' films and papers, instant materials have a reduced contrast scale which requires a slightly different attitude towards exposure (see Chapter 5).

The limitations of the very simple run-of-the-mill instant cameras do not seem to be a factor reducing your creative abilities. I have always regarded this as a challenge which actually enhances the photographer's awareness of his materials and equipment.

In order to illustrate these points, I have chosen here a small group of pictures I took using an old instant camera (now out of production) with a simple plastic lens and automatic exposure system, which can be influenced but not switched off.

4 TECHNIQUE AND LANDSCAPE – NEGATIVE SIZE AND FILM

Even if you already have a suitable camera for landscape photography (which is likely), you should read this carefully. The kind of film used and the negative size have a strong influence on how you produce your landscape photographs. Even if you stick exclusively to one kind of film in one size only, you should know about these influences, so that you can consciously incorporate them into your work and explore the technical boundaries thus imposed on you.

Influence of negative size

The first, and perhaps even the greatest of these influences, comes about by the sheer weight and size of the equipment needed for various formats. I think it is quite obvious that a view camera requires a different attitude towards taking pictures of nature than, for example, a 35mm camera.

The slow, probably more methodical and planned approach called for with a view camera and tripod is as clearly visible in the finished picture as the 'free' and spontaneous use of 35mm.

Unfortunately, some people seem drawn into producing sloppy work and using a kind of hit-and-miss technique when they work with a 35mm camera, simply because there are so many exposures on a roll they believe that one of them is sure to come out right. Nobody using a view camera would ever dream of such goings-on because for him each negative is a single shot and a separate physical entity.

But apart from these differences in attitude, which are likely to influence your choice in accordance with your basic psychological make-up, there are also major technical differences.

Grain information

Assuming that a good lens is used, the amount of information that can be stored in a negative depends on the grain structure and also the negative size. Strictly speaking, the actual grain is invisible to the eye except under a microscope. What we refer to as grains (on conventional materials) are accumulations or 'clumps' of grain. But as these are coloquially called 'grain' I will stick to the common usage of the word in order to avoid confusion.

Naturally, a photograph cannot show any detail which is smaller than the grain itself. In many enlargements the grain is actually the smallest visible detail. Therefore a larger negative shows more detail than a small one.

The more decisive factor here is the 'speed' of the film: high-speed film, ie. ASA 400/27 DIN (ISO = 400/27°) shows a coarser grain than slow film, ie. ASA 50/18 DIN (ISO = 50/18°) or ASA 100/21 DIN (ISO = 100/21°). These assumptions are only disturbed to any extent by tabular grain films which have relatively little grain for their speed—and consequently greater resolution than comparable films of the conventional type. The question now is: could you use a very slow speed film with a 35mm camera and thus arrive at a negative which is comparable to that obtained with a view camera, taken with 'normal' film and could you—for special purposes—make very grainy, full-sized negatives with a view camera?

The answer in both cases is no. The difference in the grain size between high- and low-speed films is smaller than the difference provided by the negative sizes. This applies even if you compare 35mm and medium format negatives.

The inevitable conclusion is that detailed pictures require greater negative sizes although some variation is possible with the use of films of different speeds. The question remaining to be answered is, how does varying the amount of detail actually affect the impact of a landscape photograph? We will discuss this at greater length later on, but a tentative answer is called for at this stage.

If the grain is distinctly visible in an enlargement the 'graphic' quality of the picture is stressed —you are made aware of the actual surface of the paper and of the two-dimensionality of the picture. If, on the other hand, the grain is distinctly below the threshold of visibility the representational quality of the picture is stressed and, with this, the spatial properties of the objects seen in it.

Of course, both approaches are possible and equally valid but I think it is safe to say that they reflect basically different attitudes if not towards landscape photography in general, then at least towards the subject matter in question. You should check your feelings concerning one or the other possibility carefully before finally deciding on a negative size.

One kind of black-and-white material—chromogenic film—does not fit neatly into these

19 This photograph was taken on a 9 x 12cm negative using fine grain film. Although the composition is bold and simple, it draws a considerable part of its impact from the fact that it shows the finest detail, right down to the smallest grain of sand between the paving stones. What I cannot show here is that the finished print has a size of 90 x 120cm. It is quite obvious that this kind of photography requires all the detail that you can get into the print – hence the large format and the fine grain film. (75mm lens, 9 x 12cm view camera, ASA 15 film)

categories. Although yielding only a monochrome image, this film works like colour material. The silver image is bleached out and what remains is a residue of dye representing the grey values. Accordingly, these films do not have any grain in the normal sense: instead they show a kind of 'cloudy' structure. Although they have an enormous exposure latitude and may therefore be tempting as a kind of all-purpose film, they are not, at least in my opinion, very suitable for creative photography. On the one hand, their cloudy structure is visible in enlargements from 18 x 24cm upwards; on the other, this structure somehow looks 'muddy' and 'untidy' and not at all like the sharply defined and clear grain of normal black-and-white films. I like my photographs either exceedingly detailed, or with a clearly visible, acutely sharp grain, but nothing in between. This is, however, an entirely personal opinion and you should not hesitate to check whether these films suit your own preferences.

Colour saturation and related factors

Similar considerations apply to colour photo-

20 This is the opposite to the previous illustration. Taken with a 35mm camera on orthochromatic film, it suppresses much of the detail without destroying the recognisability of the subject – thus enhancing its stark simplicity. The subject was not handled in this way because of some whim of mine. I thought that by this method I could reveal the emotional quality I associated with the subject – ancient, dilapidated, primitive. (21mm lens, 53mm camera, ASA 15 orthochromatic film ASA 15)

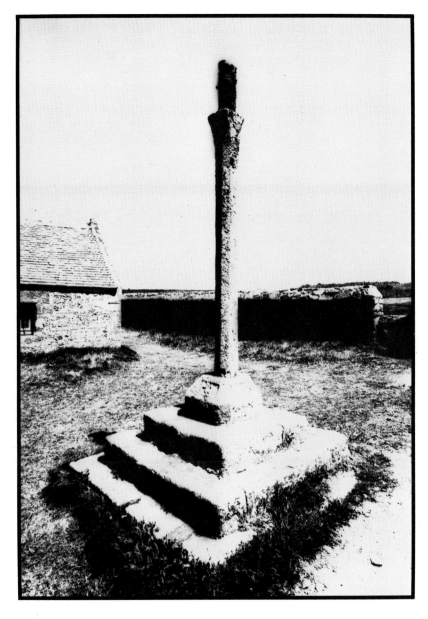

graphy. Although there is no grain in colour materials (negatives or slides) there is a more or less granular distribution of colour particles. This varies with the speed of the film and works—as far as the impact of the photographs is concerned—along the same lines as the grain in black-and-white photography.

An additional factor is colour saturation. Generally this is better with the larger negatives or slides. In pictorial terms colour saturation could be described as 'richness of colour' and 'subtlety of hues'. In this respect there is really quite a noticeable difference between a 35mm slide and one made with a medium format or even larger camera.

Sometimes people make extreme enlargements of very small sections of colour negatives or slides in order to incorporate the colour grains themselves in the structure of their pictures. But apart from this application I can think of no situation where a stronger colour saturation would not be a definite advantage. So larger format might be particularly appealing to you if you work exclusively in colour.

21 The shadows on the left hand wall created by the oblique angle of the lighting gave the contrast sufficient punch to allow the use of an ASA 400 film. Notice the comparatively low contrast of the right hand wall, (which would hardly have sufficed for a whole picture). This was fortunate because the subtle variations of grey values in the sky, which play an important role in the photograph, would have been too coarse with a slower speed film. (21mm lens, 35mm camera, ASA 400 film)

Perspective and field depth

The choice of a certain negative format not only imposes on you the use of cameras of a given size and weight, it influences your selection of lenses as well. We will discuss this here in relation to the standard lens only but, of course, it applies to all kinds of lenses.

As is well known, the standard or 'normal' lens is the lens that gives an apparent perspective rendering of the subject which comes closest to the way in which the eyes perceive this same subject.

A standard lens covers an angle of view of approximately 45°. Another way of defining it is that its focal length is approximately equal to the diagonal of the negative. Consequently, the focal length of the standard lens is different for each negative size. The following table gives the focal lengths for various negative sizes:

Negative size	Standard lens (approx)
(cm)	(mm)
24 x 36	50
6 x 6	80
6 x 7	90
9 x 12	150
18 x 24	300

With all these lenses the rendering of space and the perspective impression is exactly the same but the other properties are quite different.

Let us assume, for example, that you photograph the same subject with a 35mm camera and also a camera of 18 x 24cm (6½ x 8½in), whole plate format, having focused on 10m using an aperture of f/5.6. The depth of field is then:

50mm lens (35mm camera): 5.9–32m (19–105ft) = 26.7m (88ft) total
300mm lens (18 x 24cm camera): 9.82–10.2m (32–33ft) = 0.38m (1ft) total.

You are not, perhaps, very likely to use a whole plate camera but even between a 35mm and 6 x 7cm camera, the difference is quite noticeable; viz, (same distance and f/number as above):

50mm lens (35mm camera): 26.7m (88ft)
90mm lens (6 x 7cm camera): 3.7m (12ft)

Therefore the available field depth should be an important factor in your choice of negative size. Some people tend to work with very small field depths because they wish to make use of differential effects of sharpness and unsharpness in their pictures. For them a larger negative format would be preferable because it offers small field depths with even relatively short focal length lenses.

Other people prefer to have an effect of overall sharpness in their pictures. For them a smaller negative size would be the obvious choice. However, the movements available on view cameras allow you to manipulate the distribution of sharpness within the picture plane so that it is, in some cases, easier to achieve overall sharpness with a

view camera than with a 35mm camera and short focal length lenses.

We will return to the question of perspective impression and field depth later. Suffice it to say for the present that the problem is closely related to your choice of negative size and you must therefore take into account the considerations described above.

Films

Some people turn the question of which film to use into quite a major problem. They run various tests in order to determine which film is 'sharpest' or suchlike, or they study the appropriate test reports and constantly switch between films accordingly.

In my view this is rather foolish. If you are not content with the quality of your photographs, the chances are very slim that this is because of the film you use. It is much more likely that the fault lies with your 'vision' or your technical approach (meaning the way in which you handle your technique in order to achieve a previsualised result). If, on the other hand, you attach special importance to grainlessness or contrast, for example, then why not change to a larger format?

In my opinion the best (and only) way to settle the problem of films is to decide to use one kind of material only and then stay with it. You can then try to improve your handling of it with exposure, development, etc. rather than by switching to something new.

The important thing with films is to be as familiar with their properties as possible. You must know how they react to over- and under-exposure, or to various kinds of development. You should have a feeling for the way in which the film reacts to different conditions of subject and light-ing contrast, or how it works with filters of each type. In these respects each film differs from the next and it would be difficult to gain the necessary experience to handle it with confidence if you do not use the same kind of film all the time.

You may prefer a different solution to your problems but I have found the approach on which I finally settled after some experimentation to be very practical. I use only one brand of black-and-white film, in two different speeds, for all my work and all camera formats (apart from some very special exceptions discussed below). It is an ASA 100/21 DIN (ISO = 100/21°) material suitable for subjects of low contrast, or for those with strong contrast where I want to stress the contrast still further, or for subjects of average contrast that I want to render without grain.

The other film is an ASA 400/27 DIN (ISO = 400/27°) material, which I use for subjects with very high contrast, or for those with low contrast where I want to stress this property, and for all subjects that I want to render with pronounced grain.

For both these films I use two standardised developments, one for underexposure and one for overexposure. Together with the controlled exposure this furnishes me with so wide a variety of creative possibilities that I am not likely to need anything else. On the other hand, the number of variables is small enough for it to be quite easy to predict the results when deciding on a particular procedure.

Creative potential of films

Apart from the effects of over- and under-exposure, which are discussed later, I have assembled all the possibilities in a 'yes-and-no tree', or flow-chart of options, which should clarify matters.

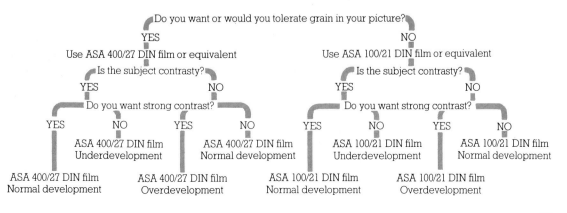

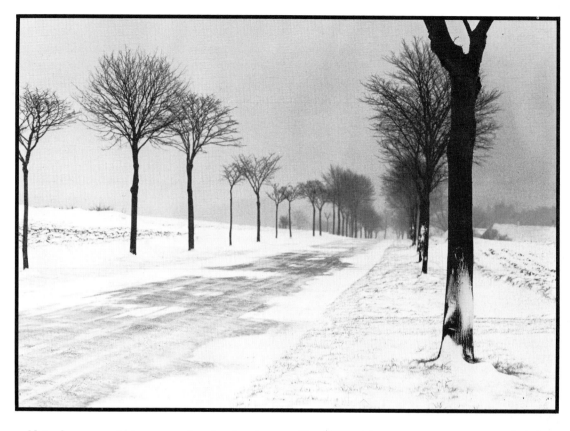

Note, however, that over- and underdevelopment require the appropriate exposure to be really effective and that this diagram offers only a tentative approach. If, for example, you consider the question of grain to be of secondary importance, you would decide along different lines, choosing an ASA 100/21 DIN film for strong contrasts and an ASA 400/27 DIN film for weak contrast, irrespective of the contrast of the subject.

You may have noticed that so far we have not discussed the relative strength of the light. In creative photography, it is simply a misconception to think along these lines. We should be thankful that the industry has developed high speed films for use in low light and so on, but we should take a quite different viewpoint.

Let us assume, for example, that you want to take pictures in equatorial countries with very strong light and, accordingly, strong contrast. Usually, you would expect to load a low speed film. But in reality it might be much better to use a film of high speed (together with a neutral density filter, if need be) in order to achieve a normal rendering of contrast.

On the other hand, you may want to photograph

22 and 23 These two photographs were taken under almost identical lighting conditions. Additionally, they show very similar subjects (in grey values and contrast). Nevertheless, they seem quite different owing to the films and the exposure used. Illustration **23** was taken on ASA 50 film with overexposure, which almost reduced the contrast to pure black and white, while illustration **22** was taken on ASA 400 film with normal exposure. I think that the difference in impact of these two pictures is quite obvious. (**23** 100mm lens, 35mm camera, **22** 90mm lens, 6 x 7cm camera)

under low light conditions, for example, landscape at dusk or during the night. Generally speaking, such conditions exhibit very low contrast, so that a low speed film would be best even if it means using a tripod.

The exceptions to this general rule are scenes that contain light sources. The contrast between street lamps, illuminated shop windows or advertisements (or specular reflections from them) and the general scene can be extreme at night but may be tolerable at dusk.

Options: different types of film

So far, we have discussed only what might be

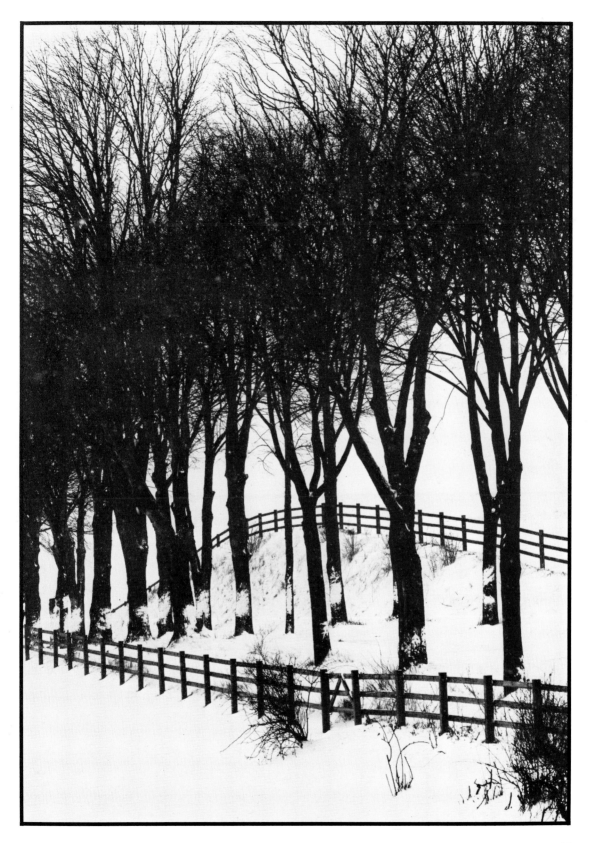

24 This photograph draws strength from the very subtle gradations in the colour of the waves. For all such subjects it is advantageous to use a larger format, offering the greatest possible colour saturation and which consequently records the finest gradations of hue. I believe that the negative (and print) or slide size should generally be larger, the more monochromatic the subject. (110mm lens, 6 x 6cm camera, ASA 64 film)

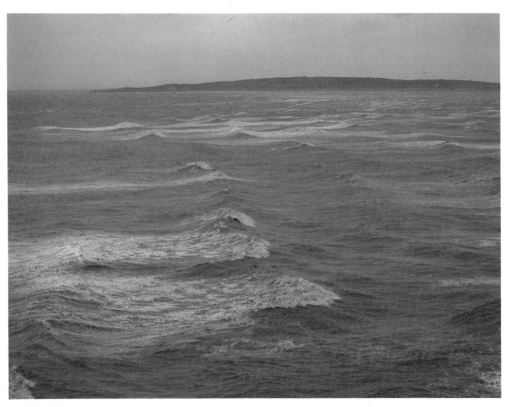

25 Monochromatic subjects usually work best in colour. Although a seeming contradiction, this should actually be obvious: when looking at a black-and-white enlargement you cannot see that the subject itself is monochrome. This is especially the case with grey-white-black subjects like the one shown here. In colour, you can feel the special emotional qualities of the scene: in black-and-white, it would appear more or less 'normal'. (17mm lens, 35mm camera, ASA 50 film)

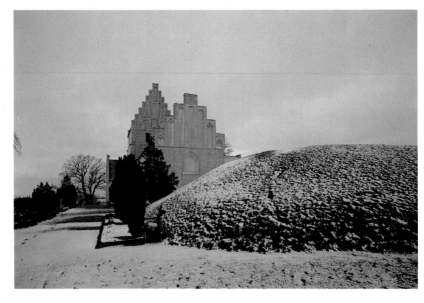

26 The large proportion of monochromatic colour pictures in the book derives from a personal preference of mine. Perhaps your own pictures reflect such an inclination. I believe that it is a sound idea to consciously explore your own preferences as being the most natural stepping-off point to develop a personal style in colour photography (110mm lens, 6 x 6cm camera, 6 x 4.5cm magazine, ASA 64 film)

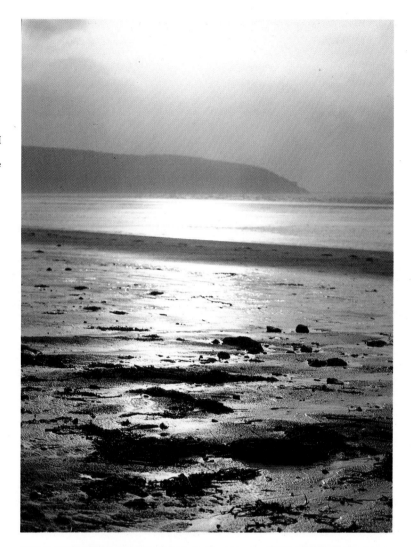

27 Sometimes 'wrong' colours strengthen the feeling of a picture without letting it appear unnatural. The trees in this photograph give the impression of a very wet, dense wood. In fact, the weather was quite normal. But the photograph was taken in daylight on a film balanced for artificial light and no 'real' lens was used – it belongs to a series taken with a spectacle lens fastened with double-sided adhesive tape to the front standard of a bellows unit. (Spectacle lens approx 120mm focal length, 35mm camera, ASA 120 tungsten-balanced film)

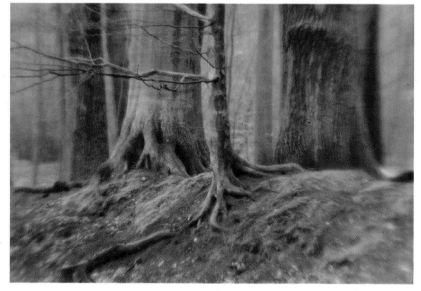

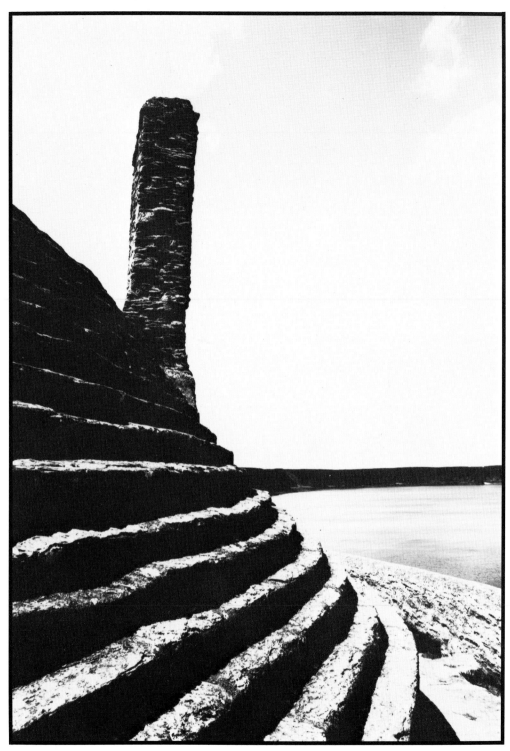

28 Here again an orthochromatic film was used to further increase the already strong contrasts in the subject. The few remaining grey values between black and white result from developing the film in normal chemistry instead of the special 'line' developer normally used to render everything in pure black and white. Admittedly, these experiments usually go wrong because it is nearly impossible to pre-visualise the results. In this case, it was the only exposure on a whole roll of film which turned out as I had hoped. (21mm lens, 35mm camera, orthochromatic film)

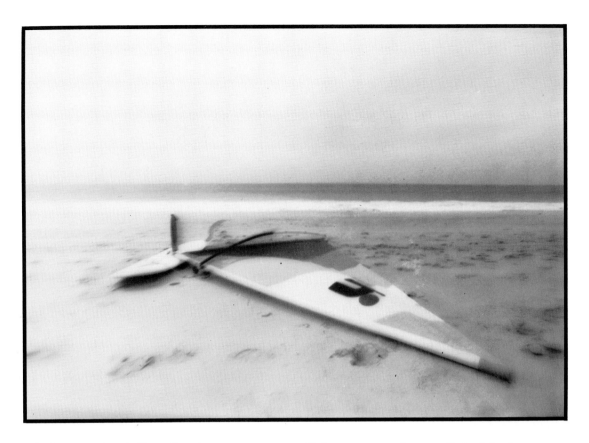

called conventional films. But there are some other kinds that might yield interesting results in landscape work.

Special films sensitive to infra-red (IR) radiation, for example, can be bought in both black-and-white and colour versions. They can be used with or without filters. The colour films represent the scene in false, but sometimes striking colours (red vegetation, for example), while the black-and-white films depict all living things with a curious 'glow'. The problems with the use of these films are not so much technical, but compositional. In order not to remain a mere effect that arouses, at best, passing interest the effects achieved with infra-red film would have to mean something in the context of your work. Judging by the results I have seen so far, this seems to be exceedingly difficult to achieve.

In an entire class by itself are the orthochromatic films which are normally used for reproduction purposes. Handled properly, they can be very versatile for landscape work.

Used in accordance with the manufacturer's instructions, these films will reduce almost all the grey values in strongly lit, high contrast subjects to pure black and white. This can result either in black and white planes or, with finely textured

29 Appearances can be deceptive: this picture actually shows a very high contrast scene taken on ASA 100 film, exposed and developed for contrast. It looks 'soft' because instead of a photographic lens I fitted a spectacle lens to the front of a close-up bellows unit (with double-sided adhesive tape; the bellows provided the necessary adjustment to allow it to be focused. (Spectacle lens on 35mm camera, ASA 100 film)

subjects, in a very detailed picture looking as if it has been passed through a graphic process.

On the other hand, there are special developers for orthochromatic films, which bring out a complete grey scale and result in negatives with extremely fine grain suitable for enlargement.

However you use these films you should take two things into account. They react strongly to very slight changes in exposure, so that if you are not entirely familiar with them you should bracket your exposures. Secondly, orthochromatic films are 'blind' to the colour red. This means that all red subjects or any subject containing red hues at a significant level do not register on the film. Autumn leaves, for example, could show in the print as either entirely white or light grey in front of a mid-grey or dark grey sky. This effect applies too if you use 'normal' development.

5 TECHNIQUE AND LANDSCAPE– LENSES, FILTERS, EXPOSURE

The various effects that you can create by using lenses of different focal length so influences the impact of your picture that they should be investigated most carefully.

Field depth and composition

Depth of field (the range of acceptable sharpness in front of and beyond the point focused on) depends upon three factors: the distance at which the lens is focused, the focal length of the lens, and the aperture setting. The closer the focused distance, the longer the focal length and the wider the aperture setting (smaller f-numbers) the smaller the depth of field. The differences can be enormous. At $f/16$, for example, the field depth of a 17mm lens ranges from approximately 25cm to infinity (at the shortest focusing distance for a particular lens model), while with a 300mm lens it is down to less than 20cm overall (at $f/16$ and the shortest focusing distance with that lens).

Equivalent differences in depth of field can be effected by changing the aperture: with a 100mm lens set at $f/32$ and a focusing distance of 10m, you have a depth of field of 4.9m to infinity and at $f/2.8$, 9.3m to 10.9m.

These figures show that you have an almost limitless control of field depth by either changing the focal length of your lens or the aperture used. This is most important because the field depth is a decisive factor in controlling the content and meaning of your pictures. If you look at the examples chosen to illustrate this chapter, you can easily see to what extent this applies. Extensive field depth (or what might be called an overall sharpness) tends to look more 'natural', especially if it has been achieved with very small stops and 'normal' or standard lenses, while very limited depth of field results in a more 'artificial' or graphic appearance.

Restricted depth of field allows you to stress some parts of the scene by placing them in focus while suppressing others. Disturbing elements in the background may simply be made to disappear in uniform grey values or a merging of colours, while continuous changes from sharpness to unsharpness are especially interesting in colour work. Generally speaking, photographs with very large out-of-focus areas work better in colour; in black-and-white extended areas of uniform grey are not often interesting enough.

Together with the other means of rendering space, discussed next, the control of field depth is the most versatile tool of composition, so:

Never choose an aperture purely to achieve an exposure time that makes it possible to hand-hold the camera. If necessary use a tripod, bean bag or similar support. Failing this, use a high speed film.

Decide on the stop first, according to your compositional ideas and adjust the exposure time accordingly—whatever it may happen to be.

When using zoom lenses (or a wide variety of normal lenses) never frame your picture by changing the focal length, unless, of course, you want to change the spatial impression (as explained below). A change in focal length also means a change in field depth. The normal way to make such framing adjustments is by altering the taking distance.

This last point should be self-evident, but my experience shows me that it is unfortunately not so. Most cameras have a preview lever or some other arrangement which allows you to stop down the lens so that you can see the distribution of sharpness in the viewfinder. It is very important to

30 The perspective rendering of a subject does not change with the focal length of the lens but normally, certain lenses are used in specific ways which creates different perspective *impressions*. Wide-angle lenses induce you to step closer to your subject, which sometimes results in dramatic changes in the magnification of the objects depicted. Here, for example, the old bone on the heap of black gravel looks much larger than the tree in the background owing to the use of a 17mm lens and a very close viewpoint. Subjects with unusual grey values (like the predominant black and dark grey here) should not be photographed with an automatic exposure system, which would result in faulty exposures. (17mm lens, 35mm camera, ASA 100 film)

31 The combination of a very static overall composition and (the position of) the cat exiting right is responsible for the strange feeling in this picture. Note that the tree is very slightly cut off by the right-hand margin in order to create a balance for the action in the foreground. (21mm lens, 35mm camera, ASA 50 film)

32 In contrast to the exaggerated spatial impression of the previous picture, this one does not show space at all. The subject is reduced to two planes and the distant one has the appearance of a backdrop. The only indication of space is the haze, which lightened the grey values of the background at the distance of a few kilometres. The picture was taken with a 1500mm lens on two tripods, using a 35mm camera and ASA 400 film.

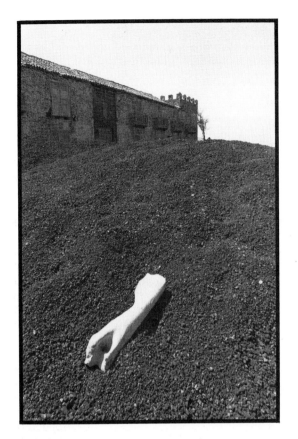
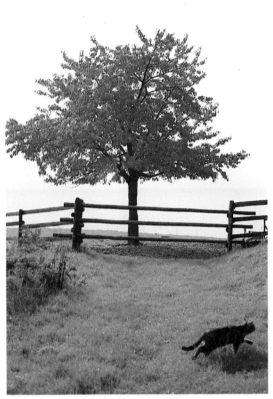

use this facility for each photograph otherwise you cannot possibly control the effects of what you do. If your camera does not offer this feature it is, strictly speaking, unsuitable for landscape work, although this can be partly compensated for by consulting depth of field tables—a cumbersome substitute in general photography. (Taking pictures is primarily a visual process and therefore visual control is indispensable for serious work.)

Focal length and geometric perspective

It has already been said that a change in the focal length of the lens used changes the spatial im-

pression of a photograph. This does not mean that different lenses have different perspectives.

All lenses with the exception of the fish eye and anamorphotic types have exactly the same geometric perspective, irrespective of focal length. Thus, the central area of a photograph taken with a 17mm lens, if enlarged to the same dimensions, would be indistinguishable from one taken with a 500mm lens. (This applies only to the perspective: there will, of course, be differences in the coarseness of the grain and other practical aspects.) That this is really true is proved by the first series of pictures (below).

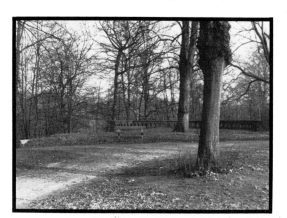

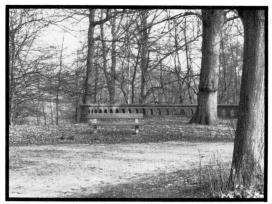

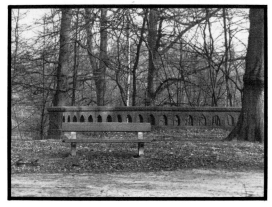

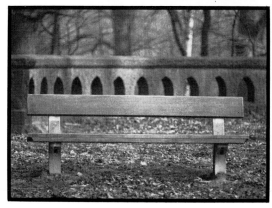

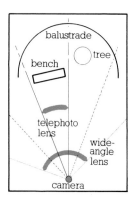

This set of pictures may be rather uninteresting, but you should study it carefully, because it was designed to show the various effects of interchangeable lenses. The first four photographs were taken with different focal lengths, but from the same viewpoint. The situation is shown in the diagram.
33 In this series the camera is at eye-level. The 17mm lens (35mm camera) predictably gives the overall view. Please note that the

camera was held level, so that there would be no distortion.
34 The same, but with 35mm lens.
35 The same, with 75mm lens.
36 The same, with 250mm (mirror) lens. If you compare this set of pictures carefully you will notice, for example, that the one shot with the 250mm lens shows only a small part of what is visible in the first photograph, taken with the 17mm lens. Apart

from the framing of the subject, the only difference is in the depth of field. This demonstrates that the use of lenses of various focal lengths does not change the perspective rendering, provided, of course, that you do not change the viewpoint.
37–40 What happens if you do change the viewpoint is illustrated in the next set of photographs, again showing the same subject. As the

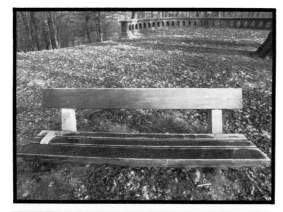

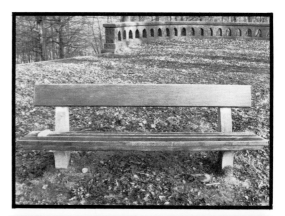

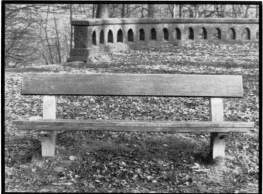

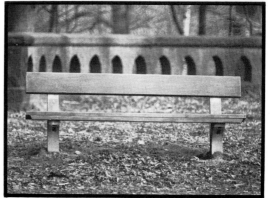

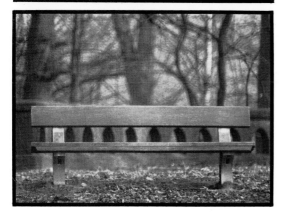

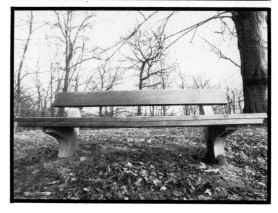

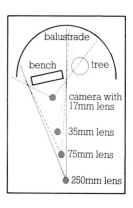

diagram shows, I adjusted the viewpoint so as to keep the bench at approximately the same size on the film in all the pictures. The shorter the focal length, the shorter the focusing distance. Again taken with 17mm, 35mm, 75mm and 250mm lenses respectively, these photographs show that different focal lengths do have an effect on the perspective impression of a photograph (not on the geometric rendering, as has

been shown with the previous pictures) if you not only change the lens but the viewpoint. It should be noted however, that the camera was also tilted downwards by varying degrees in order to include the bench in the frame. The height of the viewpoint could have been changed instead but this would have led to very different perspective impressions again, as is shown in the next two illustrations.

41–42 Here again we have the same subject (and for the last time!). Both photographs were taken from a knee-level viewpoint, while the focusing distance is the same as in the corresponding pictures in the previous set (compare **40** with **38** and **41** with **39**). You can easily see that the spatial impression does not change much with the long focal length (250mm), while the change is drastic with the wide-angle lens (17mm)

Nevertheless, photographs taken with different lenses *do* look different, the reason being that each type of lens tends to be used in a certain way, resulting in the typical 'extreme wide-angle' or 'telephoto' characteristics that we see in photographs. How this comes about and what it looks like is shown in the second set of pictures (p41).

In many kinds of photography (sports, wildlife, reportage, interior architecture and many others) you are forced to use certain focal lengths due to circumstances which are not under your control. This does not, and should not, apply to creative landscape work. Here your choice of focal length should depend exclusively on pictorial considerations. If a subject is at some distance you should not use a long focal length simply because you are too lazy to walk to a closer viewpoint. As can be seen from these pictures, you achieve an entirely different result if you walk to a closer position or, on the other hand, use a longer focal length lens. The decisive factor here is (or at least should be) how you want your photograph to look.

Space: its representation in a photograph

It all boils down to this. The focal length of the lens and shooting distance combine to determine how space is represented in your photograph. This is

43 An extreme wide-angle lens shooting from a very low position usually exaggerates the apparent size of subjects. This, of course, works especially well with objects or features whose size is not known to the viewer. The sandstone formation bordering a 'barranco' (dried river bed) in Fuerteventura, Canary Islands, looks quite monumental although in reality it was not more than 50cm in height. (17mm lens, 35mm camera, ASA 100 film)

44 The reverse applies to this immense river valley where the camera, looking down from a high viewpoint, exchanges an impression of height for one of distance. The trees, as recognisable details, provide the main evidence of scale. (50mm lens, 35mm camera, ASA 64 film)

important for the very simple reason that in our (normal) perception, space is immutable. However, and wherever you look, whether in the normal way or in some unusual fashion (like standing on your head) the perception of space always remains exactly the same. But in a photograph it does not. The spatial impression varies not only with depth of field, focal length and taking distance, but also with the height of the viewpoint and deviations from a horizontal camera angle (see Chapter 11).

The fact that such deviations contrary to our

perception can occur at all and the way in which they do so is of special interest to the viewer. He or she will react more strongly to them than to other factors in a photograph which seem to be more or less 'normal' compared with human perception. (This distribution of attention is due to basic patterns of thought and/or perception, of which the viewer may not even be conscious. Even so, if the photographer knows about them, he can use them to his advantage.)

Beyond this the question remains, when should you or can you use which kind of representation? This is a problem that cannot be answered in a generalised way. In principle you can photograph each subject with lenses of all focal lengths. Which one you use depends on your feelings about the subject. Does the subject seem to need 'breathing space'? Is the separateness of the various objects within your angle of view important and do you therefore want to stress the distances between the objects? Or do you want to stress the size of one object while relegating others to a distant and insignificant background? Do you want to give a feeling of texture and structure in the foreground and, at the same time, have a vast landscape for the surroundings?

In all of these cases an extreme, or moderate, wide-angle lens would be suitable.

On the other hand, the use of a standard focal length lens would render space as more or less 'normal'—in other words, at its least obtrusive—so that other properties of your picture could occupy a greater part of the viewer's attention.

With long focal lengths a subject which is close by can look intimate, closed-off and self-reliant. Faraway subjects would appear even more distant due to the effect of the intervening density of the atmosphere (Chapter 9). Scenery will appear more 'flat', almost like a backdrop. (If a foreground subject has a normal contrast range and the background is very hazy, the effect can sometimes seem quite artificial—almost as if the subject is not in a genuine location!) The longer the focal length of the lens used, the closer in size is the relationship of different objects seen in the picture—and so on.

These are some of the major differences between photographs taken with different focal lengths of lens. But one cannot really convey the subtleties that give real visual impact to a photograph in such generalised terms. In order to develop a feeling for this kind of thing you will have to look at pictures in this book as well as in other publications. Above all, you must look at your own pictures. If you succeed in analysing your emotional and probably subconscious response to the photographs along the lines and according to the categories which I have tried to indicate here, you should be able to make the best possible use of interchangeable lenses.

I think it is a very good idea to shoot some subjects with a variety of lenses from different

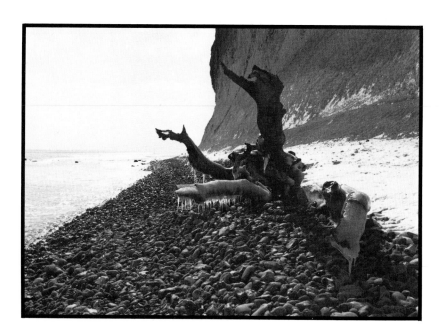

45 If you are unsure about the lens to be used for a given subject, it is always worthwhile trying different ones with different viewpoints. Apart from the didactic benefit of this you can be sure to have secured the best possible version. The accomplished photographer can usually do this without experimenting. But not all subjects are so obvious in their appeal that the decision is so easy. Here, for example, a longer focal length would have worked as well, but the 55mm lens (which is a wide-angle on a 6 x 7cm camera) was finally chosen, because it allowed me to balance the planes, the water, beach and cliff, nicely. (55mm lens, 6 x 7cm camera, ASA 100 film)

46 When looking at a finished photograph it is not always easy to judge what focal length of lens was used to achieve the effect. Here, for example there seems to be conflicting evidence: the closeness of the different planes seems to suggest a long focal length, while the slightly converging lines imply that a moderately wide-angle lens was used. In fact, this picture was taken with a standard lens. The peculiar spatial impact has been achieved solely by a careful choice of viewpoint and by framing the subject in this particular way. (50mm lens, 35mm camera, ASA 125 film)

viewpoints (much as I shot the illustrations in the first part of this chapter) and to investigate the differences in impact of the resulting pictures. The following paragraph will give you some more ideas about how to organise this.

Inter-relationships

The problem is that various factors come together to form the spatial impression of a photograph, weakening and/or strengthening each other according to the use you make of them. Some

systematisation would probably be helpful.

We can take two simple statements of fact, for example: 1 The spatial impression is stronger. 2 The spatial impression is weaker. By 'spatial impression' we only mean that the space (or, to be more precise, its rendering in the photograph) which is shown between the objects and, so, their relationships to each other, is stressed, or suppressed, as the case may be.

This over-simplification now allows us to assign concrete effects to the factors that we use to influ-

ence the impact of our pictures.

1 The spatial impression becomes stronger with shorter focal lengths; it weakens with longer ones.

2 It becomes stronger with elevated viewpoints, while it is weaker with eye-level or lower-than-eye-level viewpoints. (An exception can be a combination of extreme wide-angle lens, very low viewpoint and an upward tilt: the resulting converging lines can sometimes strengthen the effect.)

3 A tilted camera strengthens the spatial effect (either up or down) while it is weakest (or neutral) with a horizontally levelled camera.

4 A combination of short camera distance and wide-angle lens strengthens spatial impression by introducing great differences in the magnification of nearby and far off objects, while a combination of great camera distance and wide-angle lens strengthens the spatial impression by emphasising the foregrounds. Long focal lengths reduce the foreground and differences in magnification and therefore always reduce spatial impression.

5 Spatial impression grows larger or smaller with the amount of field depth. The greater the depth of field, the stronger the spatial impression.

6 Variations: generally speaking the spatial im-

47–48 These two shots demonstrate the interplay between the chosen focal length of lens and the properties of your subject; both were taken with the same lens (250mm) but they vary greatly in the spatial impression created because the lens was used to stress widely differing things. In **48** the wood appears to be much closer than it actually is; the trees seem very close together due to the effect of the very long focal length lens. Nevertheless, you do not exactly get the feeling of a 'backdrop' because the trees continue into the distance. This effect was achieved by setting the lens at minimum aperture, so obtaining the maximum depth of field possible with this lens. In **47,** the lens was used fully open to throw the middle ground and background areas out of focus – giving the impression of a backdrop. (Both pictures: 250mm lens, 6 x 7 camera, ASA 100 film)

pression will be smaller the more 'natural' a picture looks (colour rendition, composition and so on), because a 'normal' rendering of space does not register with the viewer at all.

If you look at this list, you might be tempted to think you need as many different lenses as possible for your landscape work. But this is not so. I even believe that it is best to start with only one lens because you are then forced to make the best possible use of the other factors described here, thus fully realising their creative potential. After

that, you can safely turn to other focal lengths to widen your 'palette'. (When writing a book on interchangeable lenses, I had the opportunity of working with 35 different lenses. Afterwards, I was glad to get rid of them again. I still, for the most part, use only three different lenses for my landscape work in 35mm photography, and only two lenses with my view camera.)

Sooner or later most photographers develop a marked preference for one type of lens or other. Some people go to the length of using nothing but

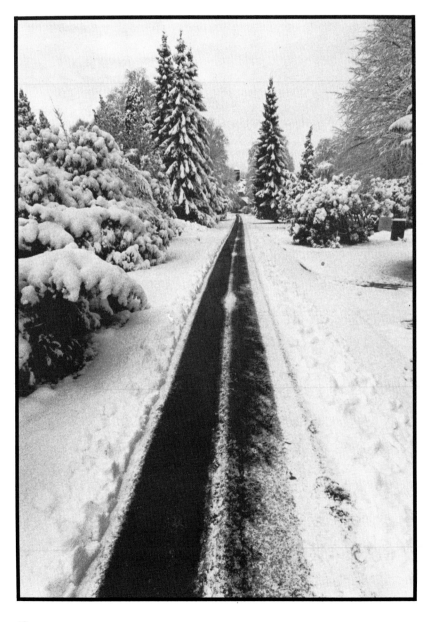

49 In normal use, wide-angle lenses provide greater depth of field than lenses of standard or long focal length. In order to take photographs like this you either have to use an extreme wide-angle lens in order to have sufficient depth of field, or you would need recourse to the movements of a view camera. Here, the additional 'stretching' of space of an extreme wide-angle lens made this composition possible. (21mm lens, 35mm camera, ASA 400 film)

extreme telephoto lenses of at least 600mm in focal length. Others stick to the shortest and most extreme wide-angle lenses that they can find. Whatever you do, you should not imitate someone else's use of lenses just for the sake of it.

If you use only two or three lenses you should be able to visualise your pictures in terms of those, whereas too many lenses crowd your vision and make it more difficult to form a mental photo-image of what you see.

The type of lens you use should reflect your personal attitude towards landscape. You have seen to what extent the choice of lens can influence the potency of your pictures, so you should not pass over the opportunities offered by this means of expression.

Filters: technically correct rendering of landscape

The practical application of filters will be discussed in later chapters. In the following paragraphs, I will confine myself to a few general remarks that you might find useful.

It is often said that a filter designed for black-and-white work lightens its own colour and darkens all others. In fact, all filters darken colours, owing to their density. But they do, indeed, transmit light of their own colour with only slight losses, while they reduce (or rather, absorb) light of all other colours to a much greater degree. A blue filter would, for example, allow sky light to pass almost unchanged, while it would darken almost all other parts of the landscape.

In practice, you can use one and the same filter to create widely differing effects. For instance, when using the above-mentioned blue filter, a normal exposure (that is, an exposure that does not take the filter factor into account) would result in a picture with an almost normal grey value for the blue sky, while everything else would be much darker than in a normal rendering. (By *normal,* I mean a technically correct representation of relative brightnesses in grey values.) An exposure which takes the filter factor into account would result in a picture with an almost normal appearance, except for the sky, which would either be very light in tone or entirely white.

If, therefore, your aim is a technically correct rendering free from these changes, filters of this kind cannot be used in black-and-white photography. There are, however, two exceptions. A very pale yellow filter can be used to darken the sky slightly, which results in better rendering of

clouds. A very pale green filter would improve the rendering of foliage without noticeably altering the other grey values. (Chapter 9.) In all other cases the modern black-and-white film can render landscape in a way that may be safely termed 'technically correct'—provided it has been exposed properly.

Although a wide variety of colour-compensating filters exists for colour work, the situation is not very different as far as landscape photography is concerned. These colour-compensating filters may not be used with available light (see Chapter 9). So that leaves us with nothing but the skylight filter (1A), which is often used to reduce excessive blue wavelengths. (Chapter 7.)

You are often advised to leave this filter (or a haze filter) on the lens at all times to protect it against damage. I do not favour this idea, because if they are not absolutely clean, undamaged and optically perfect, the additional glass surfaces can easily lead to flare and other unwanted reflections. I feel that this kind of lens-protection should only be considered when you think it indispensable, ie. when working at the seaside or in desert environments.

Creative use of filters
We have seen that filters do not play an important role in landscape work for obtaining a technically correct tonal rendering of the subject. Their strength is in their creative applications.

In black-and-white work coloured filters can be used to alter the grey values of your pictures according to your taste—only slightly with light filters, radically with the denser type, especially those designed for reproduction purposes. More variety can be introduced by variations in exposure, whether or not they comply with a recommended filter factor.

If, in colour work you use a skylight filter (1A, 1B) or other extremely light-coloured filter (such as 81A, 81C), you can modify the balance (or basic hue) of a picture only marginally. At the opposite extreme you can achieve a completely monochrome (total one-colour saturation) rendering with much stronger filters (such as 80A and 25A).

The polarising screen, which can be used for both black-and-white and colour work serves to 'deepen' colours by removing surface sheen and reflections. It is also employed to reduce or suppress mirror images and reflections on all non-metallic surfaces. If used in a suitable situation, it can deepen the blue of the sky (or shift the grey

value accordingly in black-and-white work).

Unfortunately the latter application needs some care because the effect is not always distributed evenly over the whole picture area. It is strongest when photographing at right angles to the sun and diminishes the further away from this angle the camera is directed, until with the sun directly behind you it is virtually non-existent. When you work with long focal lengths of lens the unevenness of this effect is unimportant because it is hardly visible within a small angle of view. But with wide-angle lenses you may, for instance, have an almost colourless left edge to the picture, combined with a dark blue right one. Fortunately, this can be controlled in the viewfinder of a reflex camera or by holding the screen up to the sky and looking directly through it.

Apart from these more or less 'classical' filters, nowadays an almost unlimited choice of effect filters and trick lenses is available. However, I do not personally advise their use in landscape work. They usually introduce an effect into a landscape picture which (when new) may be mildly surprising, but which does not really add to the impact of your work. They are often used to disguise the fact that a photograph is entirely devoid of meaning and sometimes even badly composed. This does not mean that they are impossible to use well. I simply advise you to avoid effect filters and lenses unless you are entirely sure of your intentions so that you can put them to uses beyond the mere effect itself.

Even if you do want to experiment with this kind of equipment you do not necessarily have to buy it. Very interesting things can be done with home-made items. 'Soft focus' effects, for example, can be created with a piece of glass partly covered with petroleum jelly (or butter) or with an old nylon stocking placed in front of the lens. Differently shaped pieces of glass can be used, or old spectacle lenses or reading glasses. The only limit is your own inventiveness.

Effects of exposure on landscape photography

The effect of exposure in combination with different films was discussed earlier and in the paragraphs above you have seen that the effect of a filter can vary with different exposures. Exposure has a very definite effect on the appearance of your pictures in other respects as well. Some of these effects will be discussed here, but for a detailed analysis of exposure you will have to consult a book entirely dedicated to this subject.

First of all there is no such thing as a 'correct' exposure for any given picture. There is one— and only one—exposure which results in what is usually thought of as a technically correct rendering. But an exposure differing from this simply leads to another kind of result and a difference in the impact of your photograph. If it coincides with your ideas, you should use it, be it 'technically correct' or not.

A common example of this process is the underexposure of slide film. I have noticed that many photographers tend to underexpose slide film because this produces stronger, more

50 Although very uncomplicated in structure, this picture consists mostly of opposites: the angular windows and doors are seen in opposition to the strongly marked triangle of the roof; the geometrical form of the house contrasts with the detailed and irregular silhouette of the tree; likewise, the white of the snow and the house with the black of the tree. Everything is kept together by the assembly of the various parts and the overall simplicity of the subject. (21mm lens, 35mm camera, ASA 50 film)

51 Nowadays you can buy multi-coloured filters in many combinations. But you can just as easily make your own by the simple expedient of placing different filters together and holding them in front of the camera lens. In this way, you yourself can decide which colours you want to use, and in what position. This picture required two filters, an orange and a yellow, slightly overlapped. The blue section at the top is the natural colour of the sky. (75mm lens, 6 x 6cm camera, ASA 200 film)

52 The sun's reflections on the sea seen through a cross-screen which has the property of extending specular highlights, or 'point' light sources such as street lamps into little crosses of light. Although this process obviously enhances the luminous quality of a scene, trick filters or screens of this type should be used sparingly. It is an effect that wears thin with overuse and more often than not destroys the composition of a picture rather than contributes to it. Generally speaking, it works best with fairly simple compositions such as the one shown here because it can then form an integral part instead of appearing to be added on as an afterthought. (200mm lens, 35mm camera, ASA 200 film)

saturated colours. Another possibility is the intentional over- or underexposure of black-and-white film, which leads to a wide variety of effects, shown here. The basic principle is very simple.

Whereas on the one hand each type of film has a certain exposure latitude, each subject has a range of contrast which can vary greatly.

A landscape without foreground in diffused light may, for example, have a contrast ratio of 10:1, which is approximately equivalent to three stops. A very brightly lit scene with sunshine reflected from white surfaces and shadows containing dark objects might have a contrast range of 160:1 (7 stops) or more.

You can measure the contrast either with a hand-held meter or with the built-in meter of your camera (this is explained below).

If you know the contrast range of your subject and the exposure latitude of your film (in other words its 'contrast recording ability') you can safely juggle around with exposure as shown here.

The following list gives you a very rough guide of what to expect by way of exposure latitude. But it should be noted that exact figures must be determined by tests that take into account your equipment and your own way of treating your materials. This is a 'must' if you want to use the so-called zone system of exposure determination. However, I am of the opinion that the rough estimates given here are adequate for most purposes.

Film	Contrast recording ability (stops)
Colour slide	5
Slow black-and-white (ASA 25)	5–6
Medium black-and-white (ASA 50–200)	7
High speed black-and-white (ASA 400 +)	10
Special film (orthochromatic graphic films)	1–3 (depending on exposure and development)

53–55 This set of pictures illustrates the effect of fully automatic exposure operation. The first photograph, **53**, shows the subject in approximately the correct grey tone because here the distribution of light and dark areas was more or less normal. The next photograph, **54**, is noticeably darker because the grey values were changed by the simple expedient of stepping a bit closer, thus excluding the middle grey pavement from the angle of view. In order to show that the automatic exposure system of the camera gave very different values for these situations, both enlargements were made with the same aperture and exposure time. The exposure for the third photograph (which was enlarged exactly as the two previous ones), was determined manually by measuring the values for the shadows on the left of the lion and the highlight on the lion's nose. The difference was approximately 7 stops. This being well within the contrast recording capacity of the film and with no special effects intended, the middle value was chosen. It should be noted that the common practice of quoting exposure times is of little value unless details of lowest and highest values, time chosen and treatment of film are given. But even this would only tell another photographer what happened in that particular case. So, in this context, I do not quote exposure times, although it is advisable to note what you have done so that you can check later if something went wrong, or particularly well. (17mm lens, 35mm camera, ASA 400 film)

A more average subject might have a contrast range of about five stops. But, in practice, your subjects may have contrast differing widely from this. A combination of fog and very low, diffuse light may, for example, lead to contrast of no more than 2½ stops.

It is quite obvious that you could use a lot of different exposures which would put the contrast range within the exposure latitude of, for example, a high speed film and thus result in a usable negative. In the case of this subject exposures like 1/125 sec f/2 or 1/125 sec f/8 or even 1/125 sec f/22 would all have placed the whole range of contrast within the contrast recording capacity of the film.

But due to the chemical and physical properties of the film these negatives would have very different qualities and would thus lead to prints with quite different characteristics. Roughly speaking, the different exposures would result in the following properties. (Line a...a represents the exposure latitude of the film, line b...b the contrast of the subject.)

Normal exposure

a .. a

b b

If the negative is exposed in this way, the grey scale of the negative is as wide as possible, which means that the details and structures of the subject are reproduced faithfully. The grain is as fine as possible with the kind of film used and the negative shows the greatest range of contrast.

Overexposure

a .. a

b b

Overexposure results in a shortening of the grey scale, which leads to a reduction of detail and structure. At the same time the grain in the print appears to be much more pronounced. If used with the appropriate printing paper, a negative of this type can lead to a 'high-key' print.

Underexposure

a .. a

b b

Underexposure has the same effect on the reproduction of detail and structure. The contrast range is also greatly reduced. An enlargement stresses

the dark areas of the subject ('low-key' effect). The grain appears to be normal in the print.

If you do your own film processing and printing you will know that this is very oversimplified because the results depend to a great extent on the handling of your materials. But, basically, this is what happens.

Meters and metering

In order to be able to control these effects, you obviously have to determine the exposure for your landscape photographs most carefully. In contrast to other fields of photographic activity, landscape work is generally a rather slow process and does not require the benefits of automatic exposure systems. On the contrary, in order to be able to really control the pictorial effect of your photographs, you should always measure exposure separately, taking into account the properties of the film used, as explained above.

You can do this with any kind of meter, but some are easier to handle than others. The built-in TTL metering systems of most 35mm cameras are of the integrating type. They measure from most of the area visible in the viewfinder (varying with the lens fitted; for example, with long focal lengths the effect resembles spot metering) but with a bias towards a selected central area. Combining these values, they give a reading *averaged out to a midtone* or 'integrated to grey'. To obtain precise readings from particular parts of the scene, therefore, you need either to move in very close to a representative area and measure from there, or use a lens of long focal length to obtain exposure readings.

Obviously a hand-held meter with a very narrow angle of view (15° is good, but 5° or even 1° would be best) would simplify matters, especially if it has a viewfinder which indicates exactly the area to be measured.

As today's automatic exposure systems yield usable negatives in perhaps more than 99 cases out of 100, you might wonder why I do not recommend them in this context. The idea is not to achieve a negative that is merely usable, but one that leads to a print with previsualised, very specific properties—and that cannot be done with the hit-and-miss approach of automatic exposure systems.

The same principle applies to slide films, with the additional need to keep within the rather restricted exposure latitude of the film in order to get optimum results.

Special metering technique

There are various ways to determine the exposure and, while using an automatic exposure system could be regarded as representing one extreme, the so-called zone system would represent the other. Although it yields the most perfect results imaginable, I do not believe that it fits the needs and temperament of the majority of photographers (including myself) because the essential tests are very time consuming. Moreover, it is more suitable for single sheet films with individual processing requirements than films containing a wide variety of shots.

A much simpler method which, nevertheless, works quite well is just to measure the lightest and the darkest areas of your subject that are intended to show detail in the finished print, calculate the number of stops between these values and to place that range within the exposure latitude of the film, as described above.

This process is not as difficult as it sounds, the only real problem is to recognise those areas of the subject which you should measure in the first place.

If you have a 1° spotmeter, particularly, you might be tempted to look for very small areas in your subject which are exceptionally black and white. But that is the wrong approach. The vast majority of subjects have a brightness range that exceeds the exposure latitude of the film when you measure them in this way. It would, for example, be nonsense to measure the 'black crevices' between the tree roots on the one hand and the highlights on dewdrops on the other if you intend shooting a general view of a landscape. Suitable points to measure would probably be the shadows of the trees and the white parts of the clouds.

This rather extreme example nevertheless demonstrates what to look for. The rest—meaning the calculation—is easy. Most spot meters have an aperture scale designed for this kind of calculation. If not, you can proceed in the following way:

The apertures are:

1.4	2	2.8	4	5.6	8	11	16	22	32	64
(1)	(2)	(3)	(4)	(5)	(6)	(7)	(8)	(9)	(10)	(11)

Let us assume that you have measured f/2.8 as the proper exposure for the darkest area of your subject and f/11 (of course for the same exposure time!) for the lightest one. The middle value would be f/5.6, so that an exposure using this stop and the exposure time for which you calculated it, would place the contrast range of the subject in the middle of the contrast recording range of the film.

Looking at the scale of apertures given above, you can see that a high speed film, for example, would record a contrast ranging from half a stop below f/1.4 to half a stop above f/22. So you could, instead, elect to use an exposure between f/2 and f/2.8 for intentional underexposure or an exposure between f/11 and f/16 for overexposure (always keeping the shutter speed constant, of course!) All these exposures would place the contrast range of the subject completely within the contrast ability of the film.

Using this type of measurement and calculation you can also exceed these limits in a controlled way, which leads to very interesting results, some of which are demonstrated in this book.

If you have never used this kind of exposure determination before, you may find it a bit bothersome. But a little practice will allow you to do it almost instinctively and within a few seconds. Considering the improvements it can make to the strength of your pictures, you should try to acquire the habit of working in this way if you have not already done so.

As I said, landscape photography is usually a rather leisurely type of work. It does not depend on sensational events.

The effectiveness of a landscape photograph depends far more on the form that it takes. Consequently this opportunity of influencing the appearance of your pictures should not be overlooked.

If you wish to excite interest with the quality of your work you should take advantage of every possible means at your disposal. Try to obtain absolute control over all aspects of the technique that influence the appearance of a picture, not only with exposure but all other technical factors, right through to darkroom work and presentation.

56 Added to the silhouettes, which account for much of the impact of this picture, are the reflections of the trees which lend the scene a strange 'floating' quality. Such against-the-light pictures present a tricky exposure problem and it is advisable to bracket all your readings. (50mm lens, 35mm camera, ASA 64 film)

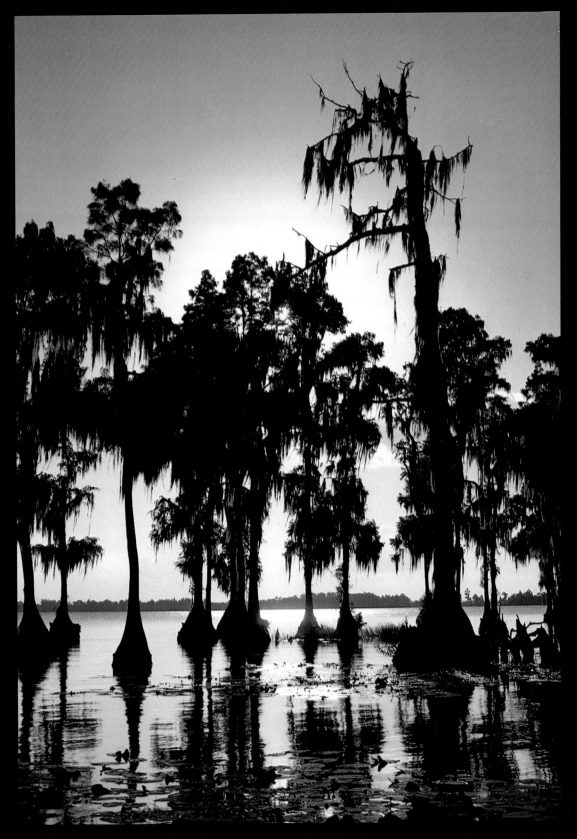

6 HOW TO FIND LANDSCAPE SUBJECTS

Some people tend to assume that if they had access to the same locations as another photographer, their own work would look equally interesting.

This attitude is not only wrong, it is even dangerous because it can lead to an attitude of resignation, especially on the part of a person who does not have the means to travel far and wide. At best, it can induce a kind of holiday-snapshot mentality, which cannot carry you far if you really want to become involved in landscape work.

(Un)importance of travel

An exotic landscape does not necessarily provide the means to good photographs. First of all, the term exotic is relative. If you live in London, New York or some other large city, camels and palm trees may seem exotic to you. But they are commonplace to the people who live where they are found (and vice-versa).

In this context the word 'exotic' simply means 'novel' or 'never seen before', which is not a photographic category and therefore has nothing whatever to do with the quality of your photographic work. In ours, a fast-living and far-travelling age, novelty is a very transient attribute. What is exotic today, is 'in' tomorrow and forgotten the day after—and forgotten with it are the photographs which have been built on this 'quality'.

The fact that you have succeeded in finding and photographing a primitive tribe somewhere could, for example, hide the fact that your photographs are quite poor, photographically speaking, because of the novelty of the subject matter. The appeal of such pictures would soon wear off and reveal them for what they actually are—bad photographs.

This, of course, is an extreme example. But it has happened more than once and serves to illustrate my point, which is simply that exotic or novel subject matter does not add to the quality of your work.

Another error, closely related to this, is to confuse the achievement of having taken a difficult photograph with its photographic quality. Because this is a very common mistake, I will explain it with two examples, again extreme:

Let us assume that you have organised a climbing expedition and have succeeded in reaching the top of Mount Everest. In doing this you have taken a photograph, which might simply show an expanse of snow, some clouds and a flag. What you did, certainly, was no mean thing, but your photograph, which documents your achievement may nevertheless be uninteresting and boring—photographically speaking.

57–59 The next three photographs show the other extreme: The subjects are exceedingly commonplace and could be found almost everywhere. If they have some merit, it lies in the ideas and feelings I had and in their photographic realisation. It is not possible to judge these photographs according to the merits of the subject, but only by whatever impression they make on the viewer. Potentially, you could take the most fascinating pictures in your own back yard – and there is at least one world-famous photographer who has done exactly that and practically nothing but that. (**57** 21mm lens, 35mm camera, ASA 400 film. **58** 250mm lens, 9 x 12cm view camera, ASA 100 film. **59** 90mm lens, 6 x 7 camera, ASA 400 film)

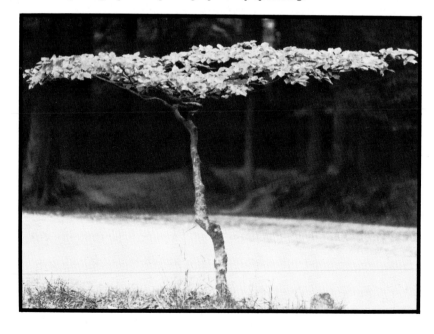

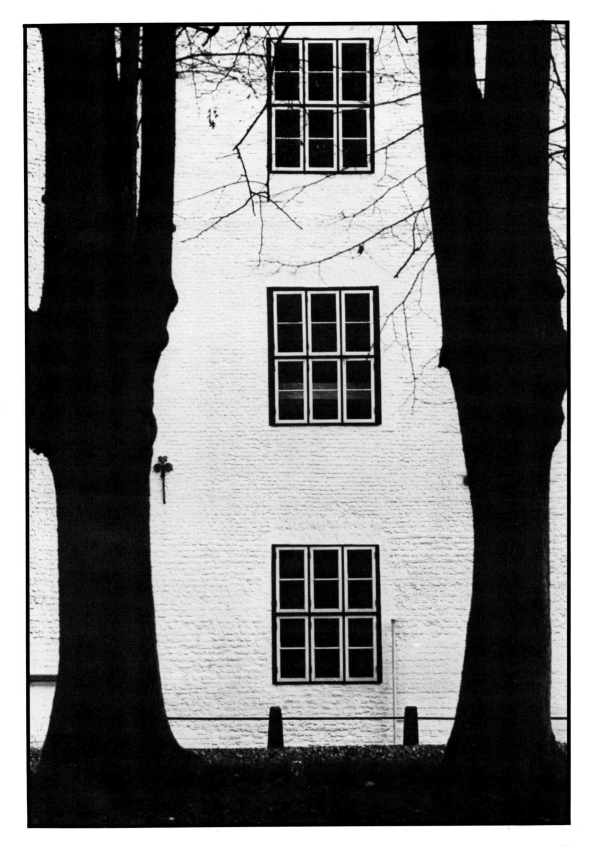

My next example combines both attitudes: imagine you had been the first man on the moon! The achievement of getting you there was surely tremendous and the 'landscape' there certainly could not be more exotic. Both these factors would ensure a wide publication of the photographs taken during the mission, but definitely not because of their photographic value nor, generally speaking, because of their pictorial merits. I do not really want to belittle this achievement; photographs taken under these conditions are not supposed to be what we might term 'good creative work' and therefore judged according to those standards. Nevertheless, doing exactly this serves to stress my point.

Merits of the local landscape

Taking pictures in your own locality is both more difficult and more rewarding than shooting some beauty spot or other. The reason for this is easy to explain: beauty spots or, generally speaking, landscapes which are worth travelling to see are usually spectacular in some way or other. It is easy to succumb to the temptation of depicting these spectacular features without really making an effort to develop imaginative interpretations of what you see.

Moreover, this type of landscape has generally been photographed very frequently and is well known from postcards and pictorial guidebooks. This can make it more difficult to find a representation which is really recognisably your own work.

This point is corroborated by the kind of guidebook that tells you that at this spot you should stand here, use such and such a lens and take the pictures in the late afternoon, pointing your camera at this or that. Could someone please explain why, instead, you are not advised to go to the local shop and buy a picture postcard which shows exactly the photograph you have been advised to take?

If it is your aim to make a landscape photograph a personal realisation of the subject—as I have suggested—then your immediate surroundings would be the best place to do it, at least until you have developed your own style and are no longer likely to fall into the traps I have just described.

On the other hand, photographing your local landscape may seem difficult because you feel that it has nothing of special interest or no graphic potential. But this is sure to be untrue.

In visiting an exotic landscape you have never seen before you are likely to notice things simply because they are new. You are more aware. Your perceptive faculties are heightened and you see things and 'feel' them more easily because you subconsciously *expect* them to be exotic. This, again, shows that 'exoticness' is not a property of certain places that other places lack, but an attitude or state of mind.

The art of photographing your local surroundings is to enter this same state of mind when surrounded by the familiar. If you can perform this trick, you will see your everyday world with virtually 'new' eyes.

Handled in this way, photography is not only an interesting or even fascinating pursuit, it is a way of living which enhances your sensitivity and heightens your awareness generally.

But how can this habit be acquired? The only solution I suggest is practice. If you do not go out and take pictures you are not going to find the merits in your local landscape, be it wildly 'scenic' or an industrial town.

In the chapters that follow you will find suggestions about handling different types of landscape. Why not try to imagine being a foreigner who is visiting your own town and its surroundings for the first time? Applying the suggestions made there and developing them further, you should be able to come up with some striking photographs of the place where you live. Once you have made a start the rest will follow.

If you doubt the validity of my advice, have a closer look at the work of famous photographers. Many shoot in the most exotic places imaginable because it is their job to do so. But in their own, personal work more often than not they stick to the places where they live, while others work exclusively in their local landscape. (I have just counted my published photographs. About 90 per cent of my published work up to now has been taken at home or in the immediate surroundings.)

This does not mean, of course, that you should not photograph exotic landscapes. My idea has been to show that all landscapes are photographically equal, including that on your own doorstep, and that the latter is a good place both to start with and to continue to use as part of your photographic development.

Exotic landscapes

Now I can turn the preceding arguments around and tell you that for the experienced landscape photographer, exotic landscapes are a very special challenge.

You may have heard it said that one cannot photograph the Niagara Falls (which to me are exotic indeed), or the Pyramids, or other famous beauty spots. This is supposed to indicate something I have already discussed; it is close to impossible to take a successful picture of these places on two counts.

First, they have been photographed so often that it is difficult to perceive them in an un-preconditioned way.

Secondly, these places are usually so impressive that the photographer tends to forget his or her basic attitude to landscape photography— that the subject matter is nothing but the raw material for the work, which must be shaped by photographic means into a picture that says something definite.

You may have seen the kind of mildly funny cartoon that shows a horde of tourists festooned with cameras, all pointing their lenses in the same direction, except for one person who has turned the opposite way and is photographing something else. Although this is supposed to be a joke, this one person may have developed the right attitude towards landscape photography, at least as far as it applies to exotic places or beauty spots. He or she is photographing a personal view, whatever it may be, and not something that others have seen or been told to see.

This situation neatly encapsulates both the challenge of photographing exotic places and the solution to the problems.

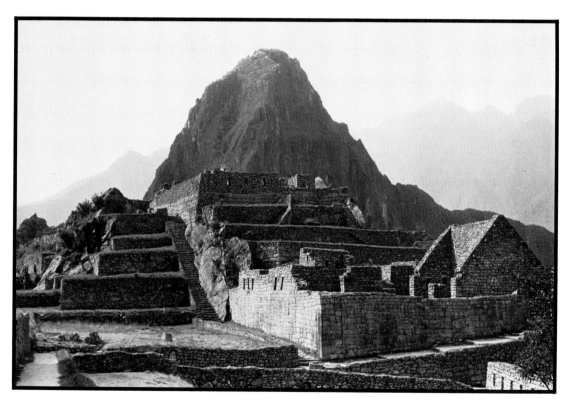

60 This picture was taken in a country that, for the photographer, really is exotic (Macchu Picchu, Peru). But again, the concept is photographically meaningless. What counts is whether the picture is sound and its composition shows what the photographer had in mind, not whether he took the photograph there or somewhere else. In my opinion this is just as irrelevant as information about the buildings in the photograph. I even believe that information like this detracts from the visual impact of a photograph, unless it serves only a documentary function (50mm lens, 35mm camera, ASA 125 film)

7 MAN AND LANDSCAPE

When the term 'landscape' is mentioned, many people automatically think of wild, untouched nature. However, to most photographers, industrial sites, towns, and related subjects are landscapes too. In fact, if you look at what has been defined as 'landscape photography' you might almost come to the conclusion that everything larger than a close-up subject and under the open sky constitutes a landscape—at least in the opinion of some.

Be that as it may, our man-made environment certainly *is* a type of landscape and should not be neglected. It offers a wide choice of interesting subjects, ranging from gardens and parks to industrial developments.

Photography in towns

Apart from industrial sites and parks, to be discussed separately, photography in towns usually means streets and architecture of every description. A documentary approach to architecture (that is, an approach in which the building or construction is to be rendered literally to provide the best possible record of factual information), usually requires the use of a view camera. This can avoid the rendering of verticals as converging or diverging lines that results from the need to tilt an ordinary camera to fit the subject into the pic-

ture. In creative work, however, this effect can be put to good advantage to create a specific feeling of space.

This aspect merits a closer look. Vertical lines are reproduced vertically in a photograph as long as the back of the camera (or to be more precise, the film) is also positioned vertically—that is to say, parallel to the subject itself. When you want to photograph buildings you often have to do so from a greater distance than you would like (if there is sufficient space to get far enough away). This naturally brings a large amount of foreground area into your picture. Or, you have to tilt your camera upwards in order to include the whole of the building in the frame, which would lead to converging vertical lines.

The movements of a view camera allow you to keep the back vertical under almost all taking conditions and with practically all lenses. Although this is not normally possible with 35mm cameras, some manufacturers offer special 'shift' lenses for architectural photography, which can be used to similar effect. I think that either a view camera or one of these lenses is a must for documentary architectural photography. On the other hand, the restriction imposed on you by the use of 'normal' 35mm camera lenses may be a boon for creative work because you feel no obli-

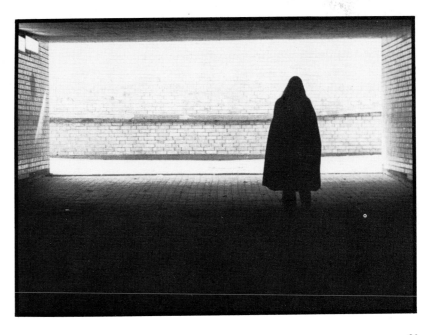

61 I wanted to show just one person in this passage, walking away from me, and thus stressing the cold and desolate feeling of this spot. It was quite surprising how long I had to wait – this always seems to be the case when you want something special to happen. But I think it is always worthwhile if it enhances the photograph, as it does here. Two or more people would have made for a rather ordinary picture, whilst none at all would have left me with an uninteresting subject. (100mm lens, 35mm camera, ASA 400 film)

62 In pictures of towns and villages visualised specifically as landscapes (and not where people and their way of life form the main subject of the photograph) it is quite possible for people to appear superfluous or even out of place, photographically speaking. It needs luck and/or patience to chance upon a scene like this, where everything fits together perfectly. The figure walking down the hill really complements and enhances the mood of this old cobbled street. (110 lens, 6 x 6 camera, 6 x 5.5cm magazine, ASA 64 film)

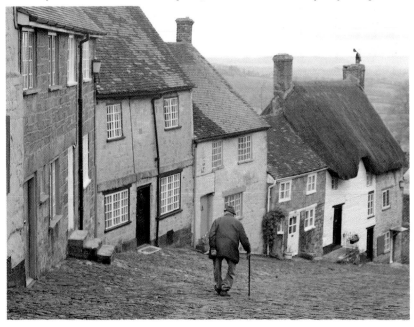

63 The problem with snapshots is that you do not usually have the time to compose carefully or to choose your viewpoint to the best advantage. Where animals are involved I find that it helps, as soon as I see an appealing subject, to start by taking a quick shot. I then go on to manoeuvre myself into a really good position, occasionally taking another shot in order to have at least something if the animal should suddenly decide that it has had enough of my antics and removes itself to a quieter spot. (100mm macro lens, 35mm camera, ASA 100 film)

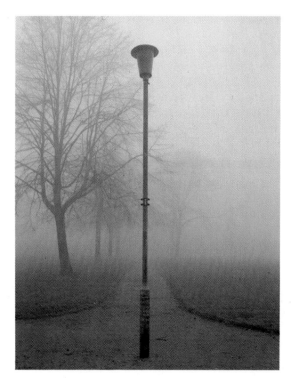

64 Street furniture can be extremely annoying to a photographer because it is often placed exactly where it has the worst effect on the composition. Conversely, it can sometimes lend itself to very striking compositions simply because it *is* in a very conspicuous spot. This ordinary scene is transformed by the centrally placed street lamp. (50mm lens, 6 x 6cm camera, with 6 x 4.5cm magazine, ASA 64 film)

65 Taken in a deer park, this is a neat compromise between making a conventional rendering of the subject and not taking it at all because it *is* conventional. Although in silhouette, it is clear that the deer were looking at the photographer (ie: the viewer). The wide expanse of sky is the most important part of the composition here. It serves a very similar function to the white spaces in a Japanese woodcut. They concentrate the viewer's attention on the subject without overcrowding the composition and give a sense of space, not because they contain anything but on account of their shape and placement. (200mm lens, 35mm camera, ASA 200 film)

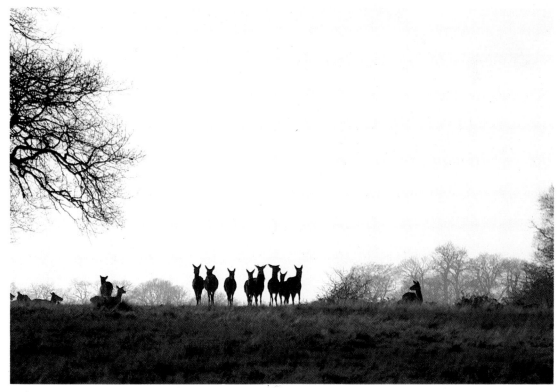

gation to give a 'natural' rendering of your subject.

If space allows, you can freely choose the amount of convergence (or foreground) by using lenses of different focal lengths. The longer the focal length, and with that, the taking distance, the smaller the amount of 'distortion' due to camera tilt and vice-versa.

On the other hand, you can use an extreme wide-angle lens with a vertically aligned camera, which would show extensive foreground combined with a small and seemingly insignificant main subject in the background. An even stronger effect of this kind can be achieved by using this same configuration, but pointing the camera slightly downwards. This would stress the foreground further and cause the vertical sides of the building to diverge. As shown in pictures **68** and **103,** these manipulations add a strong and peculiar spatial impression to the photograph, which further enhances its effect on the viewer.

Speaking generally, it can be said that wide-angle lenses give an effect of space and diversity (for example, between foreground and subject) while long focal lengths compress and suppress space, lending a unity to the things depicted.

This becomes very evident if you have included people and cars in the picture. Taken with an extreme wide-angle lens, people tend to appear solitary, even in a crowd, while a crowd really does look like one and a small group of people can even be made to look like a crowd when you use a very long focal length. (Here, of course, we are dealing with impressions and generalisations. These are not mathematical rules because much depends on the subject itself and how you turn it into a picture. These are only suggestions which are, nevertheless, worthy of investigation.)

Streets and street furniture

Street furniture is a problem on its own. Thoughtful authorities have furnished us with traffic lights, street signs, telegraph poles, wires appended to the latter, and other things which might be very useful but which often destroy the composition of a picture. The same goes for parked cars, hot dog stalls and other apparatus of civilisation.

Although we usually take this inconvenience for granted, perhaps we should pause and think about it for a moment. Our perception works selectively. We can ignore something entirely, even though it is plainly in our field of view. When, for example, we admire an ancient building situated somewhere in a street, we can overlook the street furniture and telegraph wires which impede our view. But the camera does not do this. These things may stand out clearly in a picture as

66–67 This pair of townscapes shows the range of subject matter connected with towns – the panoramic view at one extreme and a 'genre' picture at the other.

66 With this subject, the boundary between 'landscape' and 'genre' work is reached. Any greater attention to the human aspect than this would hardly qualify as landscape work. (50mm lens, 35mm camera, ASA 125 film)

67 Although taken with a standard lens the spatial impression is extremely strong. The steps, which extend into the middle ground effectively draw the viewer into the picture. However, the tree and the small building on the right are much bigger than the buildings in the middle distance and background. These, taken together, stress the expanse of space. The pig adds an implicit human aspect – being tethered, it is clearly a 'domestic' animal. (50mm lens, 35mm camera, ASA 125 film)

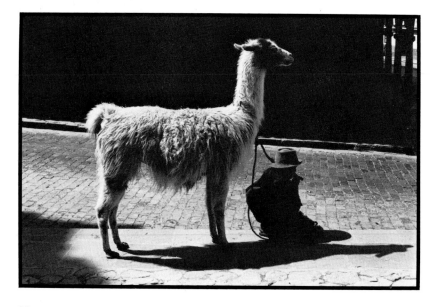

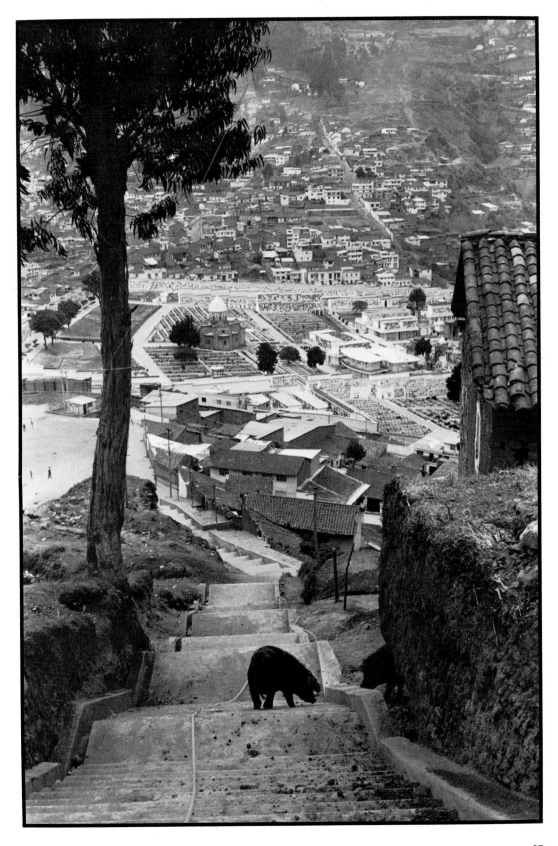

an irritant or even a major distraction, possibly destroying the impact we want to achieve.

To prevent this kind of mishap, it is important to perceive what you see and not just to look without really perceiving it.

Street furniture is an integral part of a modern town and must therefore be taken into account in some way or other. So either you have to integrate it into the composition of your picture by assigning to it a role of some value (for example, by producing a formal contrast between it and the main subject) or, if you cannot find a satisfying way of doing so, you should not take the picture at all.

When looking at the pictures in this book, you will find that street furniture is either not seen or forms an important part of the picture. This is not due to luck but results from careful consideration of these factors.

Modern architecture, streets or town life in general do not pose too much of a problem; street furniture is a natural and integral part of it and can therefore be incorporated into your photographs without difficulty. But the other aspect remains: they must be *truly* incorporated.

That is, they should not be there by chance but should be assigned a definite place as far as the composition or content is concerned. Hence the adage that the difference between a good and an outstanding photograph usually lies in the detail.

Apart from this, streets usually have a character of their own, which is not formed only by the build-ings. Shopping streets may be teeming with a multitude of people, traffic arteries may have six or more lanes, streets in slums may be dilapidated and deserted, while those in well-kept residential areas have an entirely different atmosphere. All this must be brought out in your photographs by the appropriate means. A simple example is that you can emphasise the crowdedness of streets by the use of long focal length lenses, as already mentioned, while the solitude of residential streets would be stressed by the extended empty foreground created with wide-angle lenses. Waste materials in the foreground could characterise a street as well as traffic signs painted on asphalt.

A basic decision is whether to use black-and-white or colour film for your work, because both materials would tend to lend strength to different aspects of the subject matter. Personally, I prefer colour for lively, everyday city life, while I work in black-and-white when I am interested in the architectural qualities of towns, which results in very tranquil pictures. But, whatever your preference the choice should be made consciously and not be taken as a foregone conclusion.

Industrial sites

Perhaps you have seen some of the work of Bernhard and Hilda Becher. They have been called the photographic archaeologists of industry and they have indeed put together a vast body of

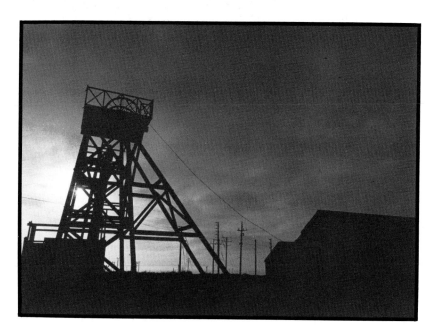

68 This disused mine in Cornwall, England, was literally covered with refuse which meant that almost the only way to take a picture of it was to shoot it as a silhouette. The structure was sufficiently intricate to provide interest when handled that way. I determined the exposure by spot-metering an area of the sky very close to the sun, which reading would leave no detail in the buildings or other structures. (21mm lens, 35mm camera, ASA 400 film)

work. It shows industrial constructions of all kinds, with an emphasis on old and derelict buildings, many of which have been destroyed since the pictures were taken. This work represents a very 'cool' and almost documentary approach to the photography of industrial sites even though the subject matter can be fantastic in conception. The opposite approach is equally possible. Many people have photographed industrial areas in a romantic style—sometimes so much that poverty and grime become abstractly attractive.

Between these extremes you will find an extensively wide range of possibilities for the development of photographic ideas. Modern industrial sites, for example, lend themselves to geometrically composed photographs because they often contain accumulations of identical details. (For example, harbours, where row upon row of

69 Snow is not only rewarding in rural scenes (see Chapter 8), it also has merit in an industrial area because it can conceal disturbing and unwanted detail and, at the same time, reveal the basic structures of subjects. The film was overexposed and developed for contrast in order to stress this effect. (100mm lens, 35mm camera, ASA 100 film)

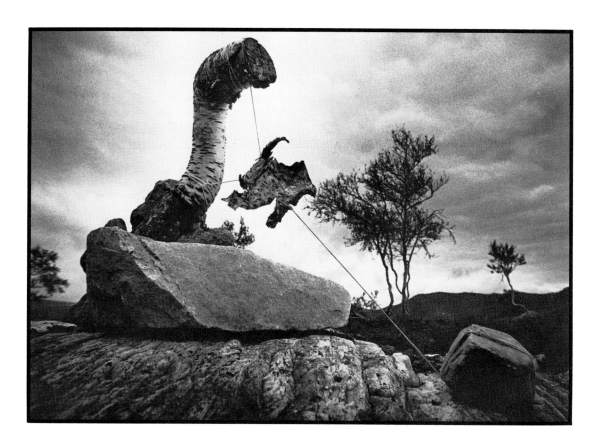

identical products like cars or containers await shipment.) Oil refineries or chemical works on the other hand could result in wildly futuristic compositions with their agglomerations of pipes and slightly mystifying structures.

The main problem with this kind of subject may not be a photographic one at all but the question of how to gain access to such places with photographic potential. This applies not only to strictly industrial sites, but also to harbours, airports, railway property and other such places. There may be more than one solution. Many large public companies give occasional guided tours through their premises which you could join. But if this does not happen and you do not have a friend or friend's friend who works there, you should try the direct approach—simply asking. It is no use asking the doorkeeper whose job it is to keep unauthorised persons out. Write to or phone the public relations department, which most companies have. Usually they are very cooperative, especially, of course, if you have some definite project in mind, like an exhibition or a publication.

In contrast to these subjects, pictures of older, dilapidated and abandoned industrial sites usually tend to be more or less of the romantic kind. But here, too, a simple and documentary ap-

70 Whereas many of the pictures show man-made objects in sometimes very uncongruous settings, here this is carried a step further by showing an object that was specially made (from materials found there) to be photographed at this spot. It belongs to a series which might be called a cross between 'objets trouvés' and 'environmental art'. (17mm lens, 35mm camera, ASA 400 film)

71 The terminus of one of Hamburg's metropolitan railways lends itself well to being photographed because a bridge leading over it affords an overall view that reveals the layout of rails and so on. This kind of thing usually has some kind of regularity which turns it into a 'precomposed' subject – provided you can find the right viewpoint and, furthermore, gain access to it.

proach would be very interesting as well.

Many industrial areas offer a fascinating type of subject, which is often overlooked. Although dust and grime are neither nice nor exactly healthy, they sometimes have surprising photographic properties. If an entire area is covered by the same kind of dust (for example, black coal dust or white kaolin dust) it assumes a unified feeling which would not otherwise exist.

The most extreme example of this kind I have so far seen was a series of slides taken in a disused flour mill, where everything was covered with a fine layer of white or light grey dust. Because the

interest of this kind of subject lies in its mono-chromaticity, you should try taking it in colour, even though your first reaction may be to do it in black-and-white. The reason is simple. If, for example, you have a subject entirely covered with coal dust, it is black and grey (perhaps also with a bluish tinge). This fact emerges only in a colour photograph. Black-and-white would render it in strictly grey tones, whatever other colours were present.

Another interesting class of subjects are factories or power plants not situated in industrial areas but far away from everything else and in natural surroundings. Here, the contrast between nature and man-made structures is often the main feature of the subject and should be brought out in the composition.

Apart from these more or less classical subjects there are, of course, many other things to be photographed in industrial areas. Slag heaps and tips can become veritable moonscapes if you use extremely wide-angle lenses, low viewpoints and shoot from nearby. The same goes for open cast mines with their gigantic machinery and mile-long conveyor belts.

Still another class of subject would be the rows and rows of identical houses where workers live, or powerlines which crisscross the country.

Railways and other man-made features

So far, I have mainly described accumulations of subjects which draw at least some of their visual appeal or interest from the fact that many similar or related things are grouped closely together and interact with each other. But the opposite situation makes for interesting subject matter as well. I have mentioned power plants, which can often be found in otherwise deserted landscapes. The same applies to such structures as dams, derricks and power lines, railway lines, roads, solitary traffic signs, bridges or tunnels and single architectural structures of all types.

The unifying feature of these subjects is that they are placed in surroundings which make them look incongruous. If you are not averse to a literary parallel—by being strange to their surroundings, they make this strange as well. They are what American science fiction writer Robert Heinlein called "strangers in a strange land".

It sometimes needs a bit of sensitivity to feel this effect. But I think it is always worth the effort, because it is such a fascinating task to translate this experience into a photograph. It is more than merely pointing out the contrast between the man-made structure and the 'natural' landscape. I find it very difficult to describe this because we are not dealing with hard facts but with feelings. Perhaps the following example will help. When we look at a mass of leaves that is part of a tree-top or shrub, we experience the way in which these leaves grow as being natural and self-evident, which usually means that we do not notice it consciously at all. But when we introduce some foreign element into this subject, the subject itself too, assumes a different quality. A wire fence, through which these leaves are partially growing, or a delicate metal structure, to name structurally-related things, or a wall made of rectangular stones, to name something with a different structure, shift the main force of our attention (perception) so that we perceive the subject in a different way, in a way that is not 'normal' or 'natural' to the subject left to itself.

That is what I meant when I referred to man-made features in nature as 'strangers in a strange land', and that is what makes these subjects so interesting. I do not want to dramatise the importance of this kind of subject here because I may well be riding a hobbyhorse, which can lead to errors in judgement. But I think, nevertheless, that it provides one of the most interesting opportunities in landscape photography because it incorporates both nature itself and the intrusion of man in some kind of synthesis which is formed in the photographer's mind.

I am afraid that all this is not very helpful, technically speaking. But the attitude you have towards your subjects is actually much more important than anything else. I have always found that, whereas it is easy to learn about f-numbers, interchangeable lenses and things like that, it is very difficult to develop an attitude towards your subject that leads to photographs that are interesting and not merely technically correct.

Looking through this book, you will notice that there are many photographs of this kind in it. The reason for this is not that a majority of subjects fall into this category, but that I have chosen to interpret many different subjects in this way.

When photographing an overall view, you do, of course, have to depend on solitary man-made structures in otherwise natural surroundings to achieve the effects described above. But when you frame your subject from very close by and pick out certain details only, you can find this effect almost everywhere. The reason for this is that it reflects a basic attitude which, once developed, embraces all your reactions to, and interactions with, landscape.

It is this, more than anything, that helps you to find and develop your own style. Once your basic attitude (whatever it may be) has evolved, it will become apparent in all your work and will tend to unify its appearance.

The reason for discussing this here is that I have found the current subject to be a highly emotive one for many people. Most people already have an attitude towards man-made structures *and* their relationship to nature (which, for example, becomes apparent in today's heated discussions on ecology). It should be relatively easy, or at least possible, to develop what is usually called a personal style on the basis of this. Only in documentary work are such attitudes irrelevant.

Parks, gardens, agricultural areas

When discussing landscape, many people inevitably think of nature in its wild or primordial state. Actually, only a very small amount of landscape really exists in such condition. Most of it has been ordered according to the taste of man, as in gardens and parks, or his needs, as in agricultural areas. Because most landscapes (including, for example, wooded areas) are in fact being used in some way or other, it is probably even safe to say that a majority of people have never even seen a really 'wild and primordial' landscape.

When taking pictures of a really untouched 'natural' landscape, a photographer can only impose his own ideas on what he sees. In cultivated landscapes, someone else has already been there before him, changing the elements of landscape according to some underlying plan and/or necessity.

For example, compare a 'natural' wood with its variety of trees, bushes and other plants and its dense and irregular growth with the straight lines

72 Although many people dislike graveyards because of their association with death, they often contain very intriguing subjects. This is expecially true of the rural and older cemetaries. In this picture, the bold effect is largely due to the snow, which suppresses detail and makes for an almost entirely black-and-white composition even though an ASA 400 film with normal development was used. (21mm lens, 35mm camera, ASA 400 film)

of fir trees and lack of variety in the plantations that have replaced many woods today. (Tolkien very aptly called them 'dungeons of trees'.)

A more pleasant aspect can be found in parks and gardens which can range from the strictly formal appeal of the baroque design to the seemingly wild, but in reality carefully devised, park in what is known outside Britain as the 'English' style. Whatever the style, parks and gardens have usually been designed with an eye to their effect on the viewer and are therefore relatively easy to photograph if you make good use of what the designers have placed before you. In most cases the parks or gardens are laid out around some building or other, or they are centred on sculptures, fountains, grottoes, or other man-made features. If so, you usually find the avenues and the enclosed spaces offer the best viewpoints for taking pictures of the scene.

But the ease of taking such pictures is fraught with danger. It is easy because someone has already done half of the work for you. It is dangerous because it might lead you into using the things offered without adding anything personal, so producing only clichés. But once you are aware of this danger it should be simple to avoid.

Another problem: many parks and gardens abound with coloured lights, installations for 'son et lumière', garlands and similar monuments to human ingenuity as well as surprising numbers of litter bins. There being no photographic way around these obstructions, if you find that they really disturb you, you simply cannot take the picture. Some of these items, however, can be very interesting subjects in themselves.

Agricultural scenery, whose main and often only object is utility, contains much of photographic interest. On the one hand, you have small farms with, perhaps, a few animals, small, old and often dilapidated buildings and old-fashioned machinery, all of which can appeal to our romantic nature and fulfil a dream of what many people still believe agricultural work to be. On the other, you have the agricultural industry, with its hedgeless fields stretching to the horizon and its gigantic machinery, not photographically very different from that used in other industries.

If you travel frequently and far, you can photograph widely contrasting types—terraced rice fields, prairie cornfields, or the small walled-in fields that can still be found in some parts of Europe.

These each have their own visual appeal and call for visual comment from the interested photographer. If you can identify it, it will not be too difficult to translate it into a successful picture.

Artificial landscapes and other pre-composed subjects

Other types of artificial landscape, including amusement parks, golf courses, race courses and so on might broadly be defined as 'pre-composed'. With these, as with towns, industrial areas, etc., someone has already done part of your job for you by imposing some kind of order upon nature.

Because so much of the landscape nowadays falls into that category, it is easy to loose any feeling for this situation. But by doing this the photographer would miss an important aspect—the underlying order, created by man. It is there, whether you like it or not and its influence should therefore be felt in your photographs. This calls for an aside. You should not be dogmatic or apodictic in your photography. What I am talking about here is not a requirement that has to be there in each individual photograph at all costs. It is more a basic feeling or attitude and, as such, part of your personality. If it is that, it will be felt or sensed in your photographic work, although most people, perhaps even including yourself, could not pin it down or put a name to it.

This is how photography works anyway: pictures are visual statements and if you could put everything in them into plain words or even into thoughts (as opposed to feelings, emotions), the visual statement would be entirely redundant.

Therefore your general state of mind or your basic attitude more often than not is a better 'photographic tool' than specific thoughts concerning the particular picture you are taking. (Which is why I always stress these things when discussing landscape photography.)

All of this does not, of course, only apply to the artificial landscapes under discussion here. It is a basic part of all landscape photography—apart from the documentary approach, which we will discuss next.

Documentary approach

So far, I have mentioned documentary landscape photography mainly in a negative context, by saying, for example, that this or that does not apply to documentary work.

Documentary photography differs substantially from our 'creative' work in its aims. The aim of a

73 Well-kept lawns and rioting weeds, showplace houses and crumbling ruins offer a natural partnership in a wide variety of combinations. The relationship between a building and its surroundings is often much more interesting photographically than either of these components on its own. (50mm lens, 35mm camera, ASA 400 film)

documentary photograph is to show the viewer the 'facts' of the subject with the least possible intervention by the photographer and his personality. (That this is inherently impossible is a philosophical problem concerning the nature of reality and the quality of 'pictorial reproduction', which cannot be discussed here.)

In order to come as close as possible to achieving this aim, you should follow some simple but very strict rules. All photographs have to be taken with a 'standard' lens—one of normal focal length for the negative size used.

The camera back (negative) always has to be exactly parallel to the subject in order to avoid converging or diverging lines. Photographs should always be taken from eye-level. They should be as 'sharp' as possible, so preferably small apertures should be used.

Documentary work can be done in black-and-white, but colour would be preferable, because it leads to what people believe to be a more faithful reproduction.

If you compare these assumptions with our discussion on creative photography you can easily see that they inevitably reduce the influence of the photographer's personality. All techniques that would change the technically correct rendering of the subject in one way or other should be avoided.

These hard and fast rules of documentary photography must, by necessity, result in (photographically) uninteresting pictures, even if they have a high information value. So most photographers do not adhere to them strictly but instead aim at a balance between what might be called 'faithful reproduction' and an 'interesting' rendering which helps to induce the viewer to look at the information being presented to him.

74 If you can't beat them, join them, and if you can't 'photograph around' litter bins, lanterns, loudspeakers or other accoutrements of modern civilisation, make them a subject in themselves. The only thing that never works is to have them in a picture by chance! This 'litter bin with park' was taken with a 17mm lens on a 35mm camera, using ASA 400 film.

Documentary photography is an important part of landscape work because we need records of what is (and often enough will soon be no more). But it should never be confused with creative work; we have seen that the aims and the means are very different. In my opinion, mixing some parts of this with some parts of that leads to confusion and therefore to bad photographs. Your aim should either be to develop an imaginative idea or to record as faithfully as possible—but not both at once, which results only in a muddle.

People in landscape photography

If the landscape subject you have chosen is such that people are around at most times of the day, you must either include them in the picture or be prepared for what might be a considerable wait to make sure nobody is visible. Never compromise in this respect. People either belong in your photograph or they do not. This calls for explanation:

Someone looking at a photograph usually reacts very strongly to the human element and

75 I am afraid that this against-the-light picture of the harbour of Camaret (Brittany, France) is one of the few pictures I have taken of people in a landscape, apart from nudes in landscape which I do relatively often. The reason for this is not that I dislike people or find this type of subject inferior. It is simply that people do not fit into the category of things I want to express in my landscape photographs. You may find this attitude strange, but if you are really involved with landscape work, you will surely discover that your work shows similar – or very different – personality traits, which is not a fault at all. (360mm lens, 6 x 9 view camera, ASA 400 film)

76 The easiest way to balance the people in a photograph against their surroundings is by controlling the size-relationship between them. But you must take into account that a viewer is very likely to react much more strongly to the human element in a picture than to the other features. Although here the two people occupy only a relatively small amount of space, the viewer's attention is immediately centered on them, while the surrounding townscape is clearly of secondary importance. (50mm lens, 35mm camera, ASA 125 film)

this emotional response can be much stronger than to the rest of the picture. Another point: in earlier chapters I mentioned how our perception works selectively and we tend to overlook things in our field of view which do not seem to be related to our current preoccupation. Consequently, we may fail to notice a person in the scene while we are taking the picture but in the finished picture he or she will stand out and draw too much of the viewer's attention. So the inclusion of the human element in your landscape work needs careful thought.

There is an old 'rule' which you still sometimes hear or read, by which you are advised to place a person in the foreground of your picture (preferably in a red garment when working in colour) in order to create a 'pleasing composition'. This is quite absurd, for the reason just given, as well as other compositional factors, even if one felt tempted to approach landscape photography in this way.

The inclusion of people in your landscape picture can be a major problem, governed by your basic attitude towards landscape itself. You may, for example, have noticed that in my work I insist on people-less landscape (this is said to be

psychologically very revealing, but never mind that now!) while other photographers almost always show people in theirs. It is impossible to say that one or the other way is better; both ways reflect different personalities. But it can be safely assumed that to incorporate people by chance is asking for trouble. If people do appear within your field of view, ask yourself whether they have a definite function and enhance, or disturbing elements which detract from, the effect you are trying to create. Waiting for people to go away can be a tedious business, especially if someone has settled down for a nap or a picnic! Occasionally you will even have to give up entirely, but you should not compromise.

If you want to show people in the foreground, take care that the landscape does not become reduced to a mere background. This is, of course, not a bad thing in itself, but the result could probably no longer be called a landscape photograph.

The nude in landscape
All these remarks apply equally to pictures of the landscape incorporating the nude figure although you are not very likely to incorporate nude people

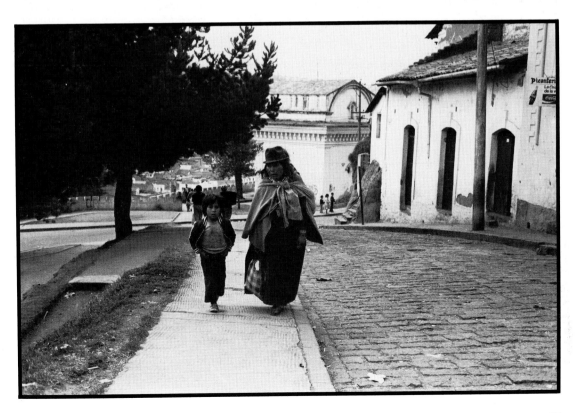

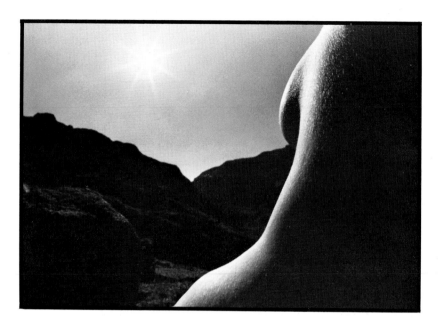

77–78 Put simply, there are two main possibilities for photographing the nude in landscapes – cheesecake photography, and the rest. I have always felt that cheesecake pictures in landscape do not usually work. Props of the kind associated with this type of picture, like umbrellas, scarves, etc, can easily look incongruous or even ridiculous out of doors – something that does not occur indoors, for some reason. I think that very plain and simple pictures like these have a much better chance of success with someone who is really looking for photographic qualities. (Both pictures: 55mm lens, 6 x 7 camera, ASA 400 film)

by accident, or fail to notice their presence.

I have always found the nude in landscape to be a particularly fascinating subject. But it is not easy. If people in a landscape attract attention to a disproportionate degree, this is even more true of the nude. Therefore the need for the figure to merge and blend with landscape must pose special problems. Please note that here we are talking about landscapes with nudes and *not* nude photography in landscape settings. There is an appreciable difference. The nude is not normally a part of the landscape. To make it look like that is the challenge.

Some places, like nude bathing areas, lend themselves more or less naturally to this kind of work. In most other cases the feeling is more one of bringing together opposites or of merging subjects that are not normally related. I think that the easiest way to get a grip on these problems is to approach them in a purely formal way. You have made a good start if you succeed in making a composition where all parts (ie. the nude and the landscape) seem to fall naturally into place.

This can be done by playing on contrasts. An example might be the contrast between rounded and soft female forms and a formal and strictly organised landscape, like the vertical and evenly spaced trunks of fir trees. Or, it might be done by stressing similarities: for example, the same subject combined with equally rounded, smooth stones on a beach.

Once you have acquired a 'vocabulary' of this formal kind, you can begin to look for things to say with it. This very personal process unfortunately defies description but I will try to give a very simple example. I have noticed that I practically never show a person's face when photographing nudes in landscapes. But I usually—or at least, often—do so when I place nudes in other surroundings. When I started to think about this, I came up with the following explanation.

In most cases, people are shown as transient beings. They are seen in moments which, when you look at the photograph, clearly belong to the past. This is particularly noticeable if you look at rather old photographs. A person is identifiable as an individual and related to things that are gone, or at least transitory. But being nude and with their face hidden in a picture, the person is what you might call de-individualised. This effect is further enhanced by showing the figure in a landscape which does not contain perceptible traces of man, landscape that we usually associate with durability or timelessness. This, of course, is only an example of what can induce one particular photographer to attempt to combine the nude with the landscape (apart from the fun of simply doing it). Your ideas are probably very different. But in realising them you are sure to have to follow thought processes or visual clarifications running on the sort of patterns described here.

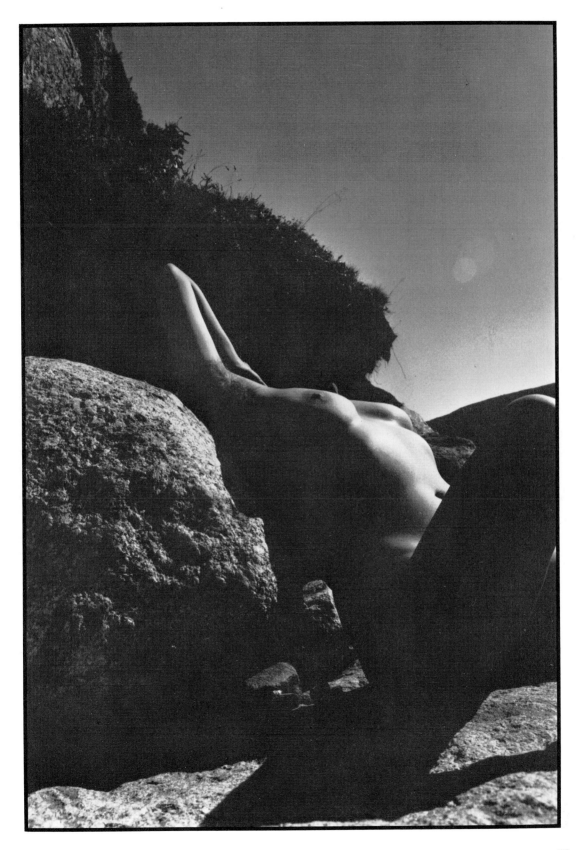

Different kinds of landscape offer different picture opportunities in forms of composition, atmosphere and local colour. Hand in hand with this go some special problems due to their peculiar nature.

Deserts

First of all, working in deserts raises some practical problems concerning the treatment of your equipment. Dust and sand are everywhere and have a tendency to find the smallest chink in your bags and boxes. Preferably you should use special airtight camera bags manufactured for use in this type of environment. If you are in doubt or if you only occasionally venture into deserts, you can also wrap up your equipment tightly in plastic bags. Nevertheless, sand is apt to get through even these somehow so frequent cleaning of your equipment is called for. (This exercise, too, is not much use unless you have also kept your cleaning implements completely clean!) When using a view camera or close-up bellows this cleaning

process should include the interior folds of the bellows because sand or dust lodging there settles on the film when you extend or close the bellows.

In deserts and seaside locations, it makes sense to leave some kind of filter (skylight or UV) permanently in front of the lens in order to protect it against abrasion from sand particles.

Another serious problem is the often very intense heat which can cause a rapid deterioration of film quality, particularly if you are likely to be in the desert location for a lengthy period. There is not much you can do about that unless you have an air-conditioned car where you can leave your films and your camera until you really need them. Apart from that you should use white or plain aluminium bags or cases that reflect the heat. A black bag will 'cook' your films in no time at all!

There are also some pictorial problems, most arising from the very intense light. Sandy deserts do not present too much difficulty because the

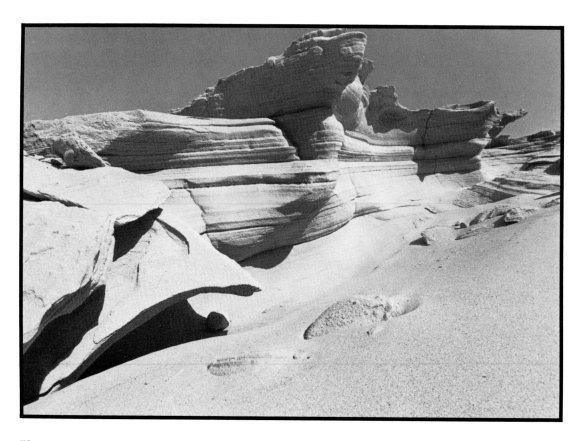

APPROACHES TO LANDSCAPE TYPES

sand, being of a very light colour, lightens the shadows by reflection. But deserts consisting of a mixture of sand and rock can be rather tricky to handle because they often contain brilliantly lit, almost white areas and, at the same time, inky-black shadows. If you follow the advice given in Chapter 4 you can see that this would call for high speed film, even if it means using extremely strong neutral density filters.

You will have to calculate your exposures most carefully, because the distribution of light and dark areas only seldom mixes to the average middle grey needed by an integrating automatic exposure meter system. Above all, do not trust your eyes. Lighting in desert landscapes is often very deceptive.

If, when working in black-and-white, you want to make use of yellow or light orange filters to darken the sky, remember that more often than not, this is also the colour of the sand, which would become relatively light. The effect could well lead to contrasts beyond the recording range of your film. Therefore a polarising screen would probably provide a better solution to the problem. (A yellow or orange filter would not only lighten the sand, it would at the same time darken the shadows, because they contain a portion of blue light reflected from the sky.)

Apart from these practical considerations photography of desert landscapes poses some compositional problems involving the foreground. This is discussed in detail in Chapter 11. Additionally, it can be very interesting to shoot desert landscapes on high speed film (35mm). If exposed and developed normally, the grain of this film is just so pronounced in enlargements of 30 x 40cm and greater that it appears to be a representation of the individual grains of sand. Certainly the real size of the grain is very different from an actual representation of sand, but the viewer usually falls for this illusion and takes the print to be acutely sharp and detailed, indeed more so than one made from a 'normal' negative.

Seascapes

The general remarks concerning care of equipment that I made when discussing photography in the desert also apply to locations by the sea, but

79 The main problem with taking pictures in a desert is usually the contrast. This barranco (dried river-bed) illustrates it: the sand was almost entirely white, while the shadows came close to being black. But by careful determination of the exposure the full contrast range was fitted on to the film. Readings were taken from the light area in the middle of the picture and the very dark shadow in the left hand corner. The exposure was taken not with the mid-tone value, but slightly favouring the light parts. The original print shows detail even in the deepest shadows. (17mm lens, 35mm camera, ASA 100 film)

80 The cactus here serves as a compositional counterpoint to the regular-looking mountain in the background, its size and position being stressed by the use of the wide-angle lens. The exposure problems were the same as for the previous picture and were solved in a similar way. (17mm lens, 35mm camera, ASA 100 film)

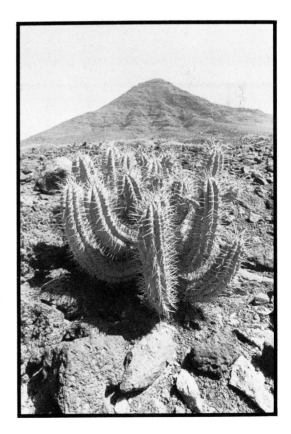

81 This is the closest I have come to a photograph of a crowded beach, because the crowd had just left. But what would otherwise have been a simple snapshot now takes on a bit more significance. Designed to be used by people, the things depicted reveal more of their significance compositionally, as well as in the meaning, when they are shown simply there on their own. This is difficult to put into words, but I think the theme of this picture is quite clear. (17mm lens, 35mm camera, ASA 100 film)

82–83 It is of course not only the beach itself that makes for interesting subjects at the seaside, but also the flotsam and jetsam you can find after the high tide has retreated. Although dead fish and drying seaweed (both often rather smelly) may not be to everyone's taste, they surely make admirable foregrounds that can lend fascination to otherwise too uniform subjects. (**82** 55mm wide-angle lens, 6 x 7cm camera, ASA 400 film, **83** 17mm lens, 35mm camera, ASA 100 film)

with additional problems. Even when there is only a light wind blowing, the air contains a fair amount of salt. (If you should wear spectacles, you will be familiar with the effect. After a long walk along the beach your glasses will be covered with a fine deposit.) But salt and humidity combined (not to mention sun-tan lotion) are a camera's worst enemies, especially with electronic circuitry.

To protect your equipment against the hazard, you should always wrap your camera in an ordinary plastic bag and remove it only for the few moments needed to take a picture. Additionally, clean the camera at least daily, by the method recommended by the manufacturer in the owner's manual. (But don't do that on the beach, which would make matters worse!)

Seascapes are very varied in appearance and offer many different kinds of subject. You will find everything ranging from desert (sand-dunes) to mountain scenery (the scenic fjords of Norway, for example), or from nudes in landscape to industrial sites (harbours) or seaside structures.

Other features—lighthouses, buoys, wrecks, old fishing nets, lifeboat stations and so on—have great potential. I have always found lighthouses especially interesting. They are not only architecturally interesting (meaning photogenic) but they have a wide range of emotionally charged associations for almost everybody, on which you can play when composing the photograph.

When you include the sea itself in the picture take special care with placing the horizon. It has a really great bearing on the impact of the picture (Chapter 11). Although it is often partly obscured by haze or by trees or by architectural structures, the horizon is generally a straight line. Its role is even more significant in seascapes than in landscape pictures.

At least part of the colour of the water is due to reflection from the sky. Consequently, any filter that affects the rendering of the sky is likely to affect the water as well. This can restrict your choice of filters considerably, because a darkening in the rendering of water often gives it a very flat and 'dead' appearance. The same applies to the use of a polarising screen (in both black-and-white and colour). It will, at least in part, remove the sparkle and surface sheen of the water, especially with waves and surf. This can easily transform an otherwise vivid picture into an unrecognisable mass of greys. So the best bet is probably not to use any filter (with the possible exception of a skylight or UV type) as long as the picture contains a significant amount of water.

These remarks do not, of course, apply only to the sea, but to all other pictures of water. Another aspect is the rendering of water movement. You may have seen pictures taken with extremely long exposure times (in the region of a minute) which show water as a very dense, amorphous fog lying over the beach. At the other extreme are waves 'frozen' at the moment of breaking.

Both effects are interesting and legitimate, although photographers more often tend to 'freeze' the motion of water with very short exposure times. To aim for a 'natural' effect you should avoid both extremes. This is best achieved by showing water with its main part frozen and a few additional areas blurred due to motion. It is not easy to hit exactly the right exposure time for this effect because it not only depends on the velocity of the motion, but on the camera distance and the angle between the axis of motion and the camera direction. But the following rules of thumb may help.

A good starting point to achieve the effect described above is shutter speeds of 1/125 sec or 1/250 sec. The exposure time can be longer if you photograph the movement head-on and in the middle distance, or background. The exposure time should be shorter if the motion runs more or less parallel to the film plane and/or it takes place in the foreground. There is always an element of uncertainty in situations of this kind and therefore you should bracket your exposures, including the values quoted above.

At the time of writing, cameras are available which are suitable for both 'normal' photography and for underwater work. Although we are not concerned with underwater work here, these cameras are worthy of mention because very interesting landscape photographs can be taken with them as well. You can assume points of view which are otherwise impossible, for example, in the water or very close to its surface—which would result in a 'frog's eye view'. Theoretically, this can be done with normal cameras too, but yours would not be the first to be ruined by an unexpected wavelet! The other possibility would be to include the waterline itself in the picture. This

84 Oblique lighting shapes the sand itself into a distinct feature by reinforcing the shallow indentations in its surface. The relatively low contrast of the film I was using and the weakness of the diffused sunlight made it easier to retain full shadow detail in the print. (21mm lens, 35mm camera, ASA 400 film)

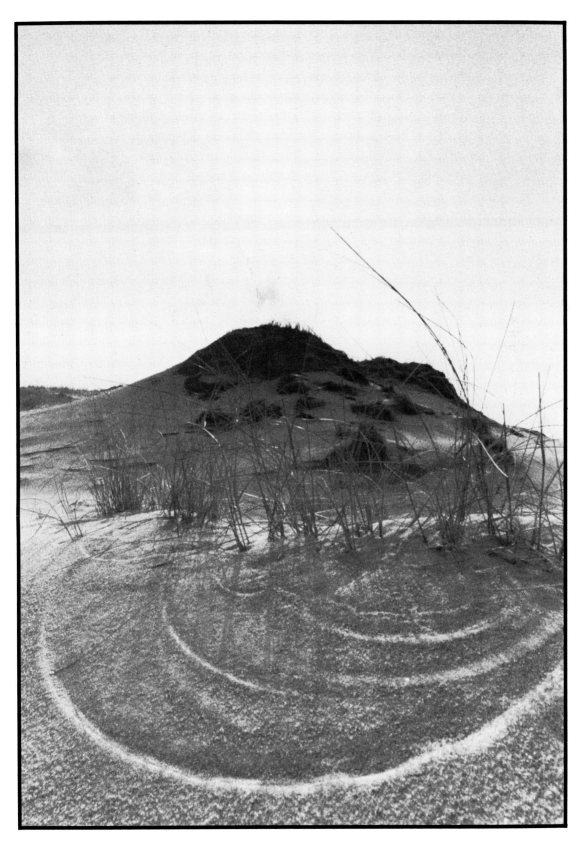

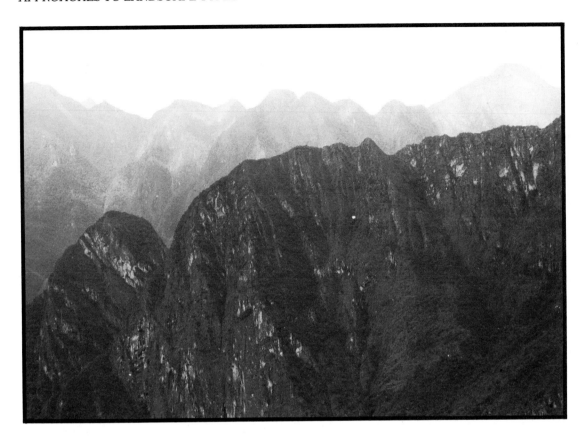

can be achieved by immersing the lens only half-way into the water. I have seen some very beautiful pictures taken in this way, which in their lower part showed an underwater landscape, while in the upper part one could see the beach. However, this works only in extremely clear water.

Many people associate the word 'seaside' with crowded beaches and holiday excitement of every kind. I have always preferred a rainy, empty beach to a sunny crowded one and suggest that you should at least try this as well. I always feel that seascapes are, in effect, immensely tranquil 'landscapes'. When looking at crowded beaches and the activities going on there, I sometimes cannot help feeling that many people have lost the ability to respond emotionally to a landscape or to find a personal relationship with it. But I am quite sure that both these states of mind are entirely indispensable to a landscape photographer. (Oddly enough, people who are not particularly sensitive or interested enough to respond to a landscape often do so when confronted with a photograph showing the same landscape. If the photograph is good, the feeling and atmosphere in it is condensed and strengthened

85 A very pale blue filter strengthened the hazy appearance of the background mountain range. Because the relative sizes of the nearer and more distant ridges are very similar, the impression of space rests on this haze effect alone. (50mm lens, 35mm camera, ASA 125 film)

and the stimulus is greater than that of the landscape itself. The main part of the work—to perceive the special qualities of the landscape—has already been done by the photographer.)

I am not suggesting by this that a landscape photographer is a superior being! His interests are different, and this enables him to take outstanding photographs which others do not, or cannot.

Mountains

Mountains usually impress by their size. It is often said that mountains 'dwarf' the viewer. You are made aware of your insignificance in the scheme of things when actually confronted by something of this size—albeit a slightly different reaction with different people.

It is easy to feel this but very difficult to convey these impressions in a photograph because the sheer scale of the scenery poses special prob-

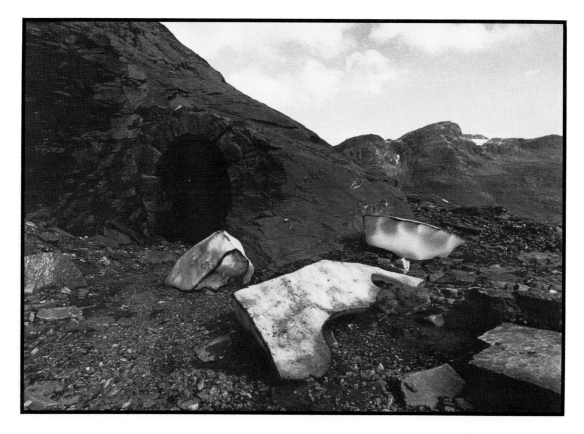

86 The very impressive atmosphere of this disused mountain road with its delapidated tunnel and residue of snow did not need anything special to turn it into a strong photographic statement. The main problem was to find a viewpoint which created a convincing relationship between three pieces of snow (there were more, but I excluded them from view) and the black opening of the tunnel. (17mm lens, 35mm camera, ASA 400 film)

lens. It seems to me that mountain scenery is about the only form of landscape of which you can give no feeling by photographing only a small section of the overall view. With sea and deserts for example, you may select a relatively tiny part of the scene to give an impression of the whole.

A few stones, a small stretch of sand and a clear sky could suffice to evoke the idea of 'desert' (provided, of course, that the photographer has done his job well!). But with mountain scenery this almost never works—absolute size is a basic ingredient of the overall impression.

The photographic problem is therefore simply this: if you use long focal length lenses, your picture will tend to show things more closely in proportion to one another and, by implication, to their natural size. If you take a picture of a tree with a mountain in the background both at a very great distance, with an appropriately long focal length of lens (for example, a 100mm or even longer) the result will show the tree and a section of the mountain wall in approximately the same (realistic) size relationship. Even if very impressive in itself, it could hardly be called a mountain scene.

On the other hand, a wide-angle lens (used from proportionally shorter range) would show the whole mountain, greatly reduced in size, perhaps even appearing smaller than the tree. This problem is impossible to solve, although it is generally better to opt for a wide-angle lens. The only way out is to stress other properties of mountain scenery to enhance the impression of size in an indirect way. For example, the use of fog and haze to enhance the spatial distribution of mountain ridges or peaks (as described in Chapter 9) can indirectly achieve a feeling of size.

Another possibility is to concentrate on regularities in the formation of mountains. Often they have at least one view from which they appear to be of a very regular geometric form. Or, two mountains of roughly the same shape are grouped closely together. Or, again, various different, but

in themselves regular, shapes come together to form an interesting combination. Curiously enough all this tends to enhance the impression of size, perhaps because we tend to associate irregularity and disorder more with rocks and rubble than with whole mountains.

A neutral foreground is often better for this kind of picture, because it offers no clue as to absolute size. This does not, of course, mean that the foreground has to be uninteresting, simply that it should not give any clues as to its size. An extreme example of this would be picture no **120**, where I constructed the foreground for the photograph.

Apart from these basic considerations there are a few technical matters worthy of mention. It is, of course, convenient to have with you everything you might need. But mountaineering, even of the most unambitious kind, is exhausting to say the least. It is no help if you have everything in your bag but are much too tired to use it once you arrive at the location. One camera body and two lenses seem to be as much as the average climber would want to carry. (I have occasionally carried 30kg (66lb) of view camera equipment in a backpack but I am not in a hurry to repeat this performance.)

Additionally, you should carry a skylight or UV-absorbing filter for your lenses. At heights of more than 1000 or 1500m (or, say 300 to 400 feet) you should always use it, provided that the sun is shining. A good rule of thumb is that you need this kind of filter if you are in danger of sunburn. The filter is not necessary with lenses containing very thick glass elements (for example, zoom lenses and many extreme wide-angle designs) which themselves effectively absorb untra-violet radiation. However, always use a lens hood (sunshade) for landscape work whatever the lens.

Solutions to problems

By discussing here three very distinct and easily recognisable types of landscape I have tried to show that the problems of landscape photography are twofold. The technical is relatively easy and straightforward. Of course, it is of paramount importance that you handle your materials properly and with assurance, for which I have tried to give some hints. The main problems, however, cannot be stated in technical terms and you are more likely to find solutions within yourself than in technical manuals. Awareness probably is the keynote here. If you are aware of your reaction to a landscape, you will know what to photograph.

That much is plain sailing for everybody who has the basic sensibility for this kind of emotional and intellectual involvement (and it is safe to assume that everybody who really wants to take landscape photographs has it!).

On the other hand, it should be relatively easy to master the technical aspect. Given today's near-perfection of materials and equipment, there should not be any problems that a little patience cannot solve.

What remains is the middle part, the 'translation' of your ideas or feelings into pictorial statements—as discussed. I hope that by showing you one solution, that is, my own personal one, I have succeeded in explaining the structure of conscious and/or subconscious photographic decision-making. But how should you apply this to your own situation?

There are, perhaps, three ways to go about it. First, you can improve your work along the lines proposed in this book. This seems to me the most straightforward and essentially easiest way.

Secondly, you could try to analyse the work of other people, applying the guidelines described here, which would show you the many possible approaches to landscape photography. In my view, this is less satisfactory than the first way because it does not necessarily improve your initiative and lead you to look for your own solutions. Therefore I would not advise you to try it without the first approach.

Thirdly, you could try to imitate someone else's photography. This is the most dangerous process. It only works if you do not simply aim for the surface effects, which may be inherent in another person's pictures, but really try to find out what gives their work its emotional power.

The danger of this latter process is not only that you may continue to copy another person's work. You may also overestimate the conscious approach to photography. Although this is exactly what suits some people best, it may not be best for you. Analysing another person's work is an intellectual approach, whilst taking pictures may be a more spontaneous process for you. Both are valid but you should choose the one that suits you best. Usually this choice is a subconscious one, established before you even start taking pictures. But working along the lines of the second two options described here could easily shift the balance in the wrong direction. The most important part of all photographic advice is its provisional character. What counts is what you make out of it!

9 GENERAL PROBLEMS IN LANDSCAPE PHOTOGRAPHY

Perhaps your first reaction to certain conditions that prevail in landscape photography is to see them simply as technical problems to be overcome. I will attempt here to show how these conditions, common to landscape work of all kinds, may be incorporated into your pictures, not just because they are there, but to reinforce the effect. First the most general problem of all.

How to render clouds

The first question to be answered is, do you want to show clouds at all or would you prefer a clear, empty sky? Obviously, this depends on the weather conditions. But apart from the fact that you cannot produce clouds where there is an entirely blue sky, there are various photographic techniques which leave enormous leeway.

The more or less classical ideal of a landscape includes, among other things, a sky dotted with fleecy clouds. The aim of many photographers has been to create this effect even when natural conditions were entirely different, sometimes going as far as to insert clouds by way of darkroom manipulation. I find the attitude behind this kind of picture exceedingly silly. If you consider your reactions to a landscape carefully you will notice that you respond to the visual elements, including the clouds, as they are. When translating this into a photograph, it is of course perfectly legitimate to enhance or weaken aspects of it in the way which I have previously described. I believe this to be legitimate because the impact of the picture on the viewer should be as strong and as homogeneous as possible—the condition being that the final picture should reflect honestly what moved you when taking it.

Suppose you see a landscape under an intense blue sky, devoid of clouds. What could move you to add fleecy clouds to it? Do you perhaps think that the landscape would then look more pleasing or 'pastoral' with them? It is quite possible and—I think—even normal to react in this way to a landscape. But I believe that the way to deal with this problem is not to add the clouds in order to make a pleasing, saccharin-sweet picture. I think a more honest and interesting solution is to face it as it is. The emotion that moved you to notice the absence of clouds is one of discontent, of being unfulfilled (or, perhaps, even of feeling insecure). If *that* is what is behind your reaction to

the landscape in this special state, then this is exactly what should constitute the subject of your photograph.

This interesting problem, however, raises a more general question. People tend to think about clouds only in extreme situations, either when there are none at all, or when a storm is brewing up. Or they may observe clouds in unusual configurations or unusual lighting. But, as a photographer, you must always take them into account. They form an important part of your picture and have a bearing on its impact, even if the viewer does not realise this consciously.

How can you influence the appearance of clouds in your pictures?

In colour work, the possibilities are almost nil. You cannot use any filters except a polarising screen, which serves (sometimes) to deepen the blue of the sky and thus strengthen the rendering of the clouds. (Do not forget that it also removes reflections on water and deadens highlights, which could result in an unwanted loss of life and sparkle in the picture. So it should be used very judiciously.)

In black-and-white work there are three different ways of influencing the rendering of clouds. These can be used separately or in combination.

The first is the choice of film. This may seem strange but it works. If you look at pictures taken with the automatic exposure system of a 35mm camera, you will notice that pictures made with slow, or medium speed films, up to ASA 100/21DIN (ISO = 100/21°) show the clouds less often than pictures taken under similar conditions on high speed films such as ASA 400/27DIN (ISO = 400/27°). Some people call ASA 400 film 'the film with the built-in filter'.

The reason for this effect is easy to explain. In many landscape scenes the sky is the lightest part, while everything else (earth, trees, buildings etc) is much darker by comparison. If you now choose an exposure based on the darker parts of

87 The clouds here are actually the main subject of the composition. Therefore the exposure was placed very high in order to render the strip of ground in the foreground entirely black. In this way the black silhouette of the bush serves to counterpoint the main mass of clouds on the left hand side of the picture. (250mm lens, 35mm camera, ASA 400 film)

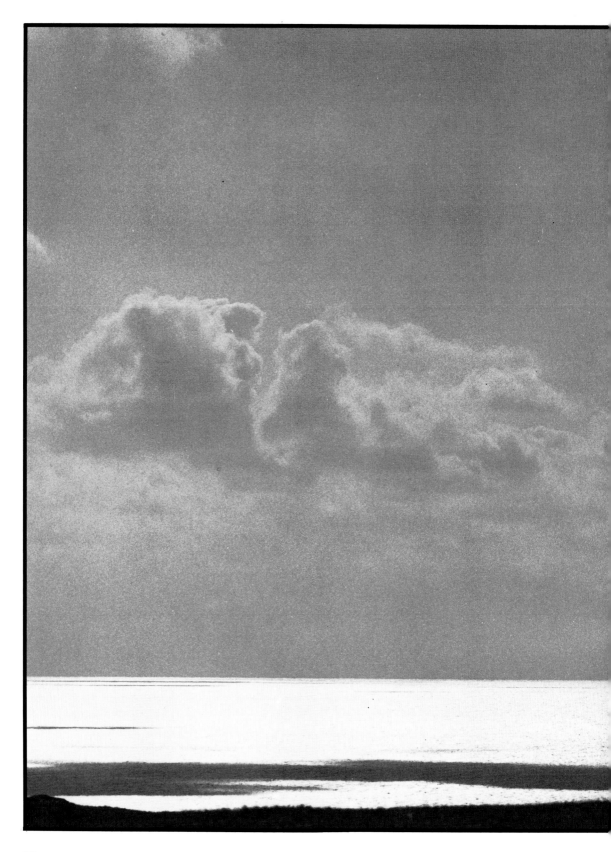

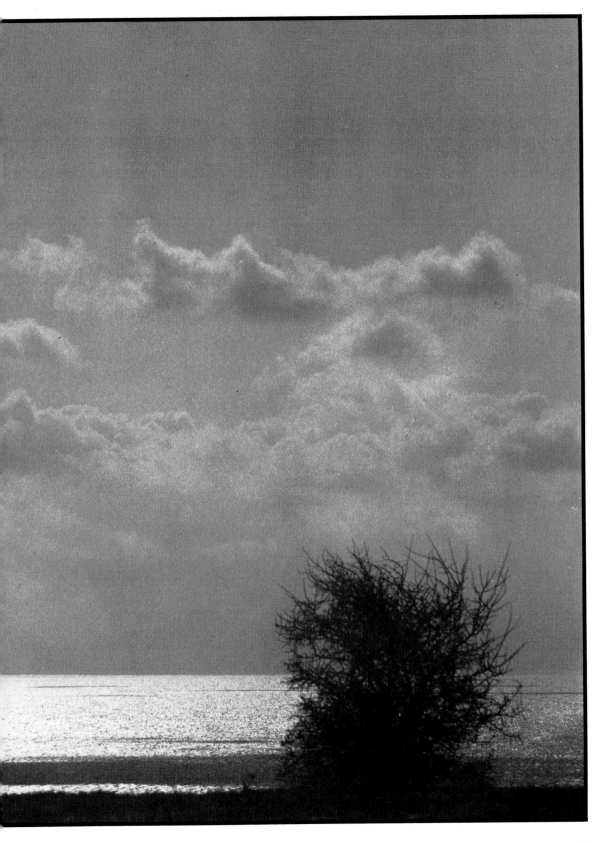

the scene, everything in the sky (meaning the blue and cloudy parts) is beyond the contrast-recording capacity of the film. In this case, therefore, the sky shows only as a blank space in the final print. The reverse would apply to ASA 400 film. Here the contrast-recording capacity of the film is so great that in almost all cases it would include sky and clouds.

However, I think that this effect is mainly due to careless exposure determination. I have found that a 'correct' determination of exposure as described in Chapter 5 usually results in the inclusion of clouds, even with slow films.

Nevertheless, this effect can be used consciously. With slow and normal speed films a low 'placement' of the exposure (see Chapter 5) would exclude the clouds, while a high placement would include them. The exception is high speed material which almost always shows clouds, even with highly erratic exposures. (Note: this, of course, only applies to scenes with a more or less 'normal' distribution of grey values but they are

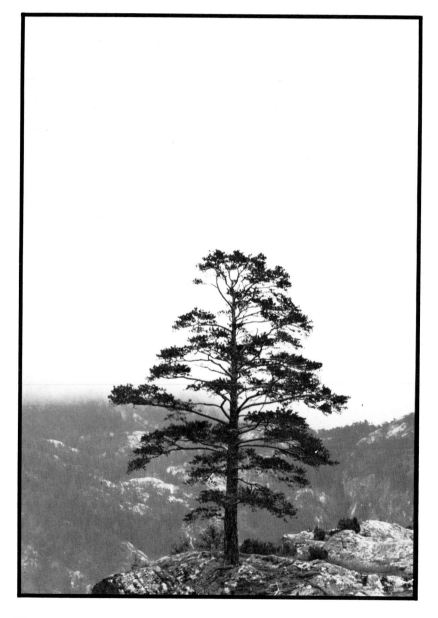

88 This illustration raises the question of clouds in a photograph: here, there aren't any. But in fact, there were quite a lot of clouds when I took this picture. Fortunately, they were very light in tone, so it was easy to suppress them by a very low placement of the exposure within the measured contrast range.

89 This picture shows a treatment of clouds which was meant to preserve the luminous quality of a slightly structured overcast sky, typical of many summer days in northern European countries, Norway in this case. (65mm lens, 6 x 9cm view camera, ASA 400 film)

90 To include the sun in the picture can easily extend the contrast range beyond the recording capability of the film. The only way out in that case is to wait until a cloud (if there are any) begins to move across the sun. This can reduce the contrast enormously, but the trick is not to wait too long – which might change the entire lighting effect. As well as acting quickly, you have to determine the correct exposure beforehand. This is easier than it seems: the brightness of the shadows does not change much in such situations, and you can measure those quite easily. If you spot-read a part of the sky very close to the sun (before it is hidden by the cloud) the contrast range can be quite correctly determined. (35mm fisheye lens on 6 x 7mm camera, ASA 400 film)

91 Compare this with the previous illustration – the placement of the cloud is carried a step further. Land, sea and even the major part of the sky are either very dark or, perhaps, entirely black, turning the quite normal evening scene into a dramatic event. This was achieved by inclusion of the sun in the picture, so giving the required contrast. (21mm lens, 35mm camera, ASA 400 film)

the most common kind anyway.)

Another way to influence the rendering of clouds is to use filters. First there is the polarising screen which works in the same way as in colour photography. But, additionally, you can use yellow, orange or even red filters to influence the rendering of the sky.

The problem with all of these filters is that they affect other parts of a photograph as well and should therefore only be employed with some care. Sometimes, the very dark and heavy impression given by the use of strong filters may en-

hance the impact of your picture. But if you want to preserve the luminous quality of a scene, you should use only the lightest yellow or orange filter you can get. When using filters, variations in exposure also influence the effect of the filter (Chapter 5) so you must take special care here.

Working method
These three possibilities: choice of film, determination of exposure and use of filters give you a wide variety of effects ranging from a slight darkening of the sky, scarcely noticeable to the

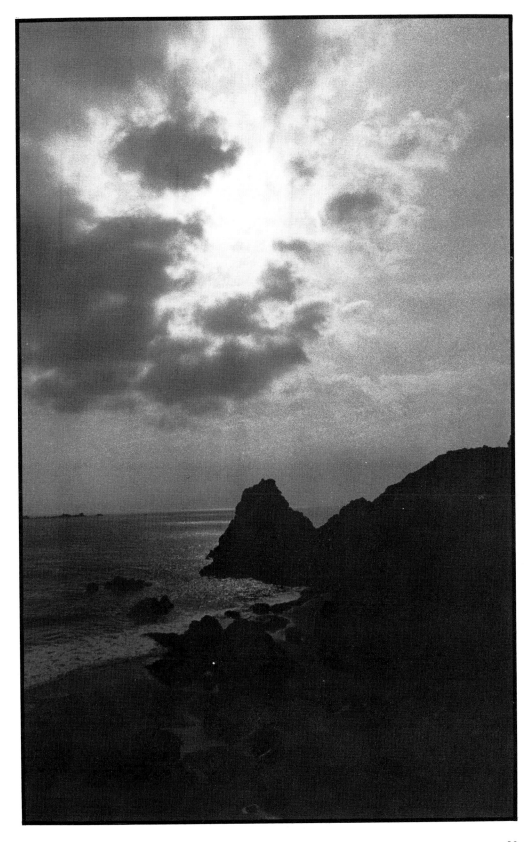

viewer, to the almost black skies which result from working with red filters. The latter gives a very surrealistic effect that looks a bit like a moonlit scene.

If you are aiming for a natural looking result, start by adjusting your exposure so that the sky and the clouds fall within the contrast range of the film. If this does not suffice consider choosing a film of higher speed. If this is not enough, then— and only then—should you consider using light yellow or orange filters.

When your aim is to suppress the clouds, the same sequence applies, but of course with reversed aims. You should increase the exposure. Failing this, choose a slower film and if that is still not enough, you might want to try lightening the sky with a pale blue filter. (Again this sequence applies only if you want to create photographs where the manipulation is as unobtrusive as possible. For dramatic results, which intentionally deviate from a natural rendering, anything goes, as long as it achieves the desired results.)

To make clouds appear as natural as possible, retaining the delicate, translucent whiteness of, say, cirrus or wind clouds, or, at the other extreme, the dark values of massive stormheads, or the brilliant whiteness of the edges of clouds passing in front of the sun, is quite a problem. To look natural, the sky should not be too dark while the lightest parts of the clouds should not be of a shapeless, uniform whiteness (apart from the edges of backlit clouds, which can be recorded as pure white).

The problem is usually further complicated if a considerable amount of landscape is to be shown. This should not be represented in distorted grey values if your aim is a 'natural' rendering. It is impossible to give rules of thumb for these problems because the appearance of clouds (and their grey values, or brightness) is so variable. The best approach is, as already mentioned, a careful determination of exposure. This can only be done accurately if you use a spot meter with a very small angle of view (see Chapter 5).

When dealing with clouds, do not forget the landscape below! Even if you succeed in rendering cumulus clouds, for example, as full of light and opalescent, as they should be, the overall picture may still appear dull and flat if you have placed the exposure so that the shadows in the landscape itself are black or dead-looking.

To avoid this problem, work as follows. First, measure the exposure for the deepest shadows that are intended to show detail. Then determine the exposure for the clouds. Refer to Chapter 5, (page 52) to find out how you can fit the overall contrast within the contrast range of your film.

In order to preserve the luminous quality of the sky, do *not* use a filter stronger than light yellow— if you are aiming for a natural rendering. If your subject allows you to shoot at right angles to the sun and if you do not use a wide-angle lens, the best expedient could be a polarising screen. This will lower the grey value of the sky slightly without interfering noticeably with the shadow values.

Your confidence in handling clouds will grow with experience, but do not be led into developing a schematic approach! There are not only many different kinds of cloud, which look different at various times of the day (height of the sun) and at differing lighting angles, but each type of landscape also has its own typical cloud-formations.

I have already mentioned that similar cloud forms vary in their appearance over different kinds of landscape—defined visually by the distribution of light and shadowed areas. A cumulus cloud over a flat and featureless plain will often have a relatively smooth surface, while the same type of cloud is usually much more structured or 'bumpy' over irregular terrain. So each situation requires individual treatment. To sum up:

Three mistakes are often made in the treatment of clouds. The first is a sky that is too dark. The reason for this is either a filter which is too strong or an exposure which is too short.

The second mistake is a rendering of clouds which is too 'chalky' and formless. The reason for this is usually too short an exposure, or a very high placement of the exposure which favours the shadows and neglects lighter parts of the subject.

The third mistake is a too 'harsh' treatment of the clouds, meaning a rendering with over-dark shadows and over-white highlights, which makes the clouds appear too massive. This is due either to a filter that is too strong for the subject or to an exposure which is placed too low (ie. too long an exposure) combined with a wrong exposure on the print.

The best sort of guideline I can offer is to avoid these three mistakes. This is actually quite easy if you closely follow the advice given in Chapters 4 (films) and 5 (filters). Additionally, you might want to consider bracketing your exposures when you are in doubt. (However, this is to no avail if you spoil your efforts by careless or unsystematic darkroom work.)

Fog and haze

The perspective effect or feeling of depth and space in a panoramic view is largely due to the effect of atmospheric haze. The blue haziness of a distant view is caused by humidity, dust and/or air pollutants. The particle-laden air scatters blue wavelengths of light to a much greater extent than red, which penetrate it more easily.

This effect varies with the weather, the time of day, the altitude in mountainous regions and the proximity of industrial activity. It is most noticeable shortly after sunrise or before sunset, after a full day's output of industrial smoke and when you photograph with the sun behind you.

Haze has three very distinct effects on your picture. It weakens the shadows, that is, even if in the foreground the shadows appear very dark, they grow lighter and weaker with distance. The same applies to the highlights, although the weakening here is not as pronounced as with shadows. Obviously, both these effects occur simultaneously and reduce the contrast in those parts of the subject which are furthest away.

The third effect is the blue distance itself. In colour photography it takes the form of bluish-grey distances. In black-and-white prints, it is responsible for the lightening and greying of distant parts of the subject.

Haze appears in various quantities as explained above, but it is almost always there, even under otherwise very favourable weather conditions (and is then, for example, responsible for lack of contrast in pictures taken with lenses of very long focal length). But in mountain areas there are sometimes special weather conditions (such as the alpine wind) which allow you to see over immense distances—provided, of course, that you are at altitudes where the horizon is far enough away.

Under normal conditions if you want to improve the visual range you have to revert to the use of filters. In colour photography, apart from the UV

92 If fog or haze and snow occur together, the effect of simplifying subjects is taken to a maximum. This combination offers the best opportunity for working with subjects that do not lend themselves to photography under 'normal' conditions because of too much unwanted detail. I had often tried to photograph these trees growing in a small lake which, here, is frozen over. This combination of fog, ice and snow was needed to make the qualitities I had seen in this subject under different conditions, visible in a photograph. (17mm lens, 35mm camera, ASA 400 film)

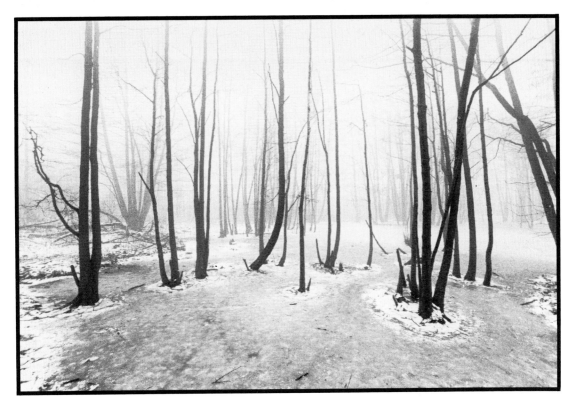

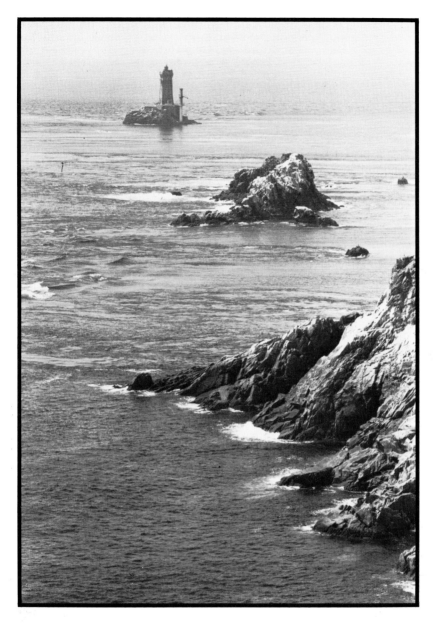

93 This long range view was taken with a 360mm lens on a 6 x 9cm view camera (ASA 400 film). It shows clearly that the effect of haze appears to be stronger in a photograph, the longer the focal length used. Looking at this picture it is hard to believe that this was to the unaided eye a perfectly clear summer day.

absorbing filter, you are restricted to using a polarising screen which slightly reduces haze. But in black-and-white you can work with strong orange or red filters. Unfortunately, however, they also affect the other parts of the subject as well so that a natural looking result is practically impossible to achieve. A red filter deepens shadows and darkens foliage, sky and water.

This is not the only reason that makes the application of filters in this context at least problematical. In most cases, aerial perspective improves a picture by giving an impression of space, distance and, with that, of size. Additionally, it often helps to separate objects that would otherwise appear as a solid and unstructured mass.

Suppose, for example, you were to take a picture of two mountain ridges, one behind the other. In the absence of haze they would probably look like a continuous slope; with haze they would appear distinctly separated. The closer one would be a darker grey than the one that was farther away.

Not only mountain ranges but all subjects which extend over a considerable distance are im-

proved by the presence of haze. It often provides the only clue or, at least, the most important one, for the viewer to form an impression of size and distance.

Occasionally, therefore, it is perhaps desirable to actually reinforce the effect of haze. This can be done with the help of a pale blue filter. It further reduces the amount of red light reaching the film, thus increasing the hazy effect.

When looking at old landscape photographs you may notice that they often show extremely hazy effects in distant views. The reason for this is simply that they have been taken with ortho-chromatic or even 'ordinary' films (ie. blue-sensitive) which are completely insensitive to red light. Today, you can achieve similar effects either with very strong blue filters or with ortho films mainly designed for workroom tasks such as document copying and probably available only in sheet film sizes and requiring special develop-ment to give continuous tone reproduction.

To summarise: by photographing shortly after sunrise or before sunset (especially the latter in industrial areas), by keeping the sun behind you and by using blue filters (or orthochromatic film), you can strengthen the aerial perspective effect in a picture.

Conversely, by working through the midday hours, by keeping the sun to one side of the camera position and by using polarising screens or orange or red filters, you can reduce the aerial perspective in a photograph.

All these points apply to haze but not to fog, although a weak ground-fog often looks very simi-lar to strong haze. The effect of fog cannot be influ-enced by the use of filters—at least, not to a noticeable degree. It is sometimes suggested that one should use a skylight filter. But this serves only to shift the colour balance slightly, which tends to be a bit on the bluish side in a 'foggy' scene. In my experience this does not usually enhance a picture because the bluish hue is accepted by the viewer as a natural part of a foggy scene.

Photographically speaking, fog is an opportun-ity not to be missed. First, it is an attractive subject in itself. Second, it enhances certain types of land-scape because it seems to belong there. This is not only true in an emotional sense (you feel, for example, that fog belongs especially to certain districts and particular times of the year) but also from a metereological standpoint. A landscape which feels as if it could make do with a good fog for an evocative effect seems to have this type of weather fairly often—or this is the impression I have.

The third, and in my opinion, the most important opportunity is that you can use fog as a 'composi-tional aid'. For example, if you have found a sub-ject like an imposing tree or another solitary ob-ject that you are unable to photograph in the way you want because of a disturbing background, you should try your luck in foggy weather. Taken with a wide-angle lens from a relatively close pos-ition the tree retains its grey value while the background either disappears in a uniform light grey or is, at least, greatly reduced.

Obviously, fog also changes the emotional effect of a subject to a considerable degree, so that this process is not always practical or approp-riate. But it is worth a try. Apart from this, fog al-ways 'simplifies' subjects, as does snow, by reduc-ing visible detail. Compositions with fog tend to be very simple, with few grey values. Parts of the subject which recede from the camera have the appearance of a backdrop.

Although the fog cannot be changed with filters (except by being added to uniformly with a 'fog' special effect screen) it can be to some extent al-tered by the combined effect of different focal lengths of lens and shooting distances. Where long focal lengths are used and the distance between the camera and the foreground is likely to be relatively long, the fog may become more apparent. Conversely, with a wide-angle lens where the shooting distance is more likely to be short, the fog probably does not affect the render-ing of the foreground at all. The illustrations show the application of this possibility quite clearly.

The contrast range of scenes shrouded in fog can be very short. If you want to stress the marked drop of grey values with distance this would call for low speed film. If you want to stress the gradual merging and blending effects of fog, a high speed film would usually be better. In any event, a very careful determination of exposure is called for because the grey values of foggy landscapes can differ widely from those prevailing under 'normal' conditions.

Snow and ice

In terms of picture composition, snow and ice can offer similar opportunities to fog. Although they do not affect the rendering of surfaces they 'simplify' the subjects by reducing the amount of detail. If the snow is very deep and covers everything, the whole landscape in a picture could be reduced to

curved shapes of relatively uniform grey values. Naturally, this offers ample opportunities for photographs that would not otherwise be possible—apart from the associations we make with snow and ice.

Technically speaking, snow creates some special problems. In colour slides snow often looks blue due to strong reflections from the sky. When looking directly at a landscape, we are not very aware of this effect. But in a photograph it may become very pronounced. If the subject consists of both shadows and directly lit areas you cannot use compensating filters because they would affect all areas uniformly, except those which are so overexposed that they do not register any density in the slide. You could perhaps compensate in printing by filtering selected areas. Or, if all of your subject is in shadow, you could filter in shooting or in printing. However, in my opinion, the bluish rendering of a scene usually heightens the feeling of coldness—an association that has, by tradition, become acceptable in pictures.

In black-and-white work, there can be another problem. Due to the whiteness of the snow the reflections may be very strong and therefore lead to weak shadows. A medium yellow or pale yellow filter would strengthen the contrast between the (blue) shadows and the sunlit areas. But you should not overdo it. To the viewer, snow always appears to be white irrespective of its real grey value. Therefore you should adjust your exposure to stress the brightness. This can sometimes be achieved better by a combination of underexposure and overdevelopment instead of using filters.

But be careful how you control your exposure. Many people tend to underexpose landscape with snow anyway. Exposure meters are designed to read for an average of mid-grey values. Snow is white. Left to its own devices, an automatic exposure system in a camera should therefore render snow as middle grey. With the resulting negative, processed normally, you have no hope of making an enlargement which shows the sparkle and brightness of snow. In a slide snow would appear a dirty blue-grey—and lifeless.

Vegetation in black-and-white

Usually, photographing scenery containing vegetation is a straightforward job. But when working with black-and-white materials you may run into some problems of a purely technical nature.

Although the spectral response (sensitivity to colour) of modern panchromatic film closely approaches that of the eye, there remain some differences, principally in the green part of the spectrum. While panchromatic film is generally less sensitive to green than to other colours, the eye is particularly sensitive to it. In photographs vegetation generally appears markedly dull and dark compared with our normal impression of it.

This effect is further aggravated by mistakes in exposure. Because of the dense structure of tree tops and shrubs the leaves present a mass of shadows which lead to further darkening with uncompensated general exposure readings. Moreover, the individual shadows and highlights are rather small (depending on the size of the leaves) so that spot metering, too, is difficult.

It is quite safe to assume that if you double the exposure indicated by an integration-to-grey reading taken only from the foliated area (of a whole tree-top, for example) you should arrive at an exposure which results in sufficient density on the negative to allow an approximately natural rendering of the foliage.

This, of course, affects the remainder of the picture which—if not also foliage—might, in consequence, become too light. In such cases the best remedy would be to use a very pale green filter. This should give a natural rendering of foliage while leaving the other parts of the subject relatively unchanged.

Another problem can be the combination of sky and foliage. Although blue and green appear very distinctly separate to the eye, under certain conditions their grey values may be very similar. A blue filter or a polarising screen could be used to darken the sky. But the blue filter would darken the foliage as well, while the polarising screen would remove the highlights on the leaves, giving the vegetation a dull and flat appearance.

It is not easy to find the best solution for each case, especially if you are not aiming for a natural rendering. But, here again, practice will help.

All of this assumes, of course, that you are trying to achieve the best results from the materials and that you attach some importance to precision in exposure rather than relying on the improved exposure tolerance of modern films and compensatory juggling with exposure in printing.

94 The simplification induced by snow and ice usually leads to very 'graphic' pictures. This effect can be either weakened or strengthened by the appropriate exposure and development combination. (21mm lens, 35mm camera, ASA 400 film)

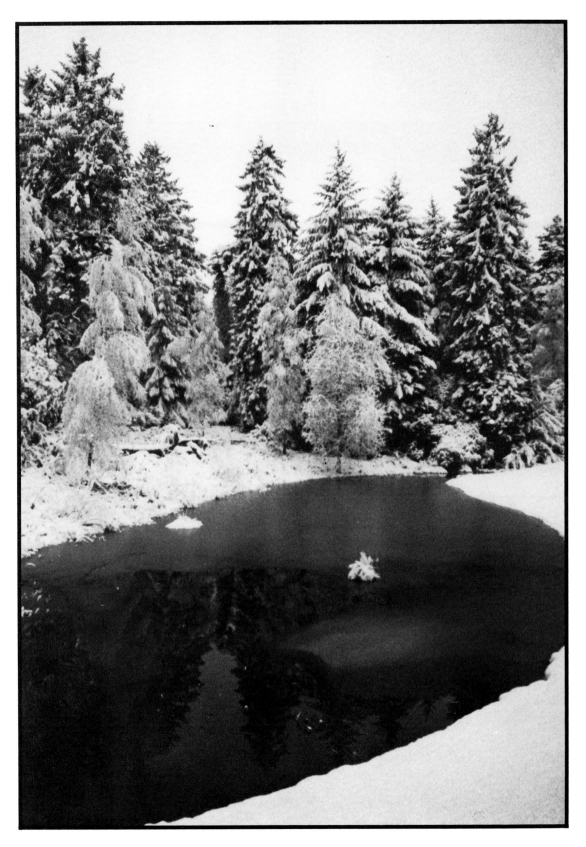

Mirror images

In landscape photography mirror images occur mostly in water, whether a puddle or a lake. In towns you also meet mirror images in windows and on metallic surfaces.

Reflections on metallic surfaces differ from the others in one respect. While you can reduce or even remove other reflections under certain conditions by using a polarising screen, reflections in metallic surfaces are not influenced at all. Apart from that, the following points apply to all types of reflection and reflecting surface.

The correct focusing distance for reflections is always the sum of the distance between the camera and the reflecting surface, and that between the surface and the reflected object. This permits you to apportion depth of field appropriately if you want to show the reflecting surface or its immediate surroundings (window frames, leaves on the surface of ponds, etc) *and* the reflection itself, both in focus.

Secondly, when determining the exposure for your picture you should take into account that under normal conditions (bright sky, etc) the reflections in water are likely to be about two stops darker than the reflected object itself. Mirror images in glass or metallic surfaces vary greatly in brightness so that no useful guidance can be given.

The third point concerns the use of a polarising screen to remove reflections. Not only may the removal of reflections result in dull and lifeless surfaces, as noted, but water may even become 'invisible'. We normally perceive it by the reflections and highlights seen in its surface or objects floating on it. So a polarising screen must be used with caution. This screen has a constant filter factor, irrespective of its rotational position. If placed in front of the lens and rotated, the exposure indicated by a TTL meter will vary according to the suppression of highlights and reflections, not because of a change in filter density. With slides, for example, for which exact exposure may be critical, it is normally best to use the polarising screen with the recommended constant filter factor rather than by following the meter.

You can influence the positioning and the relative size of reflections by adjusting your viewpoint and focusing distance, or by changing the focal length.

95 Mirror images of all kinds are of special interest because they can change and 'break up' reality in very surprising ways. Technically, the main problem is usually depth of field because the most interesting results usually require both the reflection and the reflecting surface to be in focus. Even the movements of a view camera do not help here because the planes of reflection and subject and reflecting surface are usually perpendicular to each other. This often calls for the use of extreme wide-angle lenses, which can add to the surrealistic effect overall by their distended images. Here, a standard lens could be used, because reflection and reflected object were very close together (90mm lens, 6 x 7cm camera, ASA 400 film)

96 Another type of mirror image. The vase was in the room behind the window pane, while the trees and clouds were mirrored in the glass. There was no manipulation of any kind. The problem with this type of subject is the choice of viewpoint. In my opinion the picture would have been improved by a viewpoint square-on to the window. But this was not possible because in the actual situation no mirror image would then have been visible. It is often worthwhile looking for mirror images; they are generally visible from only a few viewpoints. (90mm lens, 6 x 9 cm camera, ASA 400 film)

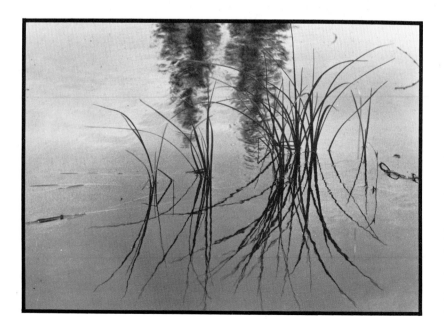

10 LIGHT AND LANDSCAPE

If I were to name just one attribute that influences our perception of landscape, I would probably single out light as the most important. Light changes with the weather, the time of day and the seasons. If you have ever followed the changes in your response to a landscape with the changing light you will probably agree.

Many people regard light as no more than a commodity of which they need a certain minimum in order to take pictures.

With the right kind of equipment, however, you can photograph under all lighting conditions, even at the dead of night.

So the actual quantity of light available to you should be immaterial. What you should really be concerned with is the *quality* of the light, its influence on the way you see the landscape, its part in the transformation of landscape into a photograph and, finally, the impression it makes on someone looking at it.

Times of day

The poets have it that the sun rises fresh and clear, or words to this effect. Dawn is, indeed, the time of the day when the outdoor subject can sparkle with light refracted in dewdrops and reflected from moist surfaces, and where the colours of nature seem to gain strength. Although perhaps thought of as a psychological effect it is, at least partly, real. Dust and soot, which reduce the brilliance and clarity of colours, are washed away by the condensed humidity. Unfortunately, the humidity quickly evaporates even under a very weak sun, so you have to get up very early if you want to take advantage of this phenomenon.

In very flat terrain, the first half hour or so after sunrise shares another advantage with the same period before sunset. The low angle of incidence of the sun makes for extremely long shadows, picking out even miniscule variations in surfaces, so that parts of the country that appear absolutely flat for most of the day reveal clearly defined contours. This can add considerable interest to subjects which you would otherwise consider dull and unattractive.

Some people believe when comparing dawn and dusk that there is a difference in the quality of the shadows. Shadows at dawn are said to be clear-cut and crisp, at dusk, of a more diffuse and 'creeping' variety. If so, the clarity of the morning

air compared with evening might account for it.

Morning and afternoon are very much alike in many respects, although very perceptive observers will notice a difference that cannot be entirely put down to an emotional response. In many countryside areas, particularly those adjacent to towns, as the air becomes charged with dust and air-pollutants during the course of the day two changes occur that are photographically relevant. The refraction of the light in the atmosphere alters, causing a slight shift towards the red during the afternoon. Also, surfaces become covered with various kinds of deposit and thus gradually lose the 'freshness' just described. In other respects, however, morning and afternoon offer the same photographic opportunities, except, of course, that shadows come from a different direction which may or may not suit the purpose.

Midday is often supposed to be a bad time for taking pictures due to the shortness or even the absence of shadows. This notion is examined later, but suffice it to say at this point that I know of no reason to stop taking pictures in the hours around noon.

However, you may run into special problems caused by the glare of the light, particularly in equatorial regions. The contrasts between directly lit and shaded areas can be so extreme as to be beyond the range of the film.

Although many of the things discussed here belong in the realm of cold fact, others differ in that they relate to subtle and probably often subconscious reactions. These influence our state of mind and, to some extent, our relationship with the landscape.

Direction of the light

When you started to learn about taking pictures you might have been told by some kindly soul to always keep the sun behind your back. This can,

97 I frequently take pictures against the light. One reason is that this type of lighting is so often avoided by photographers that it is a relatively unworn technique and pictures using it gain strength from its unfamiliarity. Additionally, its distribution of shadows and highlights gives a mood that fits well with what I want to express in my pictures. The composition of this photograph, for example, depends on the distribution of black areas in the picture plane, which would have been impossible in any other kind of lighting. (21mm lens, 35mm camera, ASA 400 film)

indeed, help to produce usable pictures, but you probably soon shed this restriction with growing confidence in your abilities. There is, in fact, no lighting situation that an experienced photographer could not handle.

Against the light (contre-jour)

If the sun or another light source is positioned directly behind your subject, the contrast is at a maximum and the subject appears as a silhouette. As only the outlines of the subject contribute to your picture, backlighting works best with subjects of intriguing and complex shapes. Good examples are trees (preferably without leaves) or pylons. Equally effective are 'hairy' outlines in the

picture, provided by people, animals and plants, for example. These shining 'haloes' are very effective.

When shooting in colour your should remember that there will be no appreciable colour visible in the subject itself as it is predominantly black. So the impact of the picture depends on the shape of the silhouetted subject and the colour of the background, eg. intense blue sky, sunset etc.

Off-centre back light

In this situation the light still falls towards the camera, but from either the left of right or from above the scene. The light source is usually outside the picture area.

98 A very interesting combination is the noonday sun with a slightly overcast sky; in such lighting subjects can appear almost shadowless, but very luminous. In order to make the most of this the exposure must be determined very carefully for the mid-tone values and so extend the grey scale as far as possible. (150mm lens, 6 x 7cm camera, ASA 400 film)

99 It is, of course, simpler to incorporate the sun directly into the field of view. Here I positioned it immediately atop this bent pole, so that the flare effect and the subject appear united. This technique is unsuitable for cloth-shuttered non-reflex cameras, or those with non-instant return mirrors. (55mm lens, 6 x 7 camera, ASA 400 film)

The most important aspect of this lighting is that the shadows fall towards the camera. Secondly, there are no highlights because they are, in effect, on the back of the subject.

As you can see in the diagram, the proportion of light and dark areas may be the same for off-centre back light and off-centre front light. But due to the direction of the shadows and the absence of highlights the character of the picture is very different.

Generally speaking, the more sombre and murky effects of a landscape are stressed if you photograph it against the light (with off-centre back light), whereas it tends to look more friendly, open and inviting taken with off-centre front light.

Very interesting effects can be achieved by photographing semi-transparent or translucent subjects against the light. Leaves, for example, seem to glow as the light shines through them. This transmitted light effect is even more spectacular if the source is outside the picture because you can choose a viewpoint where the subject is seen in front of a dark or black background. In this case, exposure must be determined for the leaves, not for the background. A close-up reading from a leaf would be the most reliable.

Off-centre front light

The main effect of this kind of lighting has already been mentioned in the comparison above. While

100 Very low light not only creates interesting shadows, it also enhances the surface structure of your subject. Here, this effect was used to show a highly detailed surface amid very dark surroundings which, nevertheless, shows all the detail in the original print.

This contrast between the bold and simple effect the viewer sees at first glance, and the very detailed rendering revealed when looking closer, lends interest to this otherwise more or less conventional subject. (90mm lens, 6 x 6 camera, ASA 100 film)

101 The intensity of shadows depends not only on the light but also on the surface colour on to which the shadow is thrown. In this example the shadows are almost invisible despite the extremely strong light because the ground consists

of black sand – a phenomenon found in the Canary Islands and some other places which owe their origin to volcanic activity, I am told. (17mm lens, 35mm camera, ASA 100 film.)

102 If you know exactly the relationship between the dimensions of your camera viewfinder and the negative size, you can arrange effects like these. The ray of light in this photograph is not due to darkroom manipulation. It was simply created by placing the sun just outside the field of view, so that it 'peeked' into the picture frame. Alignment of the camera must be very exact to be sure of such an effect. (49mm lens, 6 x 9 camera, ASA 400 film)

the other kinds of lighting require some special attention when determining exposure, this should pose few problems.

This is the most often used and therefore accepted as the 'normal' lighting. Unless it has some other unusual property, it neither adds nor detracts from the impact of the picture. However, you can introduce some interesting variations by your treatment of the shadows.

Axial lighting

Axial lighting is used only very seldom because if the sun is directly behind you, your own shadow becomes a prominent part of the picture.

Nevertheless, this type of lighting can be very interesting, if you cheat slightly by using a relatively long focal length lens and move slightly out of line with the sun so that you just exclude your shadow.

If you photograph single objects on relatively smooth and even surfaces (like single stones on sand, a nude figure on the beach, or objects found there) they seem almost to float in front of the background. This effect is due to the absence of shadows, which usually connect the main subject to the background.

Although you are dependent on the time of day, the seasons and suitable alignment or 'direction' of the subject, you can still influence the lighting by changing your viewpoint—assuming that the subject allows this. A single tree in a meadow might, for example, appear similar when photographed from all four points of the compass. However, it would be a very good subject for testing the influence of light direction on your picture.

Importance of shadows

With changes in the direction of the light come changes in the shadows. One might suppose that the length and direction of the shadows simply depends on the position of the sun and that is an end to the matter. However, you have other means of influencing the rendering of shadows. When using wide-angle lenses of extremely short focal length, you can create bird's-eye or worm's-eye views simply by tilting the camera upwards and downwards, with accompanying changes in perspective impression. In Chapter 5 we saw that when the camera is not held vertically, all parallel lines are represented as either converging or diverging. This also applies to shadows. You can either increase or diminish the importance of the shadows by tilting the camera accordingly. This works best with *very* short focal lengths, such as 15-20mm on 35mm format. Pictures **10** and **103** are typical examples of this technique.

By representing the shadows either as converging or diverging, not only can you make them larger or smaller in relation to picture size, but you can also make them look longer or shorter by using different lenses.

The effect by which long focal length lenses seem to shorten and short focal length lenses lengthen the distances between objects can also apply to shadows. Telephoto lenses foreshorten the shadows, while wide-angle lenses make them seem longer than they actually are.

It is often said that midday is not a good time to take pictures because the shadows are too small or even completely invisible. Perhaps the reason for this advice is that the shadows not only influence the picture in the ways already mentioned

but also provide a considerable part of the spatial impression. They give roundness to tree trunks, they shape and model an expanse of ground, they pick out variations in surfaces, thus revealing textures and structures which would otherwise remain invisible. They emphasise spatial relations between objects and often fill otherwise empty, and therefore, uninteresting, spaces.

In the absence of shadows none of these things happen. Nevertheless, there are occasions when you might not want shadows at all, or where you want to reduce them. In such cases it would be sensible to photograph at midday or under an overcast sky. For instance, you may want to give an overall impression without showing too much surface detail (texture) or to stress the flatness and lifelessness of a scene, or simply to reduce contrast.

In the landscape itself smaller shadows usually look black or, at least, much darker than larger ones. One reason for this is that short shadows are created by a high sun which also means an increase in brightness and, with that, in contrast. Another reason is that the eye has more difficulty in adapting to smaller shadows.

The latter, of course, does not carry over to your prints, where small shadows may simply look darker or even black because you have misjudged the exposure required.

Other ways of influencing the intensity of shadows (in the print) have already been mentioned. You can, for example, use fill-in flash or reflecting surfaces to lighten shadows. With black and white work you can influence the relative density of shadows by filtration. A blue filter over the camera lens can even lighten the shadows in relation to directly-lit areas where the shadows contain significant reflected blue light (eg. from a clear blue sky). An orange or red filter would darken such shadows in relation to directly sunlit areas.

Another way is to adjust the exposure or processing according to your intentions and/or use films with differing contrast characteristics.

These represent a wide variety of 'tools' with which to handle shadows according to your pictorial ideas. Unfortunately, no photographic device can create shadows which are not there (apart from artificial lighting) so sometimes the only way out is to wait for a change in the lighting conditions—not because you need more light, which you could, after all, simulate with longer exposures, but because you need more shadows.

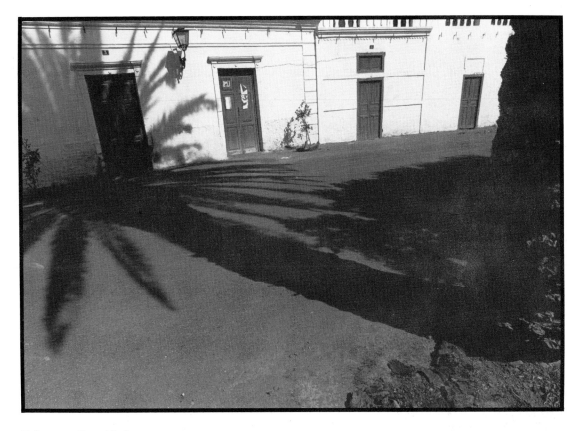

Colour quality of light

Besides the normal spectral differences between light of different wavelengths, the photographer has to cope with the fact that the light by which he normally works can vary in 'warmth' between extremes to which colour film is very sensitive, even though they are not apparent to the eye. To obtain a natural-looking rendering, corrections sometimes need to be made in order to 'balance' the prevailing light with the colour response and reproduction capabilities of the film.

The expression used to describe these differences in the quality of light is 'colour temperature' and it is measured on a scale of Kelvin (K) units or Kelvins (a method of assessment based on the heating of a theoretical body until it radiates light of a particular quality). On this scale, normal white daylight is nominally 5500K. Lower numbers indicate more yellowish or reddish light, while higher numbers signify bluer light.

Colour temperature characteristics are indicated on colour film packing and data sheets. Films of about 5500K to 5900K are intended for use with daylight and flash illumination. Films for 3200K to 3500K are designed to be used with

103–104 The importance of shadows in forming a picture: In the first, **103**, the object casting the shadow is invisible because it is outside the frame. In **104**, almost the whole scene is in shadow, pierced only by a shaft of sunlight. (**103**, 17mm lens, 35mm camera, ASA 100 film. **104**, similar, but 100mm lens)

photo lamps, and for daylight would need heavy filtration (85B) and suitable increase in exposure.

We believe when we look at it that daylight is white and that white objects seen by it are also white. A white object (for example, the wall of a white house) still looks white to us under most lighting conditions because our eyes adapt very easily to changes in the colour temperature of light and also because we associate certain colours with certain objects.

Colour films are more sensitive to variations in colour temperature than is the human eye. Even the slight changes with the time of day (height of the sun) and with the amount of cloud, fog, haze or smog are quite clearly visible in a colour slide.

The problem is further complicated by reflections. In woodlands, for example, there is often a greenish hue due to the colour of the foliage pervading all parts of the subject. A meadow can cast

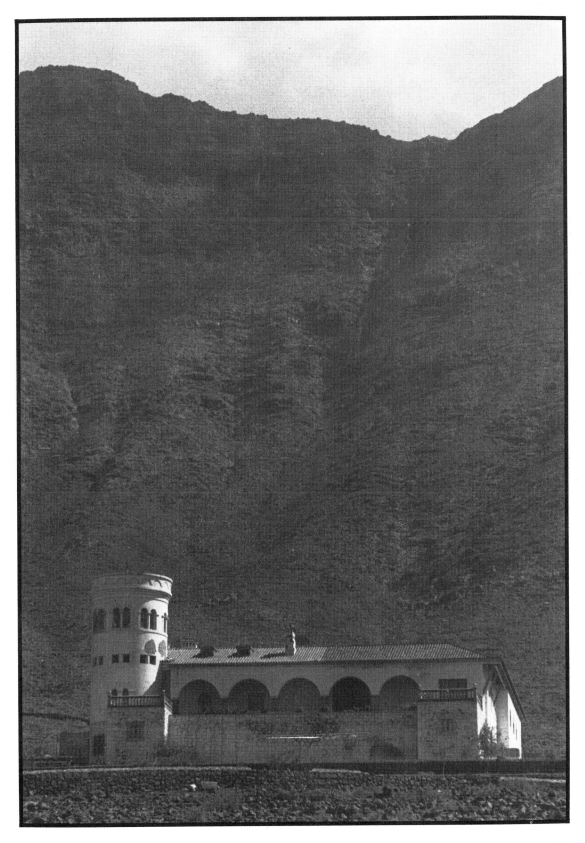

a green hue on the walls of a white building or, conversely, strongly coloured buildings can produce strange reflections in the surrounding vegetation. Generally speaking, all strongly or uniformly coloured objects, provided they are relatively large and situated in direct sunlight, are likely to influence the colour of their surroundings.

It is, of course, possible to use suitable colour correction (CC) filters to re-balance the light to suit the film. However, in my opinion, this is not a constructive approach. The impact of a subject can depend significantly on the kind of lighting present and if you were to totally alter that with filters, the result would be to produce rather uniform pictures. The lighting would always be the same whether taken by the warm glow of a sunset or in the bluish hues of a slight fog.

It is, admittedly, a matter of degree. A marginal correction towards realism is not the same thing as total elimination of the natural effect. Aside from this, however, for certain documentary purposes, total 'correction' of colours might be very suitable.

Problems posed by the reflections from coloured surfaces are impossible to control with filters. Under carefully monitored studio conditions colour temperature can be measured and appropriate correction filters selected. But with natural light this is entirely out of the question because it is composed of many different hues and is subject to constant change.

In my view it is best to ignore all this completely and to take the colour of the landscape at its face value. It is not the job of the creative landscape photographer to find a neutral and statistically significant way to render subjects, but to make pictures from the material which he or she finds there. So changes in colour temperature should be regarded as providing welcome opportunities for individual expression with great force and not as disturbing elements.

Colour casts

Having said that, now for the exception. If you photograph a relatively small section of a landscape which is very close to a large reflecting surface, strange and unacceptable hues might be visible. The classic example is a portrait in a landscape where the face looks distinctly green or bluish, depending on the location.

You cannot use colour correction filters so a possible solution is to also show at least some portion of the reflecting surface, which is causing the colour cast. Then the unnatural reflection would

suddenly appear quite natural.

This, of course, applies to other situations. If you photograph a subject in, say, the light of a sunset, it may look strange or unnatural. But if your photograph gives a clue to the lighting situation (either by showing the sunset itself or the length of the shadow) a person looking at the picture accepts the changes in the colours as normal and self-evident.

Conversely, you could create interesting effects by photographing subjects under conditions which introduce colour shifts, while concealing the source of, or the reason for, these shifts. While coloured filters, which are occasionally used for certain effects in photography affect the whole of your subject, including the background, this process is more subtle and would affect only parts of your subject, leaving the viewer mystified.

Sunsets

Sunsets are often very spectacular and therefore not easy to miss. Consequently, many 'serious' photographers avoid them. Without evaluating this attitude in any way, I must admit that I rather like sunsets. They obviously move and/or interest many people emotionally and I think that this is more than enough reason to try your luck with them, the challenge being to realise the photograph in a personal and convincing way.

This really *is* a challenge, because it seems next to impossible to avoid the numerous clichés clinging to the concept of sunsets.

Although it is difficult to overlook sunsets as subject matter, it is often left purely to chance whether or not you happen to be at a place which offers an interesting setting for the sunset. If you really want to approach the subject seriously, you can determine the best time and place for the sunset (and likewise for a sunrise) using very accurate maps and an ephemeris or a nautical almanac and by doing some calculations. Done properly, it is possible to find the correct point for setting up

105 Many people are afraid of sunset pictures and dismiss them as 'kitsch'. I do not agree. I suspect that these people are simply afraid of their emotions. So don't hesitate to take sunsets if you are really impressed by them, as I am. But do them well! They are a bit tricky as far as the exposure is concerned. If you are aiming for a more or less conventional rendering you should measure a spot in the sky about one thumbs' width distant from the sun and also a shadow close by. You can then slightly favour the lighter or darker parts by your exposure, depending on the effect you have in mind. (150mm lens on 6 x 7cm camera, ASA 400 film)

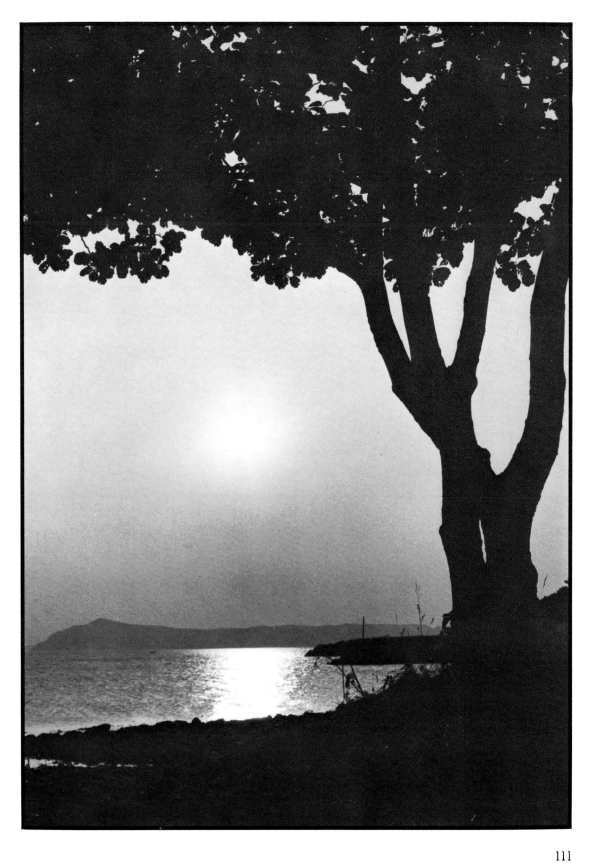

your camera with great exactitude. But unless you have a specific job to do, this procedure is not only too complicated, it also takes the fun out of it.

If you are simply out to get a sunset, a pocket diary will tell you at what time you should be on the alert and a compass will indicate the general direction in which to expect it. (This can, instead, be determined by mentally extending the path of the sun to the spot where it bisects the horizon.)

Which lens should you use? On the one hand it can be very interesting to use an extreme wide-angle lens in order to display a panorama of clouds with the sinking sun beyond. This reduces the sun to a near-pinpoint of light and is therefore usually best for scenes where the sun itself is actually hidden behind a cloud.

On the other hand it might be your aim to use a long focal length lens in order to show the sun as large as possible behind some compositionally interesting scenic detail. The question then is: how large should the sun be in the picture? This might, of course, depend on the amount by which a print is enlarged. But there is quite a good ground rule for determining the size of the sun on the negative or slide:

$$\text{Diameter of image (mm)} = \frac{\text{focal length of lens (mm)}}{100}$$

This means that the image of the sun on your slide or negative has a diameter of 5mm if you use a 500mm lens. (These are only approximate values, but they are sufficiently precise for all practical purposes.) This is the absolute size of the image, irrespective of the negative size used. So you should use a 35mm camera for your sunset pictures if you want to achieve a relatively large image of the sun.

Finally, a word of warning. Very shortly before the sun sets, its rays are very weak and cannot possibly harm you or your equipment. At any other time however, you should avoid looking directly into the sun or pointing your exposure meter at it. If you have an old non-SLR camera which has a shutter curtain made of cloth the sun could easily burn holes in it if you include the sun in your angle of view. Modern metal shutters are not affected.

Returning briefly to the subject of colour correction filters, it is true that the setting sun gives a very reddish or orange light and that you could achieve a 'normal' rendering by using either 80C or 80B filters or a film for artificial light (3200-3600K) without any filters. But what would a sunset be without its special, and spectacular colours?

The moon and photography at night

What exactly is the difference between a night and a daytime photograph? Couldn't you simply expose a night photograph so that it looks as if it has been taken during the day, and vice versa? In principle, with a few practical reservations, you could do just this. Therefore we have to try to find a difference which can be represented photographically. (Remember, here we are discussing photography without artificial light sources. If there are streetlights and related sources in your picture, the problem does not exist!)

The difference is actually fairly simple. During the day, you can discern details and structure in all parts of a scene, even in the deepest shadow, because the eye can adapt to the level of illumination over an extremely wide range. But at night the limits of this adaptability are reached. Even in bright moonlight, illumination is so weak that they appear an inky black. So you should calculate the exposure of your night photograph so that this effect is imitated in the finished print.

Another difference lies in the reflections and highlights created by the moon. Despite the general darkness prevailing in the final picture, these should appear as pure white if you want to achieve a convincing effect.

If the moon itself is to be incorporated into the photograph you have to take two things into account. The first is the size of the moon's image. Here, you can use the same formula as that given for the sun.

$$\text{Diameter of image (mm)} = \frac{\text{focal length of lens (mm)}}{100}$$

106 One may frequently see a most beautiful sunset without any remarkable foreground or background. Or, one sees a subject that would be ideal for a sunset – but the sun goes down elsewhere. Taking a sunset without everything being just perfect usually achieves very little. It only adds another picture to the multitude of sunset photographs that already exist. Finding a really unusual situation might happen only once in a lifetime. (200mm lens, 35mm camera, ASA 200 film)

107 Sometimes a whole day of bad weather can end with a spectacular sunset. As the sun goes down it sometimes just peeks through under the canopy of clouds before sinking from view. In many localities this happens only rarely, but it is well worth watching for. Only then do you get the kind of effect where the whole sky seems on fire. (150mm lens, 35mm camera, ASA 64 film)

112

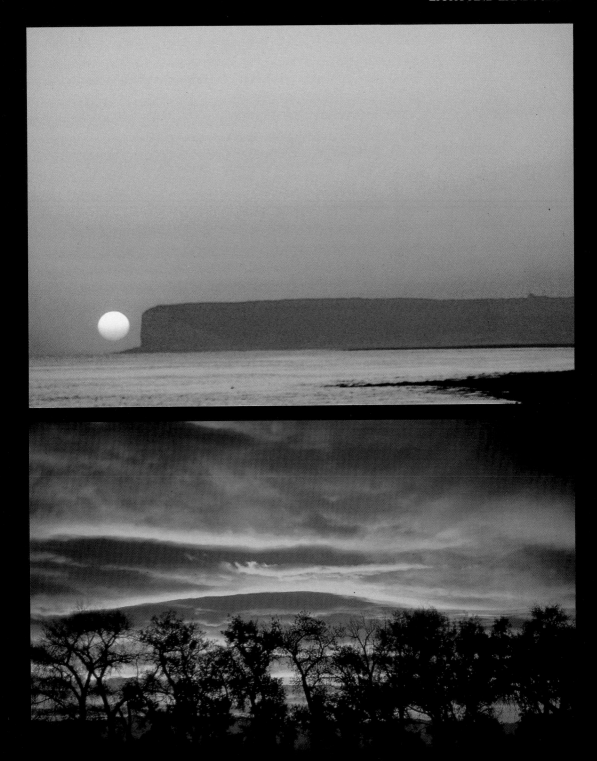

The second is the exposure time. With over-long exposure times the moon will appear blurred due to the rotation of the earth. This motion is surprisingly rapid.

There is a 'rule' for this as well.

$$\begin{array}{l}\text{Longest} \\ \text{possible exp.} \\ \text{time}\end{array} = \dfrac{1}{\text{diameter of image (mm)}}$$

The first formula tells you that with a 500mm lens you will have an image diameter of 5mm. According to the second formula, the longest possible exposure time for a sharp rendering of the moon with this lens would be 1/5 sec. (Properly speaking, this formula applies only to 35mm cameras. With larger formats, the times would be slightly longer. But you will always be on the safe side if you stick to it, irrespective of the negative size used.)

To get the short exposure times needed you may be forced to use very fast films. Apart from this, slow films are often better for night photography.

When taking pictures at night (again, without artificial light sources) you may notice that contrast can be very feeble. We have seen in an earlier chapter that it is then advantageous to use slow films, because they generally have greater contrast. As long as the moon itself is not to be incorporated into the picture, the longer exposure times should not deter you from using slow films because you need a sturdy tripod in any case.

On the other hand this can easily lead to another problem. If the air is not completely still, leaves, twigs, and small plants may be blurred.

Nevertheless, it could be interesting to include at least a slight amount of blur. In a faint breeze the trunks and larger branches of trees do not move, while the twigs and leaves do—an interesting pictorial effect.

Long exposure compensation

Films do not react to long exposure times in the same way as they do to short ones. For exposure times greater than one second, the amount of light reaching the film does not have an equivalent effect. The result is often to cause underexposure and poor colour rendering. Generally, fast films are more prone to the problem than slow films and require greater compensation in exposure. Exact, recommended figures can be found in the data sheets provided by film manufacturers. While the compensation needed varies with different films an approximate working method would be to increase exposure by ½ to 1 stop with slow/medium speed films and exposures between 1 and 10 sec, and 1 stop for exposures longer than 10 sec. With fast film 1 stop increase is called for with exposures longer than 1 sec and 1½ stops for exposures longer than 10 seconds.

In practice I have found that really long exposure times (20 sec or longer) in the context of night photography really do need exposure adjustment while shorter ones (approx 2-3 sec to 20 sec) result in a slight underexposure which often adds to the night-like appearance of the picture. The reason for this has already been explained. Underexposure results in black shadows which enhance the night effect. Underexposure due to long exposure times causes a breakdown in the exact reciprocal relationship between shutter speed and aperture and the resulting reciprocity law failure will, more often than not in practice, automatically 'adjust' the exposure so that you do not have to do so yourself to achieve night-like effects.

Artificial lighting: streetlamps

Artificial lighting in landscape or townscape scenes can include not only streetlamps, but neon-advertising, lighted buildings (as in son et lumière) the illumination provided by shop windows, the headlights of passing cars and other sources.

During the day this type of lighting does not pose any problems: any kind of artificial lighting is very weak compared to daylight. At night, however, the contrast between the light sources themselves, which are usually included in the picture, and the shadow areas of the subject can be very great.

The easiest solution to this kind of problem is not to take pictures at night, that is, when it is completely dark, but at dusk or dawn. Depending on the effect you want to achieve, the best times are when natural and artificial light are at about equal strength, or when the daylight is slightly weaker.

108 In most cases photographs showing the moon are the more interesting the longer the focal length of lens used. Here it was a 250mm lens (on a 6 x 7 camera), yielding a relatively small image of the pylon. The problem is that you often cannot use longer focal length lenses, because the foreground does not permit it. In this instance a longer lens would not have shown the structure in the foreground, which is essential to the picture. (250mm lens, 6 x 7 camera, ASA 400 film)

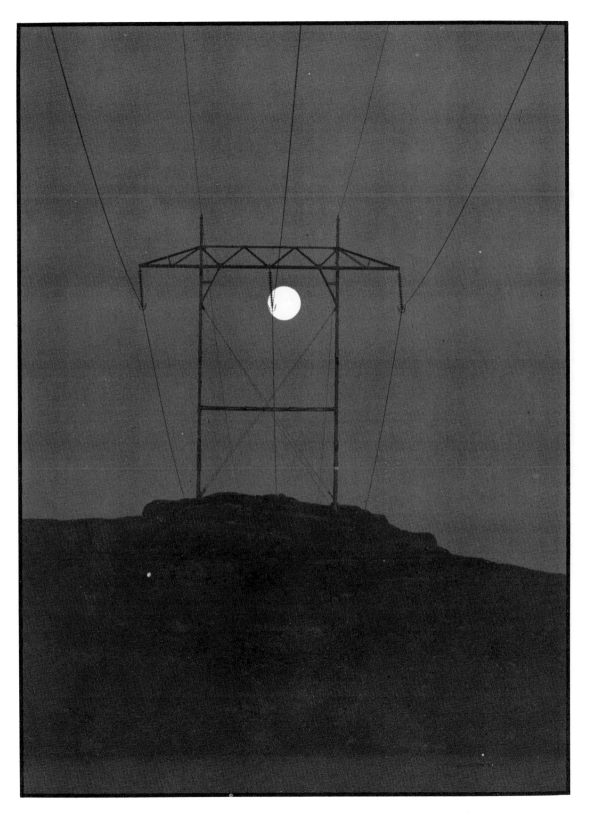

109 Under certain weather conditions and at different times of day the colour content of daylight can shift to a considerable extent. If no filter 'correction' is used this bias can be exploited for pictorial effect. Artificial tungsten lighting adds a spot of warmth to the bluish daylight seen here. (200mm lens, 35mm camera, ASA 200 film)

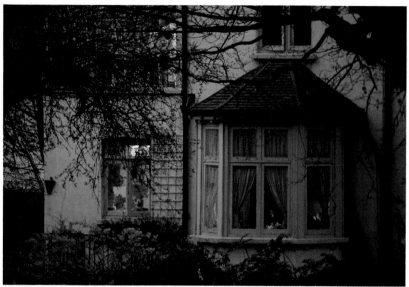

111 A regular formation of tree trunks in this Norwegian wood formed a clear pattern of verticals. But what chiefly attracted me to this spot was the harmony of colours between the trees and the woodland floor – separated by the silvery bark on the lower portions of the trunks (90mm lens, 35mm camera, ASA 100 film)

112 It may be hard to believe, but I did not place the broken chair there – I found it exactly as it was when I went to the beach to check for interesting sunset pictures (which I do routinely when at the seaside). I took a whole roll of film for this subject because I had envisaged a number of different effects – a vertical format for a title page, one having it as an almost unidentifiable, disturbing object in the background and so on. If you have to economise with your films, then in my opinion it is better to work in this way with a really promising subject than to have just one shot each of more or less mediocre ones. (17mm lens, 35mm camera, ASA 100 film)

110 The light source in this photograph is concealed by the tree trunk in the foreground and you can guess its position only by the diverging shadows on the grass. This, and the fact that the objects casting these shadows are rendered invisible by exclusion from the picture area give the picture a slightly puzzling quality. (80mm lens, 6 x 6cm camera, ASA 64 film)

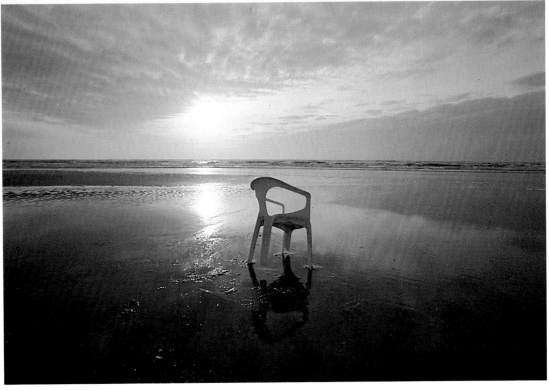

In contrast to the requirements for photographing at night *without* light sources, a high speed film would be your best choice, because it is better suited to the rendering of strong contrast.

You cannot (or rather, *should* not) use an automatic exposure system or a normal integrated meter reading because the presence of light sources would be grossly misleading. You might, however, sometimes want pictures with predominantly black areas and only light sources—highlights and reflections—showing. (This can be very effective on wet days, when streetlamps and neon-advertising are mirrored in the road and other surfaces.) This is the effect you get if you rely entirely on an automatic exposure system or simple direct readings with other meters.

For colour work you have a choice between daylight and tungsten-balanced film. With mixed light (daylight and tungsten, or tungsten and neon or fluorescent tube) daylight-balanced film gives slightly more natural-looking colours.

When tungsten light prevails, the obvious choice seems to be the appropriate film if you are aiming for natural looking colours. But be careful. Tungsten light *is* decidedly yellowish and it is at least debatable what should be regarded as natural in this context because the character of the light source is part of the subject! I always use daylight-balanced film for artificially lit landscapes because it best demonstrates the artificial quality of the lighting. However, this is a question of taste and objectives and therefore a matter for the individual.

Artificial light: flash

The other type of lighting used in landscape photography is introduced by the photographer himself. The most common form is fill-in flash, which is used to lighten shadows or to reduce constrast.

In days gone by photographers used large sheets of metal foil or plain white cardboard to achieve this effect. Nowadays everyone owns a flashgun and employs this for the same purpose but, alas, not always with the same degree of success. It is difficult to judge how flash will affect a photograph whereas it is quite easy to control the effect of reflected sunlight.

Do not misunderstand me. It is easy to use fill-in flash in a technically perfect way, because computerised flash units do most of the work for you. The problem is knowing in advance how the fill-in light will change the *emotional* quality of your scene, which is much more important.

That is why I never use flash for fill-in purposes. If I do employ fill light at all (to be honest, only in close-up work) I use a sheet of aluminium foil—glued to strong cardboard and folded like a map so that it slips easily into a pocket. You can buy this kind of thing or make it yourself. In my opinion, it is not only better but also smaller, lighter and less expensive than a useful flash unit.

But in most cases I prefer to work by carefully determining the exposure and by occasionally adjusting the development of the film (Chapter 4). But again, this is a question of temperament and you should try all methods in order to decide which works best for you.

Quite a different application of flash is to illuminate a subject or parts of a subject at night. This is a highly fascinating field for experimentation because those properties of flash illumination that are usually considered to be a disadvantage can be turned to good account for compositional control. Just two possibilities are as follows:

Some flashguns have a narrow angle of illumination or attachments are available with which you can achieve the same effect. If you combine such a flashgun or attachment with a standard lens or, even better, with a wide-angle lens, you can illuminate parts of your subject selectively, leaving others dark. If this type of flashgun or attachment is not available you can simply use a tube made from a roll of white cardboard fastened to the front window of your flashgun with adhesive tape. Although the light output is thereby greatly reduced, this works quite well.

This method gives you very impressive results if you work at dawn or dusk. The whole subject is then dimly discernible while the lit part stands out as if it were self-illuminated.

Another possibility would be to make use of the strong fall-off in flash illumination with distance. If you photograph in the dark, you can thus isolate parts of your subject from the background. The background would be entirely black, while the foreground (or the illuminated parts in general) show normal grey values or colours.

The main problem of this type of experiment is in determining the exposure. You cannot use computerised flash, so you have to switch off the automatic facility and calculate the f-numbers. Exposures can be bracketed starting from this point. You usually need one or two stops extra.

Although I am usually averse to juggling around with mere effects, I do recommend experiments

with this one. If nothing else, it will tell you much about the feelings evoked by different qualities of light and lighting.

Weather and the emotional qualities in landscape

It is a platitude to say that people are influenced by the weather. But this depends only partially on the direct physical influences of air pressure, humidity and so on. Another part is due to our emotional responses to visual qualities.

Some people are inclined to confine their photographic activity to sunny and warm weather when it is undoubtedly pleasant to be outdoors. Although quite understandable, in many climates this restriction makes really impressive landscape photography close to impossible. The landscape (or to be more precise, its emotional effect on us) changes with the weather and to concentrate on good weather is like trying to play music on the piano using only the lowest twelve black keys.

There is no such thing as bad weather for photography—there are only hydrophobic photographers. It would certainly be going too far to say that sunny, pleasant weather creates idyllic run-of-the-mill photographs, while bad weather makes for interesting, out-of-the-ordinary ones. (Some people have little choice!) Nevertheless, there is a *grain* of truth in this if only because a majority of people prefer good weather and we are most accustomed to pictures with this type of emotional quality.

Bad weather and its photographic problems

Depending on where you live, dull weather may be a dominant part of your daily life. Downright bad weather (like a storm) can be interesting photographically, because it has very marked and easily recognisable characteristics. But even quite normal dull weather can be turned to advantage, photographically.

When using black-and-white film, the main problem is that the absence of sunshine results in low contrast. Usually this does not matter as long as the adverse weather conditions (fog, haze, rain or snow) become apparent in the picture, because the viewer then subconsciously expects to see low contrast.

If the bad weather simply manifests itself in a completely overcast sky, the problem is much more difficult because the scene then lacks sparkle and depth (usually described as highlights and deep shadows)—although the *cause*

may not be immediately apparent or visible in the photograph.

An easy solution to this problem would be not to use black-and-white film but colour. But this is an evasion of the problem rather than a solution.

Consider instead the following suggestions. Low speed film generally has higher contrast than high speed film and is therefore very useful as an all-purpose material in dull weather, even if you have to use a tripod. Orthochromatic films combined with special development for continuous tone (Chapter 4) would allow you to control the contrast over a wide range, while normal low speed films yield more conventional results (but are easier to handle).

To make up for the lack of contrast and sparkle in your picture, you should in any case choose very strong and bold composition. Pictures with small forms and a lot of detail generally look dull in low-contrast lighting. So choose simple and strongly appealing forms or patterns. (There are many examples in this book because where I live the weather is usually quite dull!)

But, on the whole, photography in dull weather is much easier if you use colour film. Moderately dull weather (by which I mean a completely overcast sky) is the best possible weather for certain types of colour photography because this kind of lighting comes closest to the theoretical norm required for the so-called true or natural rendering of colours. Occasionally, the lower contrast may even be viewed as an additional benefit because colour films are weak on rendering strong contrasts (Chapter 4). In addition, the sometimes disturbing blueness of shadows, due to the reflection of light from the sky, is generally absent. Apart from reduction or absence of unwanted colour shifts in dull weather, colour photography is always less affected by low light conditions than is black-and-white because the highlights and shadows form only a small part of the overall appeal of a colour picture. The main interest—the colours— are not affected by low light.

If, nevertheless, you find that your colour pictures taken in dull weather lack appeal compared with those taken in sunlight, this could be at least partly due to a fault in your approach to colour work. It may indicate that you are relying more on the subject's general properties, such as contrast, highlight, shadow, than on the colours themselves, which should be the main subject of a colour picture.

It is not easy to offer a remedy for this kind of

113 Alternating planes of shadow and light model the surface of an object, thus emphasising its spatial properties. While this is almost indispensable in black-and-white work, you can often do without it in colour. But subjects like these clouds over the empty beach really need it; they have no colour of their own and not even 'substance' – which is why they only come alive in this kind of lighting. (50mm lens, 35mm camera, ASA 64 film)

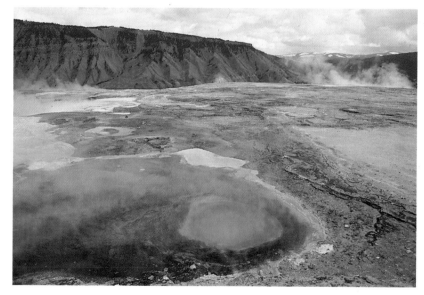

114 An overcast sky, with its very even illumination is the best light source for a natural rendering of colour. This is especially important either if your subject consists of very pastel shades or if you want to render strong hues in an understated way. The mood of a subject with very subdued and subtle colours can easily evaporate in stronger light. Moreover, in direct sunlight slight changes in the hue are often obliterated by surface sheen. (28mm lens, 35mm camera, ASA 64 film)

115 The oppressive closeness of the mountain wall in the background is entirely due to photographic options. It was created by the use of a long focal length lens, selection of appropriate viewpoint and waiting until the scene was entirely in shadow. Sunlight would have looked much more 'friendly', thus losing the overall mood I was aiming to achieve. (500mm lens, 35mm camera, ASA 25 film)

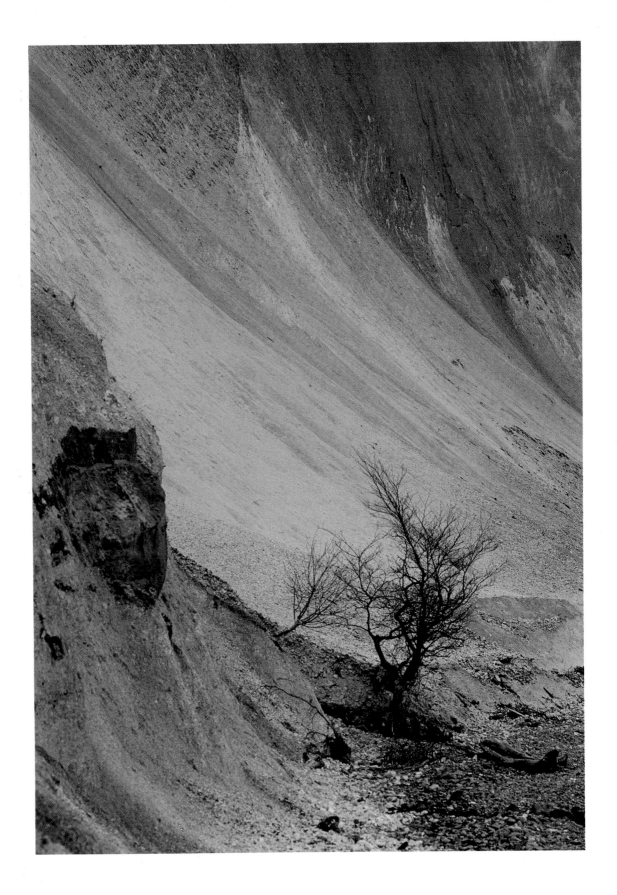

problem. But, generally speaking, it should help you to work in dull weather because this heightens your sensibility towards the importance of colours and their impact on the viewer.

Another problem may be posed by the apparently different qualities of the colours in dull weather. In direct light many colours appear highly saturated. Many photographers even enhance this effect by slightly underexposing the film and/or by using pola screens. This results in an almost garish colour rendering and has been quite *en vogue* during the last decade or so.

This effect cannot, of course, be achieved in dull weather as the colours appear much more muted with very subtle blendings and changes in tonal values. Sometimes they seem to be almost monochromatic.

The kind of colour that you prefer is, again, a very personal decision, depending on the kind of impression you want to achieve in your photographs. I prefer very subtle and even monochromatic colours for mine because in most cases strong colours would be much too loud for the things I have to say. For people with other objectives this approach would, of course, be entirely wrong. You will have to find out for yourself which kind of colour rendering best suits your ideas.

Storms

So far, we have mainly discussed simple bad weather; my final remarks concerning this subject are with respect to really bad weather, ie. storms and thunderstorms.

If you intend to take pictures in storms the first thing you have to think about is how to protect your camera. You will also meet some practical problems which could prove a bit tricky.

Strong rain or even a steady drizzle will make the more distant parts of your subject appear fuzzy and out-of-focus. This cannot be helped. So take care to compose your photograph so that the viewer can see the reason for this fuzziness and accept it as natural. This can, for example, be done by including puddles in the picture or the splashes made by raindrops.

Another problem could be that very short exposure times would freeze the distant raindrops while blurring the closer ones. Although only occasionally a problem with rain, this frequently makes photography with snow very difficult to handle satisfactorily. The effect becomes less noticeable and disturbing with shorter focal lengths of lens.

On the other hand, rain allows a few special effects which otherwise would be impossible. You could, for example, photograph from the interior of a car or building, focusing on the drops that have formed on the windscreen, or window pane, concentrating on the relections and highlights in the drops, while leaving the landscape itself out of focus. (This type of subject is usually convincing only in colour photography.)

During storms or where there are strong winds, rapidly moving clouds in the picture can blur. Low storm clouds, for example, usually call for shutter speeds of 1/15 sec or less to arrest movement.

Although lightning often occurs at relatively uniform intervals, it is impossible to predict reliably. Your only chance to include lightning in the picture is to use very long exposure times, pointing the camera in the general direction of the thunderstorm's centre. This will, of course, blur the clouds, but it cannot be helped. The best time for this kind of work is generally dusk or dawn, when the light level is still relatively low. A very sturdy tripod and a cable release are essential. Additionally, you should take some precautions yourself. Every year many people are killed by lightning and you should take care not to add yourself to the list!

I can quite understand that photography in these conditions is really not to everyone's taste. But if, for example, you are travelling by car, it would be worth stopping now and then to jump out for a second or two to take a picture. Or you could simply park somewhere and wait until conditions are perfect for a good bad-weather photograph. This really should not be asking too much for an interesting and unusual shot!

11 TRANSFORMATION OF THE LANDSCAPE – COMPOSITION

Picture composition is not simply a matter of lines and shapes in a rectangle, but has a much closer inter-relationship with the photographic process than it might first appear. Such decisions as whether to choose a high speed film to stress the graphic effect of coarse grain, or use a certain lens to help achieve a particular spatial impression (even basic decisions like choice of negative size or between colour or black-and-white film) are all a part of, and an aid to, composition. This is true at least if, in making decisions, you are primarily concerned with the visual impact of the picture and are not guided by technical considerations only. I have written elsewhere on general aspects of composition but some aspects are significant enough in landscape work to warrant detailed discussion.

Point of view

Choosing a suitable viewpoint is a problem that many photographers tackle only half-heartedly. Apart from those individuals who only take pictures out of their car windows, everyone knows that you can make worthwhile changes to a picture by shifting the viewpoint sometimes by only a few feet. Despite knowing this, however, many people still do not act accordingly. The following paragraphs contain some indicators to compositional possibilities inherent in the choice of viewpoint.

The usual way we see a landscape is while standing upright or walking. In consequence, most people take photographs almost exclusively from eye-level (apart from those owning medium format cameras with waist-level finders). This is a pity because even relatively small changes in the height of the viewpoint can drastically change the impact of a photograph.

Taking a picture from a worm's-eye view, for example, emphasises outlines or silhouettes of objects, isolates them from their surroundings and belies their size. This viewpoint always tends to increase the impression of size and isolation. (That does not necessarily mean that these qualities are actually present in a particular landscape—we have already seen in an earlier chapter that, strictly speaking, they never are, but just exist in your mind.) By using a worm's-eye view, combined with a camera angle directed upwards, a lens of short focal length and shooting at short

range (which exaggerates the proportions) you can introduce such impressions into any subject.

A higher viewpoint has a variety of effects. An elevation of only a few feet, achieved by standing on a low wall, a tree stump or a rock, reveals the structure and detail of the ground quite distinctly. Masses of shrubs or other small plants are shown individually and depressions in the ground, brooks, pools, rivulets and other variations in the surface become apparent. This results in an 'opening up' of the photograph. It appears less two-dimensional and conveys a feeling of space and life. If you favour 'poetic' renderings of the landscape, you should give particular consideration to the possibilities offered by slightly raised viewpoints.

High viewpoints: 3, 6 or even 9 m (10, 20 and 30 ft) are a different matter. These can be achieved by climbing a tree or a hill, by photographing from the first or second storey of a house or tower, or from the highest point in rolling countryside and so on. Such viewpoints give distant foregrounds. There is either no foreground at all (in the strictest sense of the term) or you have to choose fairly large objects like trees or a building to act as a foreground. Photographs of this kind are, therefore, seldom close or intimate. They go with panoramic views and wide open spaces, and represent a sweeping, generalised statement about the landscape.

So height has enormous influence on your photograph. A careful consideration of the attributes of a particular landscape suggests one of these three categories—worm's eye view, slightly raised viewpoint or very high elevation.

The practical problems of finding the required point of view can often prove quite irksome. One of my pupils always carries a long extendible ladder in his car, which is very commendable. But I must honestly admit that I have never found the energy to do this.

Mountainous country presents its own particular problems for choosing a viewpoint. It is often said that the best view of a mountain range is from 'half way up the other side'. This is generally true, for two reasons. From a valley, the view is often restricted by the surrounding hills or mountains although they may be much smaller than the summits beyond. Additionally, you often have to use lenses of short focal length to include a satisfying

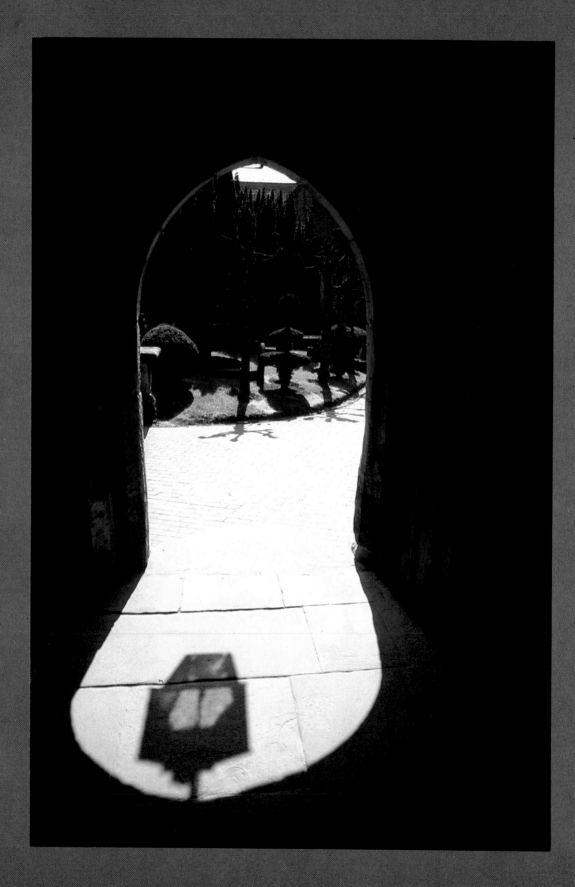

116 The composition of this picture is rather unusual on three counts. First, the repetition of the shape of the doorway in what you might call a 'negative shadow' (but, of course down) which defines the overall shape of the composition. Secondly, the very dark upper part of the view through the doorway, which slightly confuses the issue, saves the picture from over-simplification. But thirdly – and most importantly of all – there is the shadow of a lamp which is hidden from sight, though this is not immediately apparent. (40mm lens, 35mm camera, ASA 200 film)

117 We perceive everything by its shape, yet we quite often do not realise the shape that things really have. It is very rewarding to reveal the shapes of things that usually go unnoticed – often a considered choice of viewpoint is enough to bring this out. (200mm lens, 35mm camera, ASA 200 film)

118 Repetition can be a useful ingredient in landscape compositions, especially where the *overall* shape or structure repeats, but is disturbed by some small details that change. These small changes sustain the viewer's interest and curiosity where a 'clean' concept might not. (200mm lens, 35mm camera, ASA 200 film)

panoramic view—which further reduces the apparent size of the mountains. Views from the summit are also problematical. Although you can generally see an extensive range of mountains, this is often understated in the photograph as there are few indications of the scale of the subject.

Selecting a viewpoint is frequently bound up with the need to choose certain lenses rather than others. As just stated, shooting from the bottom of a valley normally forces you to use a wide-angle lens—which, in turn, makes mountain slopes appear less steep. So, the overall impression given is one of spaciousness rather than majestic size.

A view from the summit may call for the use of a moderately long focal length lens which 'compresses' the slopes of the mountains so that they not only look steeper but rather forbidding. If you want greater freedom of choice, a viewpoint half way up the other side is indeed the best as it allows you greater scope in selecting your lens.

As can be seen by these few examples, choice of viewpoint is not really as simple a question as it may seem. You should consider this problem quite carefully before taking your first shot.

Position of the horizon

Positioning of the horizon within the picture area is closely connected to the problem of viewpoint. But often this factor is simply overlooked. The reason for this is very interesting. To human vision, the horizon is in a fixed position—at eye level—whether you lie flat on your stomach or stand high on a mountain. Whether you look downward, upward, or even stand on your head the horizon always remains at eye level.

For the camera it is quite different. By pointing a camera downwards you position the horizon close to the upper border of the picture. By pointing it upwards you shift the horizon to the lower border.

Because this yields a visual result that cannot exist within normal human perception the position of the horizon is a forceful element in the composition of your pictures and the impression that they make on the viewer, even if he does not respond to it consciously.

There is said to be a safe rule according to which the horizon should never be placed in the middle of the picture, but instead should be in its upper or lower third. This so-called rule is absurd. There is absolutely no position for the horizon in the photograph which is either better or worse than any other. Where you place the horizon should depend entirely on what you want to express in your picture.

Keeping this in mind, let us examine three examples of positioning the horizon which give some indication of what to expect from these manipulations:

1 No horizon at all, or positioning the horizon very close to the upper border of the picture:

If photographed from directly above (from an aeroplane or a high tower) a landscape generally looks flat, like a map. There is no sense of space, width or perspective.

If you photograph from above still, but at a lower angle (ie. from a hill into a valley) the sky is either completely excluded or shown as a small border in the upper part of the picture. In most cases the effect is one of seclusion or confinement. The subject can even look secretive.

If you photograph from eye level using an extreme wide-angle lens and pointing the camera downwards the sky is again entirely, or almost completely, excluded. Due to the peculiar properties of wide-angle lenses the proportions of the subject are changed so that the distances and, thus, spatial impressions, are exaggerated and strengthened. Nevertheless, in most cases a sense of seclusion and 'separateness' predominates over the feeling of space.

2 Placing the horizon exactly in the middle of the picture:

As noted above, in the opinion of many photographers it is very bad practice to divide a picture by the horizon into two equal parts. A composition using this device of course looks very static. But this is not a 'bad' quality in itself.

If, for example, you have a very placid and simple subject, and if you want to stress these combined qualities in your photograph, a dynamic composition would not do at all. If you compose the subject around the optical centre of the picture and place the horizon in the middle, this in-

119 Here, the camera was placed at eye-level but pointed downwards so that the horizon was positioned relatively high. The effect was enhanced by using the movements of the view camera which further emphasised the size of the foreground in relation to the buildings in the distance. The photograph shows Mont St. Michel (Brittany, France) which rises steeply out of the flat plains and often (depending on weather conditions) seems to float on a grey sea. By placing the horizon close to the upper edge of the picture and stressing the foreground in this way, the apparition effect that a person sees when approaching this site has been suggested in the picture. (49mm lens, 6 x 9cm view camera, ASA 400 film)

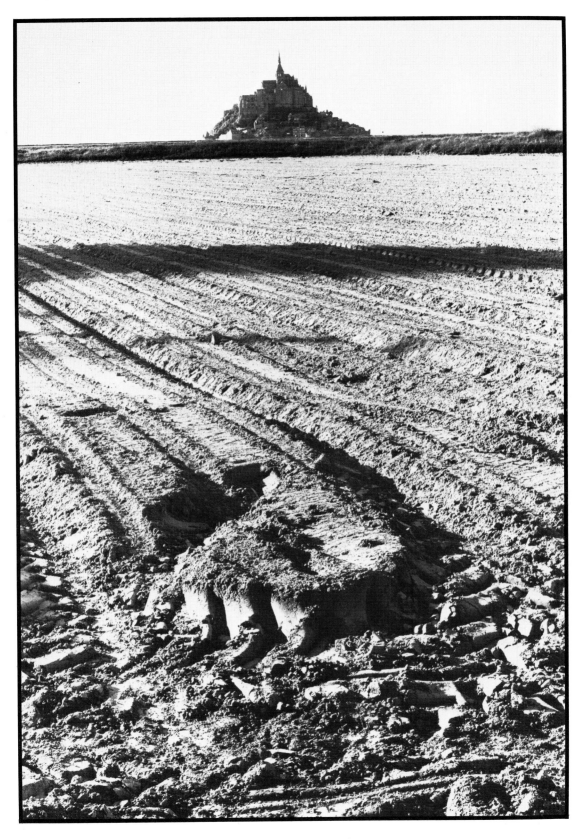

creases the impression of calmness, simplicity, peace and tranquillity.

It is a mistake to reject a technical or compositional possibility out of hand. What may be wrong for one kind of picture may save the day for the next. Being dogmatic would simply narrow your range of creative possibilities.

3 Placing the horizon in the lower half of a picture:

If most of a picture is occupied by the sky, it is usually because there are interesting clouds or related metereological phenomena. But even a blank, or almost blank sky can lead to impressive pictures. A low horizon is usually associated with wide landscapes like deserts and seascapes, while in hilly or even mountainous country a higher horizon confines the view. A low horizon is often combined with interesting clouds, but a predominantly blank sky can lead to very striking, though usually rather oppressive or even depressing photographs.

Perhaps I should add here that a picture need not necessarily be nice, or pretty or pleasant. On the contrary,' what reaches beyond the idyllic and all too often insignificant clichés into stronger feeling usually makes for much more impressive photographs with a greater impact on the person looking at them.

Of course, each placing of the horizon also affects other elements of the photograph. We have already seen this in the context of interchangeable lenses and the same applies here. For example, the horizon can appear very high in the picture either by using a very high viewpoint or with the aid of an extreme wide-angle lens and having the camera pointing downward. Both methods introduce other changes. A high viewpoint reduces the impact of tall subjects like trees and buildings, while an extreme wide-angle lens would alter the relative sizes of different parts of the subject. These effects must be taken into account too, when you decide which method you want to use. But these restrictions are not necessarily negative because the different effects going together often complement and enhance each other.

But often the best alternative for placing the horizon is none of these extremes because they would also introduce extreme effects in other parts of the picture. Intermediate positions for the horizon could convey similar impressions but to a lesser degree. It is not always easy to find a satisfying balance between the various elements of a composition.

Impression of perspective

Apart from the things already mentioned, the position of the horizon also influences the perspective impression of your photograph.

So far, we have looked at the following factors which influence perspective impression: the focal length of the lens, viewpoint, placement of horizon and the various factors introduced by aerial perspective (fog and haze).

I would now like to put these things together and examine them from a compositional point of view.

Among other things, the perspective rendering of scenery gives a person looking at a photograph a feeling of the scale, space and distance. We have already seen that you can manipulate this impression according to your intentions. Generally, the viewer cannot be guided by his memory when looking at the picture because the chances are that the scene is unfamiliar to him. His clues are what you show in your picture and he has to form his ideas of scale, space and distance solely from what he can see.

There are two approaches to this problem. On the one hand it can be interesting to conceal the true or natural size of things, so that you can stress (or suppress) certain emotional qualities of a scene. Apart from the choice of lens and viewpoint, you have to conceal or exclude everything which might give the viewer an idea of the true size, such as milestones, telegraph poles, traffic signs, houses, other buildings, cars and, of course, people. By excluding these things from your picture, you can create your own impression of size by purely photographic means. The viewer cannot make any comparison between reality and what is shown in your photograph because he lacks definite points of reference.

On the other hand, you *can* include something in your picture which is of recognisable shape and size, so that the viewer can relate this to the size of other objects. But there are several factors to take into account. If you place an easily identifiable object (or a person) in the foreground, this on its own gives no indication of the size of more distant parts of the scene. Distant objects may even look small and insignificant if the foreground is too large in relation to them and isolated from the middle distance.

The easiest way out here is to show the same type of object (like telegraph poles, milestones, houses, cars) or people at varying distances from the camera, so that they link foreground, middle

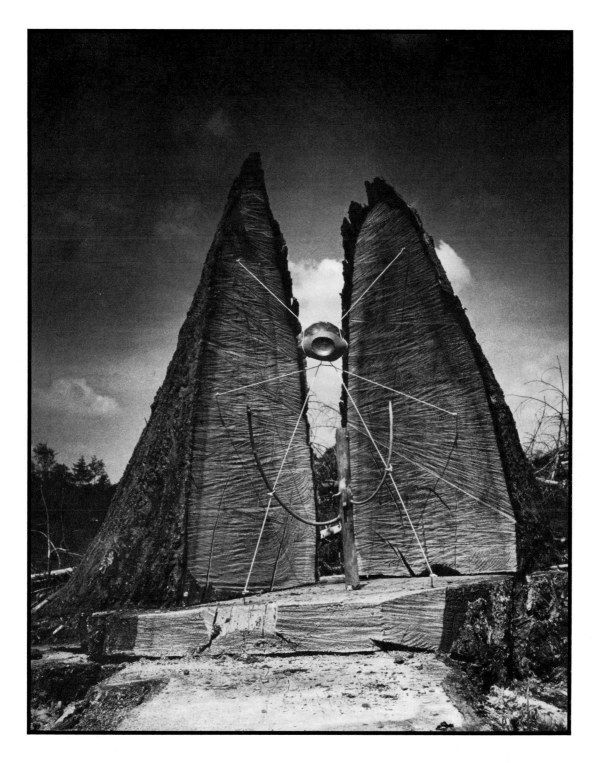

120 If an object is unknown to the viewer or if it is of a type that exists in varying sizes, it is entirely up to the photographer to create an impression of size by choice of viewpoint, and height by placement of the horizon, choice of focal length and so on. Here, for example, you cannot even guess the size of the object but most people estimate that this object was rather large. In fact, it was only about 30cm (12in). The impression of size comes largely from the low viewpoint (the camera was placed on the ground, tilted slightly upwards) and an extremely short focal length lens used. (50mm lens, 6 x 7cm camera, ASA 100 film)

distance and background.

If this fails because the subject does not contain elements that you can use in this way, you could try not having the person or object which is to indicate scale, too close to the camera. A person, for example, should then be about 20 or 30m (70-100ft) from the camera if you use a standard lens.

In panoramic views, houses and trees can serve as indicators of scale. They should be placed in the middle distance to work most effectively.

In the absence of easily identifiable objects you can use a continuous stretch of ground (from foreground to background). However, this only works if it is relatively uniform, so that the viewer can judge the diminishing effect of its components. It is moderately effective with ground covered by shrubs (of a uniform kind), gravel, sand, waves and with any other objects of roughly the same shape and size. On the other hand, this process can equally well be used to give the viewer an impression of size which completely deviates from the natural conditions, so that the visually experienced viewer might not accept your evidence at face value. (We will shortly discuss this in detail, see 'Foreground'.)

If, from all this, you have deduced that while it is difficult to give an impression of true scale in a photograph, it is relatively easy to cheat the viewer, you would be quite right. But you must know all the factors involved and the individual impression they can make in order to fully exploit the compositional scope.

This is a bit difficult to put into words because all these factors are so closely inter-related that a change in any one of them influences all the others. So the following summary can only give an approximate idea of that happens to your photographs when working along the lines discussed. But you will grasp the principle easily once you try it out in practice.

Scale

Scale depends on:

1 The distance between object and camera. A large object might look the same size as a very small one if it is much farther away.

2 The focal length. Distant objects look smaller the shorter the focal length.

3 Aerial perspective. Irrespective of the size of an object in a photograph, it seems to be smaller if strongly affected by aerial perspective and larger if less affected.

Distance and scale

1 Scale. The impression of distance is governed by the presentation of scale as described above.

2 Viewpoint. High viewpoints show the expanse of ground between various parts of a scene and therefore stress the impression of distance and space, while low viewpoints diminish it.

3 Angle of the camera axis. If the camera is not held vertically but pointed downwards or upwards, effect 2 is further strengthened or weakened.

4 Interchangeable lenses. The same applies to interchangeable lenses as described in Chapter 4.

5 Composition. 'Crowded' compositions tend to diminish the impression of distance, while wide vistas and empty spaces tend to strengthen it.

Absolute size

1 Space, scale and distance create the impression of size. This is not necessarily related to natural size, because it can be easily manipulated by the photographer.

2 The only indication of true size is given by objects whose size is known to the viewer.

3 This only works properly if the object serving as a comparison is placed near the object which is to be compared with it. Otherwise the impression received by the viewer may still be quite false.

A factor not included in this table is the presentation of your photograph. Objects shown in a large scale print tend to look larger than those depicted in a small one, and so on. We will look at these things, which are not directly connected with *taking* photographs, in the final chapter.

Foreground

There are some often-quoted rules which state that a photograph should be divided into foreground, middle distance and background, and that the foreground should serve as a 'frame' for the rest of the picture. This is usually followed by the advice to improve your picture by placing someone in the foreground—your wife, husband, aunt, mother-in-law—or, if none of the above happens to be available, to use a branch with leaves or some similar object.

As you may have gathered, I find this kind of advice rather ridiculous. The landscape you want to transform into a photograph appeals to you for some particular reason. The idea is to show this appeal in a photograph so that it can be understood and appreciated by someone who looks at it. To position someone there in order to create a

121 The skeletons of trees in the foreground, middle distance and background hold this atmospheric picture together. The repetition of these black shapes and their similarity of form, however, also increases the spatial impression, further increased by the clouds of steam drifting over these hot springs in the Rocky Mountains. (28mm lens, 35mm camera, ASA 200 film)

foreground introduces a distracting foreign element into the landscape that destroys the overall effect.

This does not mean, of course, that you should never include people in your landscapes, only that you should not place someone in the picture simply to fill an empty space or because you were told to do so—or even because you could think of no other solution. You must try to solve your compositional problems along different lines.

Firstly, a photograph does not always need a foreground. There are plenty of subjects which, by their very nature, do not have a foreground (desert landscapes, beaches and so on) and this property is an integral part of their character. You should not, then, invent one, because this will change the initial impression the landscape made on you.

A problem arises from this because photographs without a foreground often look unapproachable or 'inaccessible' to the viewer. This simply means that the viewer does not feel invited to come to terms with the photograph. There are various ways of overcoming this problem. The most interesting one (to my eyes) is to use an extreme wide-angle lens in conjunction with a relatively low viewpoint. This renders the elements of the landscape which are close to the camera disproportionately large so that, for example, each grain of sand or each pebble is discernible. The viewer then believes that he can see the structure of the whole landscape.

By making the structure of the landscape the main subject, a foreground in the conventional sense of the word becomes superfluous, both compositionally speaking and in relation to the impact of the picture on the viewer.

Landscapes which really have no kind of foreground whatever are, however, exceedingly rare —at least, if you have trained yourself to observe the elements of a landscape and know how to use them photographically. For example, an extreme wide-angle lens not only shows the structural details of a landscape as disproportionately large

122 If you compare this photograph with picture no. **103** (p. 108), you will see that the rendering of the shadows is an important part of the composition in both. But here they were shortened and compressed by a low viewpoint and use of a longer focal length lens. This gives the subject a compact and flat appearance, but was essential here in order to show the graphic and somehow unreal atmosphere of the place. This is Tintagel (Cornwall, England) and, finding the ruins somewhat disappointing, I was probably looking around for something else exuding the mysterious quality that a literary-minded person is apt to associate with this place! (100mm lens, 35mm camera, ASA 400 film)

123 Normally, the standard lens gives an impression of space that comes closest to the way in which we perceive a scene. This is especially true when the camera is held at eye-level with a horizontal view. For certain types of subject, this almost excessively simple approach really works best – but the simpler your approach the more sure you must be of your means of expression, and how to handle them. You must know exactly what you want to say; you cannot hide behind technical fireworks. (50mm lens, 35mm camera, ASA 125 film)

124 In nature, the foreground consists of everything which happens to be closest to you. But not in photography. By using a very long focal length you can, for example, turn a very distant area into the foreground. Or, if you use a wide-angle lens, you can make a foreground from the ground itself by creating a great disparity in size between a structure in the foreground and the size of more distant objects. This is very important to remember because it requires a conscious effort on the part of the photographer to deviate from the routines of his or her perceptions. (21mm lens, 35mm camera, ASA 400 film)

(if they are close to the camera) but any small twig, stone, rusty tin or old bottle can serve as a foreground.

The problem with this is not a photographic but a psychological one. You perceive a landscape selectively, which a camera cannot do. If you were to look at a landscape for a period of time, just as a test, you would realise that there were many things in it you had not noticed at first although, on the other hand, some relatively small details may have occupied your attention.

Moreover, you do not take in a landscape at one glance (as the camera does in a fraction of a second). Your eyes leap from one feature to the

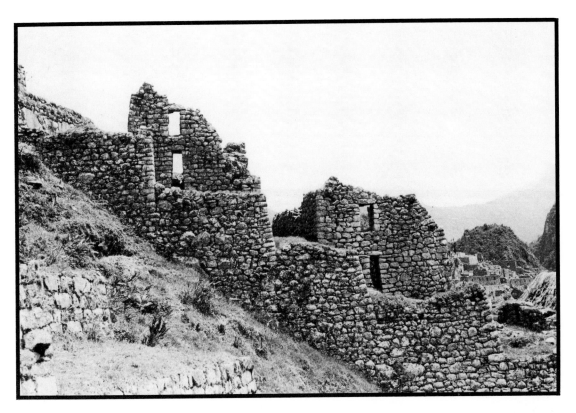

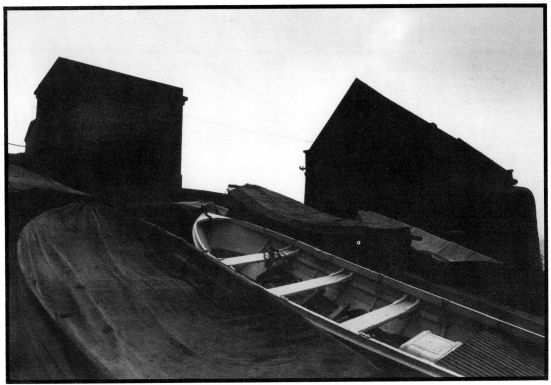

next and you focus on one thing at a time. This process is a major reason for your personal reaction to a landscape and why everyone can form a slightly different impression of the same scene. The process of perception is structured according to the perceiver/photographer's personality and is therefore individual.

The photographer's task is to create a picture which conveys the same kind of feeling as his original response to the subject. This brings us back to our initial problem of the foreground. You should not choose a foreground subject at random because its very position in the picture gives it a special importance.

Instead, try to find some detail that has played an important part in your perception of the landscape, or something which can serve as a substitute for this or which, perhaps, focuses an otherwise vague impression on one definite thing. This, then, should constitute the foreground of your photograph.

This is why an old, empty bottle can sometimes do the trick, or a twig, a stone or a small plant, for example. Your main concern should be that this object, whatever it is, emphasises the impression made on you when looking at the landscape, re-

125 In Chapter 7 we discussed pre-composed subjects, a term which embraces the fact that man-made structures often have very striking relationships with their natural surroundings, so that at least a part of your composition already exists. But this picture demonstrates that there is still enough left to be done: viewpoint, framing and the focal length of lens remain as variables to turn what you see into a convincing composition in its own right. Here, even a slight change in viewpoint, for example would destroy the composition and render the picture meaningless. (200mm lens, 35mm camera, ASA 200 film)

126 Similar and yet different – this always forms a good basis for an interesting composition. The two trees leaning towards each other are very similar in their overall shape and in their colouring. But they are very different in detail and structure. This characteristic you can often find in nature – the problem is usually one of how to isolate the relevant objects from their surroundings so that their similarities and dissimilarities are clearly underlined. Here the snow helped to restrain unwanted detail. (24mm lens, 35mm camera, ASA 200 film)

gardless of whether this impression was concerned with the landscape in general or with some particular aspect of it.

Some landscapes may evoke two or more different impressions which may even contradict each

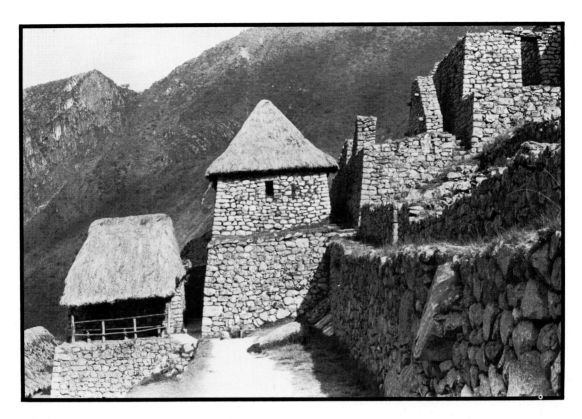

127 If, because of the weather or some other circumstances, the contrast drops below a certain level, the only thing you can do is to stick to very bold and simple compositions that look impressive even under these conditions. (55mm lens, 6 x 7 camera, ASA 400 film)

128 This shot is effective because of its composition – the mountains in the background and the buildings in the middle distance form a double diagonal line which is arrested and counteracted by the lines of the walls on the right hand side of the photograph.

other. In this case, it is useless to try to incorporate them in one photograph (unless, of course, the contradiction itself is the subject of your picture!). Sort them out and try to create a separate photograph for each of the different aspects.

All this is obviously more in the nature of a creative problem rather than a technical one and it actually adds up to this: you can use anything as a foreground subject as long as it fits into the context of your idea and provides the viewer with a key to the understanding of your photograph.

Subjective aspects of composition
In the remainder of this chapter I shall discuss some other elements belonging to a different level of picture-organisation—those reflecting your basic attitude rather than any concrete property of the scene itself.

Details and texture
Whatever your landscape subject, you are always likely to be confronted with the problem of representing detail and structure which, in turn, is closely related to the question of picture size.

Normally, the various components of a landscape are much larger than they are shown in a picture—even in a photo-mural. The exception to this is the kind of landscape photography concerning itself with what Ansel Adams has termed the 'minutiae of nature'. Otherwise you must always decide how much importance you want to assign to the representation of detail.

If detail is to be shown, the first thing to take into account is the relation between picture size and negative size. This is discussed in greater depth in the final chapter but our main concern here is how you can give an impression of detail in the picture other than by placing certain elements of the landscape in the foreground.

The foreground subject usually shows all the necessary (or intended) detail even in relatively small pictures. The viewer is then led to believe

129 The distribution of light and dark areas and similarity in form of the long and narrow barge and the stretch of canal itself, emphasised by the use of a wide-angle lens and downward angled camera make the interest of this photograph. (35mm lens, 35mm camera, ASA 200 film)

130 The size of the sun in relation to the picture area is determined by the focal length of the lens. While people usually try to show the sun as large as possible, it is often at least as interesting to stress the surroundings instead. If you want to show a foreground feature and the clouds in the background at the same time, both in reasonably sharp focus, you have to resort to a short focal length of lens anyway. (21mm lens, 35mm camera, ASA 25 film)

that he sees the same amount of detail in more distant (and consequently smaller) elements of the photograph as well. This can work only if you compose your picture so that the same type of subject matter is shown in the foreground, middle distance *and* background.

If, for example, you photograph an expanse of sand or pebbles with a wide-angle lens at a relatively short focusing distance, you can discern the grains of sand or the pebbles in the foreground. This impression is automatically transferred to the whole of the picture, provided that sand or pebbles are shown in the middle distance and background also, although a closer inspection would reveal that the detail is actually visible only in the foreground.

This can be applied to almost every kind of landscape, because there will nearly always be some feature (stones, flowers, shrubs, trees, telegraph poles, etc) that can be repeated in all picture planes. It works the other way round, too. If you want to confine the picture to an overall view with detail suppressed as much as possible, the first thing to do is to choose a composition without a foreground.

You should not, by the way, confuse detail with texture: they are interdependent. What I have said so far about detail is also true for texture. The difference is this. 'Detail' signifies all the small elements of a photograph (or a landscape) that are separately visible, while *texture* refers to that class of detail which comes into being through the spatial organisation of an object. An example: tree bark may be of uniform colour and flat. In that case, it has neither detail nor texture. But if it is brown with green spots, it has detail. If it is monochrome, but cleft and fissured (structured spatially) it has texture.

131 This picture does not differ much from the one opposite in terms of subject matter and the treatment of structure and shapes. Nevertheless, it works on an entirely different level, because the human element has been introduced – albeit subversively. While the content of **132** rests entirely on the formal elements of the picture, here something has happened and the photograph tells its own story, however simple it may be. Note the oblique angle of the dark form on the right hand side, which 'pushes' the footstep still further into the foreground, giving the picture greater force. A close examination of the print reveals that the structure of the sand is actually the grain of the high speed film. (21mm lens, 35mm camera, ASA 400 film)

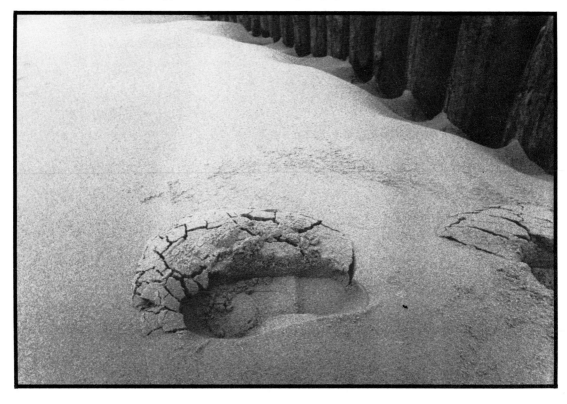

132 The importance of detail and structure in the framework of your pictures depends on what you want to express. But generally speaking, the importance of these elements is stronger, the smaller your subject. This one, for example, which belongs somewhere between landscape and close up work, is justified only by the shapes and textures of the things depicted. But it shows also that the composition must be the stronger and bolder, the simpler the subject is in itself. In fact, pictures like these could be said to be more about composition than the objects seen in them. Many photographers go in almost entirely for this kind of picture and, indeed, it offers considerable scope for the imagination of the more formally minded. (21mm lens, 35mm camera, ASA 100 film)

Surprisingly enough, this is not splitting hairs but has very important practical significance. In colour photography, detail that depends on different colouring will always be shown. (Detail is an inherent property of the subject itself (ie its colouring), while texture is a spatial property, whose recognisability depends on the interaction of subject and lighting.)

In black-and-white this would depend on the grey values into which the various colours are translated. But texture may, or may not be visible in colour or black-and-white, according to the lighting. The visibility of texture is so dependent upon the lighting that it can entirely disappear in strictly axial or totally diffuse light.

If you want to reveal or suppress texture you can only do so by either waiting for a change in the light or by using a different camera angle in relation to the sun, which would strengthen or weaken the presentation of shadows.

Importance of texture

If you aim for a natural rendering of landscape it must include texture. This is less pressing in colour photography, because differences in colour, which do not necessarily coincide with tex-

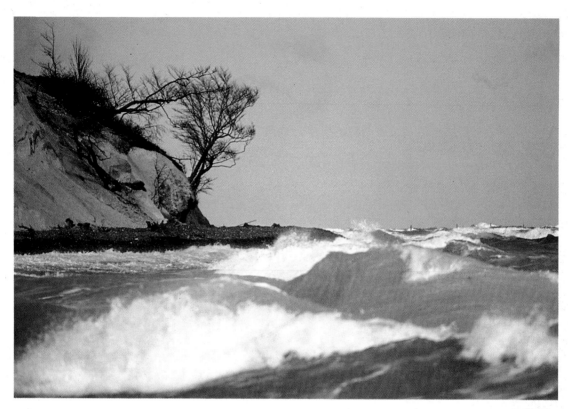

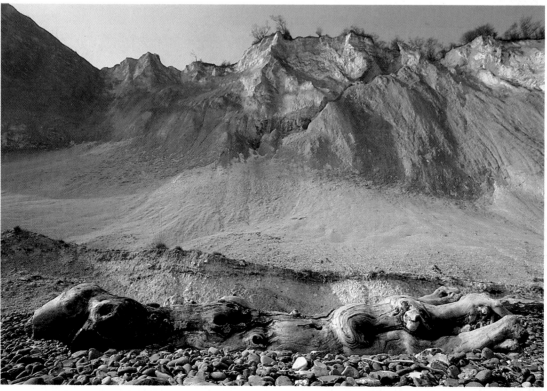

133 Although this picture looks as if it was taken from a viewpoint in the middle of the waves, my feet stayed quite dry. The effect is due to having the camera at waist level but using a very long focal length of lens – in this case an 800mm mirror (catadioptric) type. For shots of this kind it is important to exclude everything from view that the very limited depth of field would render out of focus—also, everything which would display the 'backdrop' appearance typical of pictures taken with extreme focal lengths. Only if you avoid both these effects can you disguise your real viewpoint (800mm mirror lens, 35mm camera, ASA 50 film)

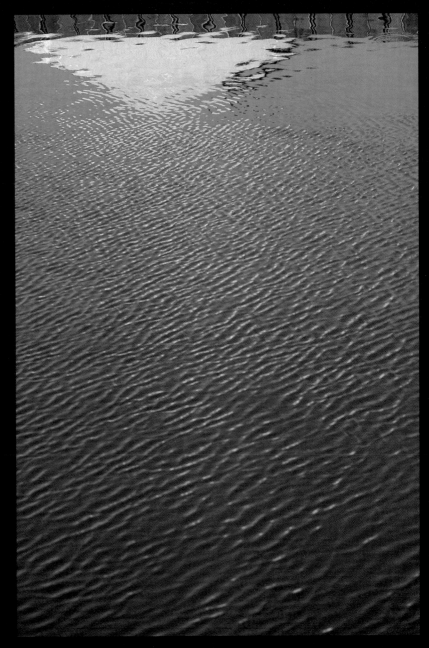

134 What looks like a fossilised creature of fable, or a fantastic surreal sculpture is, of course, nothing but an old tree trunk. Very often, things have structural properties that lend themselves easily to interesting associations. Here the art of the photographer consists in drawing out these properties while holding back everything else that could distract the viewer's attention. Careful framing, choice of viewpoint and lens are essential for a concentrated effect. (21mm lens, 35mm camera, ASA 50 film)

135 The strength of simplicity; the problem is that simple compositions offer nothing beyond the initial 'shock', after which the viewer's interest soon fades. The trick is to add some ingredient to counteract this weakness. Imagine a simple yellow triangle on a blue ground – it may look nice but would not sustain much interest. Turned into a reflection however, it suddenly gains a new dimension. (75mm lens, 6 x 6cm camera, ASA 200 film)

ture, are at least equally characteristic of many subjects and so at least equally important for recognition. But it is very important in black-and-white work; sometimes the texture may be the sole means of identifying an object properly.

For a good and natural rendering of texture, as well as differences in colour, you should frame the subject from as nearby as possible and seek sidelight of moderate strength. If the light is too weak and diffuse, the texture will not be shown. If it is too strong, the surface will be broken up by black patches of shadow.

Where the natural rendering of texture is your primary concern, sidelight which falls on the scene from the left-hand side is preferable because, for physiological reasons, the human eye can best recognise the spatial organisation of surfaces in light of this kind.

Patterns and shapes
What detail and texture are to the internal organisation of pictorial elements, patterns and shapes are for their external organisation.

Every scene is built up from patterns and

136 Even an entirely empty foreground can play an important part in a picture. (This one is 'unusual' in that it deviates from our normal perception, being much closer and steeper in perspective.) If something were placed on the road in the foreground, the impact of the picture would be entirely destroyed. (49mm lens, 6 x 9 view camera, ASA 400 film)

137 A pattern or natural arrangement that can give shape to a composition comes, more often than not, from the combination of subject and setting rather than from the subject itself. However interesting the subject, it is important not to overlook the reinforcing potential of the surroundings. (50mm lens, 35mm camera, ASA 125 film)

shapes. Usually the problem is how to recognise their photographic potential and how to arrange them into a picture. The only thing that really works here is practice—and plenty of it. But the following hints may be of some help too.

The shape of an object is the space (or to be more accurate, the plane) which it occupies in your field of view. It is defined by its outlines. Shapes are easiest to recognise when they are back-lit. If you see something against strong lighting, you see its abstract shape only. You can then judge its photographic potential most clearly.

The shapes of subjects are, however, equally important in all types of lighting and in all photographs. Many common mistakes found in amateur photographs, such as telegraph poles that seem to grow out of people's heads, or branches that grow out of their ears, show how in 'pure' landscape photography, forms are too often allowed to obstruct each other, leading to muddled compositions. All these errors can be avoided by being more conscious of the shapes of things.

A photograph is purely two dimensional and therefore shapes are even more important when looking at a picture than when looking at nature, where the perception of three dimensions tends to impose other impressions on the viewer.

To get the feeling for handling forms within the picture you should start by trying to visualise things as pure shapes, that is, as planes without structure and texture, without highlights and shadows—in fact, as simple cutouts. To look with one eye closed can help a little because this at least omits spatial impressions.

Then ask yourself how a shape works, and if it is strong or weak: in other words, whether it is easy to recognise and has simple, bold outlines, or whether it is convoluted and therefore difficult to recognise as a compositional unit. Also, whether or not it is partly obscured or obstructed by other shapes in the field of view. Decide on the best relationship between different shapes.

Now, ask yourself if you could rearrange the shapes by changing the viewpoint or the focal length of the lens in order to improve the composition. If this works out, you can then go on to consider texture, structure and light. If the basic concept of the composition—the shapes and their configuration—is good, it can only improve. If not, the photograph is a muddle from the beginning and will remain so, irrespective of the trimmings.

If you do not already know it, you will discover in due course that an accomplished photographer can usually 'feel' shapes instinctively. This is not due to any sixth sense but to constant training and practice.

Patterns are repetitions of identical or similar shapes and should be treated in a similar way. There is an infinite variety of pattern both in nature and in artifacts.

The blades of grass in a meadow, for example, form a characteristic pattern. You do not identify a meadow by the individual blades of grass but by its typical pattern. Other patterns include ripples of windblown sand, pebbles on a beach, trees growing in regular rows, similar houses making up a street frontage, waves at sea and so on.

Patterns abound and you can use them to make your photographs more interesting. But how do you recognise them? The simple answer is that two make a pair, three and more can form a pattern.

Study your subject to see the number and the position of the objects in it. If it contains similar or identical things, they can be formed into a pattern. For example, three trees distributed haphazardly across the picture plane might not make a good photograph. But if, by changing the viewpoint and/or the focal length of your lens, you can place them—say—in a row, one after the other, or, perhaps, in a perfect triangle, they form a pattern and thus assume a 'meaning', or simply acquire an additional strength that they did not have before. Due to the peculiar process of human perception we tend to see a meaning in order and meaningless in disorder. So, by showing order, ie. superimposing it on nature, you introduce a meaning into your photograph where there actually is none!

Usually, a pattern becomes more pronounced and, in consequence, more obvious to the viewer the more single elements there are in it and/or the more regular their distribution. The few elements of our tree example only form a pattern through their regular distribution, whereas the blades of grass in a meadow form a pattern due to their

138 An accumulation of similar shapes can be treated in various ways. A very high viewpoint (with the camera angled downwards) stresses the uniformity or similarity of the shapes, while a lower viewpoint (together with a wide-angle lens) relies more on their spatial distribution. In the latter treatment, the closer shapes reveal their surface structure, which the viewer subconsciously transfers to the more distant ones, thus assuming an overall detail in the picture, which is not really there. (49mm lens, 6 x 9cm view camera, ASA 400 film)

sheer number, although they are disordered. Thus, a car park can form an intricate and fascinating pattern, while a few single cars may be uninteresting. Rows upon rows of goods or machinery in harbours, factories and the like can form appealing patterns, while the single object might only make an uninteresting picture.

This is also true for many other things. A single blade of grass, one pebble, a handful of sand, may be fascinating—or not. If they are not, a pattern of them could be, or may at least be more interesting.

When you start looking for patterns you will probably first hit upon the more or less obvious ones that turn up frequently in photographs. As your awareness sharpens, however, you will be able to discern patterns where others have not seen them—then you really are in business.

But there is still a further step. Patterns are very obvious (at least, to the competent photographer) and if you have learned how to handle them, you should start taking them apart again. For example, an expanse of pebbly beach may be very pretty, but a single rusty beer can could provide a means of breaking the pattern and the monotony. Or a row of wooden posts could be included in the pic-

139 With many panoramic or bird's-eye views, detail and texture can be dealt with summarily because the picture depends on the overall impression. Other pictures however, would mean little to the viewer if they did not reveal all the detail and structure that you can achieve in a photograph. This picture is a case in point; although it was an interesting overall composition, consisting mainly of the vertical strips of masonry set off against the more irregular and undulating forms of the hill, its main impact derives from the detail and structure – clearly visible differences between stone, grass, earth and sand. (50mm lens, 35mm camera, ASA 125 film)

ture-plane to form a pattern within a pattern, or ripples on the waves could be shown to superimpose one pattern upon another.

There is absolutely no limit to these possibilities—except for the limits of your imagination, and you can expand these by training your vision. Patterns are relatively easy to recognise and to create out of the raw material of your subject. If used with imagination they can improve your photography greatly.

How the photographer thinks his way through

In previous chapters I explained that the impact of a photograph may depend to only a very limited

extent upon the subject matter itself. I have also demonstrated with many practical examples how you can create a picture out of the elements of a subject and how to do this in a way that allows you to achieve the strongly defined image you have in mind. But how do you go about it, when taking pictures?

The answer to this is actually quite simple. Obviously most people do not wander around in a landscape, wondering what deep thoughts to have and how to transform them into photographs. And that is just as well, because pictures generated in this way usually look very 'literary' and artificial.

The things I have described in this book should be thought through beforehand and should be practised as long as you have the feeling that they are not, as yet, second nature to you.

The important step is not to think about your problems whilst taking pictures, but to train your photographic instincts to such a fine degree that you can react spontaneously to any situation. This is simply achieved by thinking beforehand and practising constantly.

In my opinion this approach works better than thinking while shooting, because the role of the subconscious should not be underestimated. Apart from constructivist art, which is very rational in execution (but not in apperception and conception) the subconscious of the artist/photographer is not only an important factor in the motivation towards creating something, it also furnishes a sizeable part of the content of the work. This, and the fact that we are dealing with a visual medium that cannot easily be 'translated' into words, makes photographs and works of art so difficult, if not downright impossible, to describe.

If you have not thought out your approach beforehand and if you have not practised so much that you can react spontaneously, but with precision, to the impetus to take a picture, one of two things happens. You either think too much, which slows you down and suppresses your instinctive reactions (associations, feelings etc), or you react in an uncontrolled way, which would result in a good shot only occasionally and by chance.

A detailed description of this process would go beyond the framework of this book, and would probably not interest you very much. But the preceding paragraphs should show you how to apply your ideas, and what you have learned in this book and elsewhere, to your practical work.

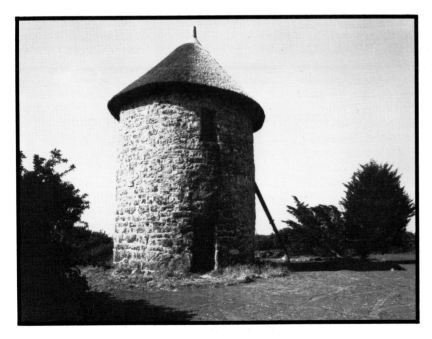

140 You can simply declare some shape or other to be the central part of your composition, by treating it in the proper way (with choice of viewpoint, focal length and so on), or – to put it another way – by deviating from the way in which our perception works on a scene. Here it is the very low viewpoint that isolates the old windmill from the sky, thus stressing its simple and archaic shapes (47mm lens, 6 x 9cm view camera, ASA 100 film)

12 PRESENTATION OF LANDSCAPE PHOTOGRAPHS

Suitable presentation of your work can increase its power. Conversely, inappropriate treatment can weaken, or even destroy the effect. Furthermore, sloppy presentation suggests to the viewer that you do not value your own efforts highly—and he will react accordingly. On the other hand, a bombastic presentation with passepartout, frame, coloured borders and what have you, would look ridiculous and out of place if the thing thus enhanced is not worth it.

You might feel that preparing a photograph for presentation is too much of a bother. But I believe that a photograph which is not worth the extra work of this kind may not be worth showing at all.

It is much better to show only ten outstanding photographs with meticulous presentation than a multitude of mediocre ones with those ten good photographs lost among them and kept, partly crushed and dirty, in a shoebox. I exaggerate, but the sentiment is true, nevertheless.

Presentation is more than clean and careful handling of your work, it includes the whole finish of the picture, be it a slide or a print.

Series: colour slides

The only sensible way to show colour slides is to project them on to a screen. Colour slides are seldom looked at singly but are usually thought of as part of a whole series. So it is a good idea to consider the relationship between the different photographs you are likely to show together.

If, for example, you have different slides of the same subject, or of subjects closely related to each other, it is worth arranging them in a sequence which would stress that relationship. You could start with a general view of some subject and then split it up into differently framed details. Or you could show the same subject taken from different viewpoints, and so on.

Because of differences in viewpoint, shadows, lighting and so on, different views in a series, however they have been handled, will each give a different impression. So the presentation of photographs in a series is not an empty formality but, if properly done, enhances the significance of each individual picture.

This is especially true for slide shows with dissolve effects. Often these fail because it is thought sufficient just to string pretty pictures together in the hope that the dissolves will conceal any faults in the composition of individual pictures. In a series, each picture must be related in at least two respects to those that precede and those that follow it. The formal structure (composition) and the content (impact) of the series must come together to form something which is of greater significance than the individual pictures.

Enlargements

If you show your pictures in the form of enlargements—colour or black-and-white—different problems arise. A very interesting way of presenting related pictures is to put them together in the form of a 'tableau'.

This usually consists of a large board on which the photographs are displayed. The relationship between the various pictures must be especially strong with this type of presentation. In a slide show you see the photographs in succession. In a tableau they are grouped together so that you can see them all at once. So, each picture may be appreciated individually, while at the same time they are all viewed simultaneously as a single compositional unit.

Tableau display might be chosen for more than one reason. You can capture the same subject in different states—say, a landscape through the four seasons, or different times of day or in different lighting.

Another idea would be to show the progression of change in a subject, such as a sunset. Or you could assemble pictures of related subjects, such as doors, windows, churches, solitary trees, or pub signs.

Even if your pictures are simply put into an album, remember that even a photographic album constitutes a kind of series. Photographs on opposite pages should be complementary in some way and on consecutive pages should be arranged so that the viewer can see some kind of progression, be it in content or composition, when leafing through. This will greatly enhance the strength of individual photographs.

Print size and detail

Some photographic processes dictate the print size.

All instant pictures, for example, are of a fixed size and you have to arrange the picture composition accordingly. In most other cases you can

determine the print size yourself.

For panoramic views containing great detail, you should use a large negative size and/or fine grain film. If you want to show all the detail, the enlargement should be correspondingly large. The proper size for your purposes can be found by trial and error.

Make enlargements with different magnifications using only a small part of the negative, to save paper. Compare these enlargements. You will see that the amount of detail increases up to a certain magnification, beyond which no new detail becomes visible, because it is broken up by the grain of the negative. If the detail is of paramount importance, choose a magnification that barely shows the grain from a normal viewing distance (see below).

In other pictures, on the other hand, you may not want to show much detail. If you are more interested in the general shape of a landscape, in the distribution of light and dark areas, in the shape of the horizon or in perspective effects, then the rendering of detail would detract from the overall impact of the picture.

One way of producing pictures with these, or similar effects, is to use high speed film and to process it for coarse grain. The graininess achieved varies with the brand of film and treatment, so results cannot be easily quantified for the different picture sizes.

The figures quoted below relate to my own equipment and the quality of my eyesight, but they can give you an approximate idea of what to expect in each instance.

High speed film

1 Treated for fine grain. Greatest enlargement showing all detail but almost no grain: 26 x 36cm (10 x 14in)
2 Treated for coarse grain. Optimum relationship between print size and grain for 35mm film: 30 x 40cm (12 x 16in)

Low speed film

1 35mm negative. Optimum rendering of detail in print from 30 x 40cm to 50 x 60cm (12 x 16in to 20 x 24in)
2 6 x 9 negative. Enlargements: 50 x 60cm to 100 x 150cm (20 x 24in to 40 x 60in)
3 Document film (orthochromatic), developed for continuous tone. 35mm: print size up to 100 x 150cm (40 x 60in) 6 x 9cm: up to 200 x 300cm (80 x 120in)

There are, however, other factors apart from these that you might consider equally important.

A great many factors can play a part in determining the ideal print size for each individual picture. Rules applied to this question are generally based upon particular concerns, such as viewing conditions, 'correct' perspective, scale and detail in the subject, limits of image quality and so on. In practice, these often conflict with one another or cannot realistically be applied at all. One very simple rule suggests that the diagonal of a print (image area) should be about half the length of the intended viewing distance. It is agreed that a comfortable 'reading' distance is about 25cm (10in), and the size of a print intended for a book or album should therefore be related to that. At this distance a print size of about 9 x 12cm (3½ x 5in) would cover the angle of view of the scanning eye and all details in the picture would be visible clearly without needing to peer at the print from closer range.

This is not an absolute rule, but it provides a useful point of reference. If, for example, you wanted to stress the vastness of a scene, the print would have to be much larger than is required by this rule in order to convey the impression of size through its scale alone.

A reasonable relationship of print size to viewing distance is always important. But in landscape photography, it is especially so, because our appreciation of landscape is greatly affected by impressions of size, grandeur and space which can (and should) be reflected in the print size.

Print surfaces

The number of different surfaces in which photographic papers are obtainable has been greatly reduced in the last few years but almost all papers (including colour) can be bought in at least three surfaces: glossy, matt (or semi-matt) and textured. In addition to these there are various methods of adding texture to print surfaces, for example,

141 A general word on black borders: they have been all the rage for some time, but are rather outdated now. I used them long ago and still use them now because they form an integral part of the compositions which I prefer. When black borders are effective and when not depends on basic qualities of the composition. This print is quite large (the intended size is 40 x 50cm (16 x 20in) on 50 x 60cm (20 x 24in) paper) because the amount of detail requires a presentation of substantial scale. (55mm lens, 6 x 7cm camera, ASA 400 film)

Fuerte: Jandia Playa a. Grill

canvas structure and/or brush-stroke imitations.

In my view the latter can do nothing but destroy essentially photographic qualities and should be avoided. A photograph is a photograph and not an imitation painting. The same applies to textured photographic papers. These are imitations of special papers used in other artistic media.

If you really think you need any of these special effects, you should take a close second look at your photographs. If they cannot stand on their own, improvements should be made to the photographs, not to the surface of the prints.

I can think of only one exception to this. I have not been able to find a photographic paper with a really matt surface for very large scale enlargements so, for this purpose, I use canvas, which does not have the sheen of paper.

Deciding whether to use matt or glossy paper requires some thought. Glossy paper allows you to make enlargements with a wider tonal range than matt. One manufacturer, for example, claims a maximum tonal range of 1:160 for his glossy paper, while the same grade of paper with a matt surface has a range of only 1:90. (This, incidentally, depends exclusively on the surface of the paper. If you were to make an enlargement on matt paper and then coat it with a glossy varnish, the tonal range of the enlargement would be the same as for one made directly on to glossy paper.)

This seems to indicate that a glossy surface is best, but the decision is not as easy as that. A matt surface looks more graphic, while a glossy one tends to stress the representational characteristics. So, if you want to render the detail in a photograph, you would probably want to render the full tonal scale of the negative as well, which would require glossy paper. A matt surface would be better if you wanted to emphasise the more general, and therefore more graphic, aspects of a landscape.

That does not necessarily mean that you have to keep stocks of both kinds of paper. Sooner or later most photographers develop a marked preference for one kind of presentation and therefore

can work with one kind of paper. For example, I use matt paper almost exclusively because it suits my style.

Borders and margins

There has been some controversy as to whether a picture should fill the whole printed area of the paper, should have a white margin or perhaps even a black border. Before discussing this point, a few practical remarks are called for.

If you decide to have a white margin, do not glue the enlargement on a sheet of paper. If at all possible it is much better to make a smaller enlargement on a larger sheet of paper so that picture and margin form a single unit. If you want a black border you should never draw it on the enlargement! Use either special enlarging easels with cut-out masks or the transparent area of film surrounding the negative. This latter technique requires the inclusion of the whole negative and precludes (the bad habit of) cropping.

White margins and black borders do involve a lot of additional work. Whether this is worthwhile or not depends to some degree on the kind of photographs you take. Very dynamic compositions work quite well, indeed, usually better, without a border or margin. But how often do you take dynamic landscape photographs?

Usually landscape photographs are quiet, self-contained pictures, in composition and content. This kind of photograph needs to be set off well against its surroundings to be most effective. You can do this either by using a white margin or by placing the photograph on, or behind, a cardboard mask, or both.

If you make enlargements with white margins, in most cases a black border is needed as well. This is because most landscape pictures contain pure white or very light grey areas (the sky, for example) which would spoil the composition if bled into the white margin.

The colour or grey tone of the margin and/or mask is also important. In colour pictures obviously the tone of the mask and the main colours of the picture should not clash. Generally speaking, a very neutral colour, such as dark grey, dark brown-grey or blue-grey works best. With anything else you are in danger of giving your work an arty appearance.

But there are, as usual, no hard and fast rules for choice in picture presentation because so much depends on what you wish to express.

142 Unfortunately, aspects of presentation, such as print size and paper surface, cannot be shown in a book. This print is, for example, about 14 x 20cm (5½ x 8in) on 30 x 40cm (12 x 16in) paper. This relationship is most important because being full of detail it needs white space around it to be effective. With a smaller border it would look overcrowded. (17mm lens, 35mm camera, ASA 100 film)

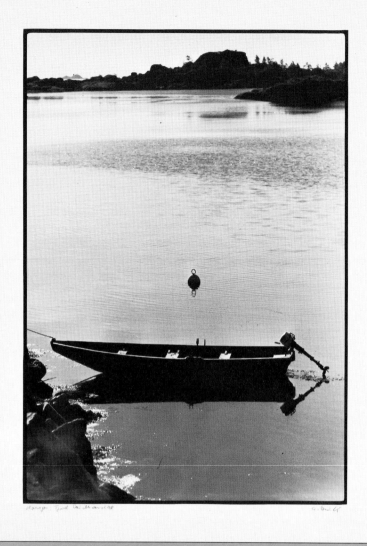

143 Whether you prefer the more dramatic and dynamic type of picture like the previous one, or a more tranquil and peaceful one like this, attention to every detail, including the presentation of your work, should be the first and the last consideration. What you want to say or to do, either *is* worth the effort and the considerable amount of work going into each picture, or it is not. If you throw away all prints (and negatives) that do not seem worth the time needed to be put into them and lavish even more care on the few remaining, you should end up with a number of excellent pictures instead of a vast quantity of mediocre ones. Ten excellent photographs that leave nothing to be desired are more than I usually hope to achieve as the result of a long 'photo-safari' ('long' meaning four to six weeks!). This picture was taken with a 25mm lens on a 6 x 7cm camera, using ASA 400 film.

BIBLIOGRAPHY/
ACKNOWLEDGEMENTS

Literature:
Camera and Lens / Ansel Adams / New York Graphic Society
Creative Camera Technique / Axel Brück / Focal Press
Natural Light Photography / Ansel Adams / New York Graphic Society
The Negative / Ansel Adams / New York Graphic Society
The Painter and the Photograph / Van Deren Coke / University of New Mexico Press
Perspectives on Landscape (cat.) / Bill Gaskins (ed) / Arts Council of Great Britain
Practical Composition / Axel Brück / Focal Press
The Print / Ansel Adams / New York Graphic Society

Pictures:
Axel Brück 1,3–12, 15–23, 25, 27–43, 45, 47–50, 53–59, 61, 63, 68–75, 77–85, 85–105, 108, 111–112, 115, 119–120, 122, 124, 127, 130–134, 136, 138, 140–143.

Paul Petzold 2, 13–14, 24, 26, 46, 51–52, 60, 62, 64–67, 76, 85, 106, 109–110, 116–118, 123, 125–126, 128–129, 135, 137, 139

Jack Taylor 44, 56, 107, 113, 114, 121

INDEX